Places close to home and far away, indoors and out, modern and ancient, natural and man-made.

photo
idea
index:
places

Places close to home and far away, indoors and out, modern and ancient, natural and man-made.

photo idea index: **places**

JIM KRAUSE

HOW BOOKS

CINCINNATI, OHIO
www.howdesign.com

For more resources for designers, visit www.howdesign.com.

12 11 10 09 08 5 4 3 2 1

Distributed in Canada by Fraser Direct
100 Armstrong Avenue
Georgetown, Ontario, Canada L7G 5S4
Tel: (905) 877-4411

Distributed in the U.K. and Europe by David & Charles
Brunel House, Newton Abbot, Devon, TQ12 4PU, England
Tel: (+44) 1626-323200, Fax: (+44) 1626-323319
E-mail: postmaster@davidandcharles.co.uk

Distributed in Australia by Capricorn Link
P.O. Box 704, Windsor, NSW 2756 Australia
Tel: (02) 4577-3555

Library of Congress Cataloging-in-Publication Data

Krause, Jim, 1962-
 Photo idea index : places / Jim Krause.
 p. cm.
 ISBN 978-1-60061-043-1 (pbk. with flaps : alk. paper)
 1. Photography--Digital techniques. I. Title.
 TR267.K737 2008
 778--dc22 2008039582

Edited by Amy Schell
Designed by Jim Krause
Art directed by Grace Ring
Photography by Jim Krause
Production coordinated by Greg Nock

F•W PUBLICATIONS, INC.

...another one dedicated to my son, Evan.

About the Author:

Jim Krause has worked as a designer/illustrator/
photographer in the Pacific Northwest since the 1980s.
He has produced award-winning work for clients large and
small and is the author and creator of eight other titles
available from HOW Books: *Idea Index, Layout Index, Color
Index, Color Index 2, Design Basics Index, Photo Idea Index,
Type Idea Index* and *Creative Sparks.*

WWW.JIMKRAUSEDESIGN.COM

Table of Contents

Introduction

First of all, don't let the look of this book fool you. It's not a book of pictures. This is a book of ideas.

If you've seen any of my previous titles, you'll know this is what I try to do: fill pages with content that bombards readers with visuals and words in hopes of expanding and diversifying their creative output. Same goes for this volume and its two companions, **Photo Idea Index: People** and **Photo Idea Index: Things**. All the books I've created are *what if* books (as opposed to *how to* books). As an example of what I mean, look at the image on pages 110-111. If this were a *how to* book, the image of the toy monkey swinging from a rear-view mirror would probably be accompanied by step-by-step instructions on how to shoot and present a similar photo. But since this is a *what if* book, the actual purpose of the monkey picture is to nudge viewers toward creative ideas of their own by prompting questions such as, "*What if* I brought a mascot with me to use as a photo prop the next time I go on a road trip?" or, "*What if* my friend drives the next time we go someplace together and I take pictures along the way?" or, "*What if* I put something bright red in the middle of an otherwise drab scene?" or, "*What if* I bought a fisheye lens for my digital SLR?"

At the end of each chapter are brief paragraphs related to its images. These bits of text are sometimes related to circumstances surrounding the capturing of the photos and sometimes related to technical matters regarding either the shooting of the images or their digital processing. These notes will be most useful to readers who have a working understanding of their camera's operation, photography fundamentals, and Photoshop essentials (including the basic use of adjustment layers, layer masks, filters, the tools palette and color and contrast controls). If your knowledge or experience is limited in any of these areas, don't worry. You can still get ideas and inspiration looking at this book's photos. You might just want to also consider boning up on weak areas with the help of manuals and reference books for your camera or Photoshop.

You'll notice that the emphasis in this book is on digital cameras and digital processing (using Photoshop). I have nothing against cameras or people that use film—it's just that I enjoy being able to fill the memory card on my camera without worrying about emptying my wallet when it comes time to process the images. I'm also a big fan of the LCD on the back of digital cameras since it allows me to check the results of my work

as I go and make adjustments on the fly. Still, I'd like to say these two things to any film-using photographer who is reading this intro: Welcome, and know that this book was created with you in mind, too; very few (if any) of the images in these pages were shot or processed in a way that could not be emulated using traditional film and darkroom techniques.

In case you're wondering, I took all of the photos featured in this book. Most were taken specifically for this project during the 18 months prior to the book's publication. The images were shot in and around the northwest corner of Washington state (my home turf); Joshua Tree National Park, California; Charleston, South Carolina; Hopkins, Belize; Vancouver, B.C.; and the Italian cities of Rome, Florence, Siena, Assisi, Pisa and the Cinque Terre (and in addition to taking photos in these specific destinations, I also used my camera freely while traveling to and from each).

Thank you for picking up a copy of **Photo Idea Index: Places**. I had a good time putting it together and hope it proves to be a useful and inspiring resource for you. Jim K.

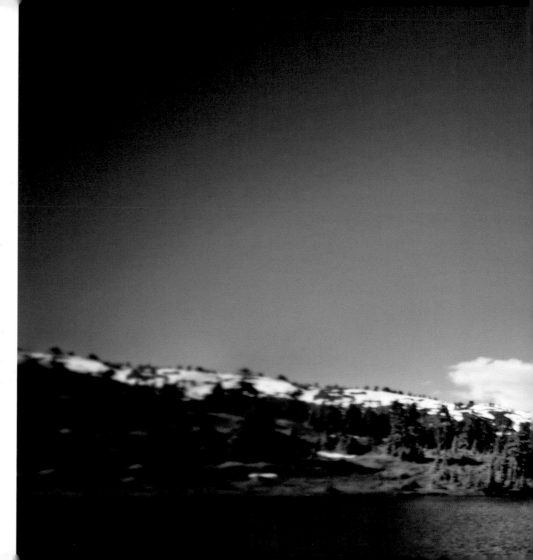

1

The Grand View

These are the perspectives that have been bringing cameras and people together since the earliest days of photography: the wide-eyed views that cause a hiker to linger along the crest of a ridge, that compel a driver to park her car along a roadway at sunset, that prompt a walker in the city to pause and lift his eyes to the surrounding skyline.

As mentioned in the introduction, the images in this book are presented for three main purposes: to lend image-capturing ideas to the reader; to suggest ways of presenting images (through the application of effects such as black and white conversions, color and contrast adjustments and special effects treatments); and—it is sincerely hoped—for viewing enjoyment. Refer to the final two pages of each chapter for more information about its images.

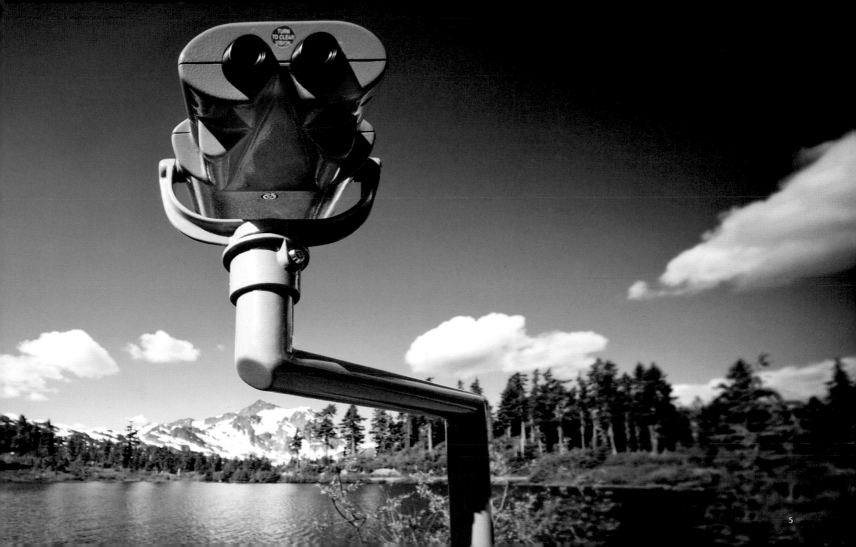

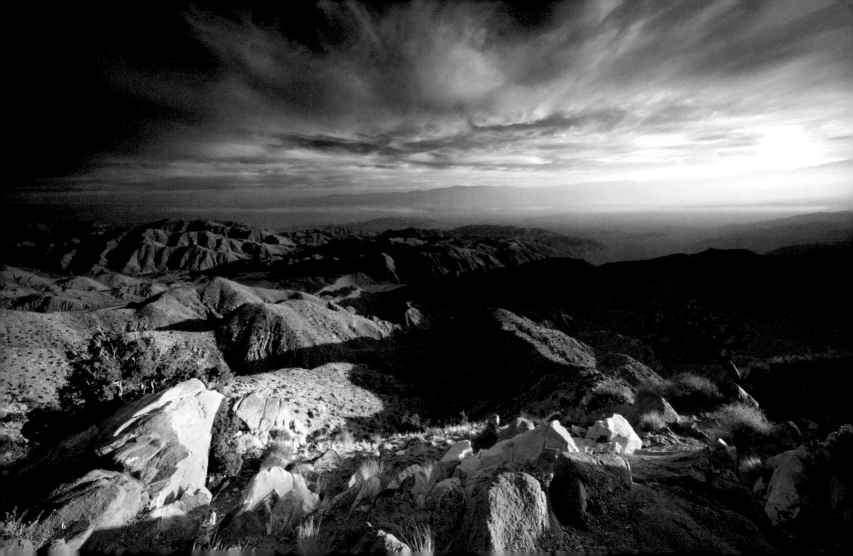

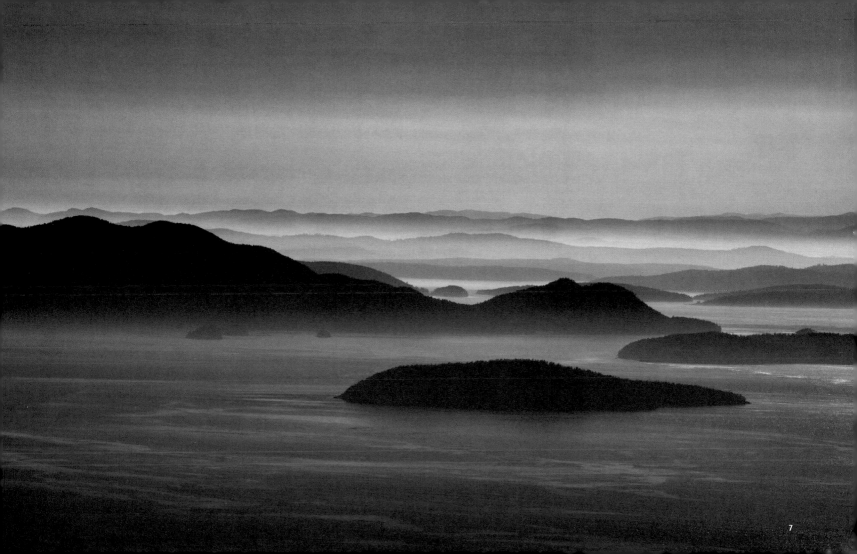

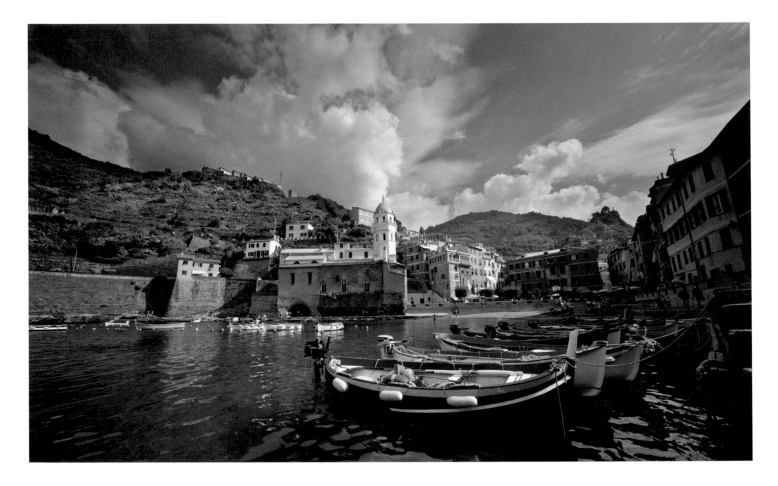

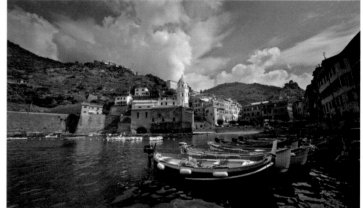
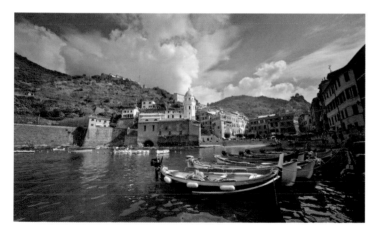
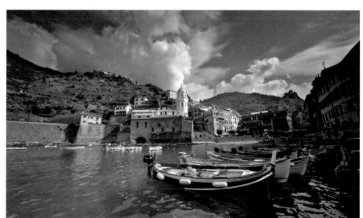

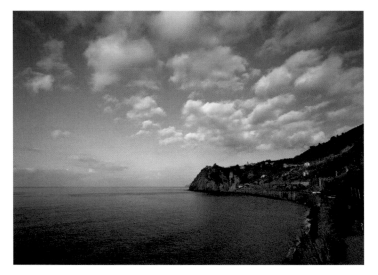
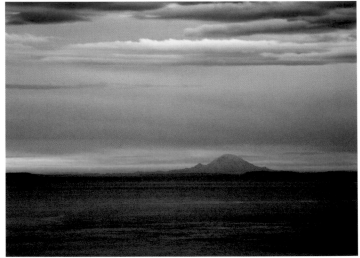

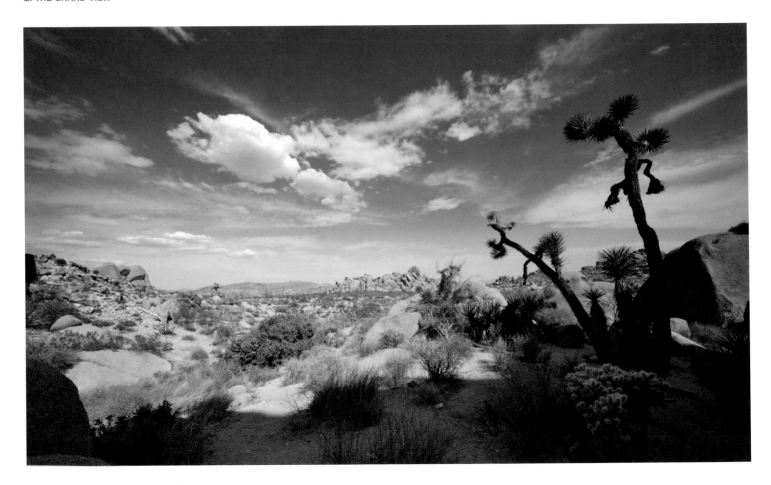

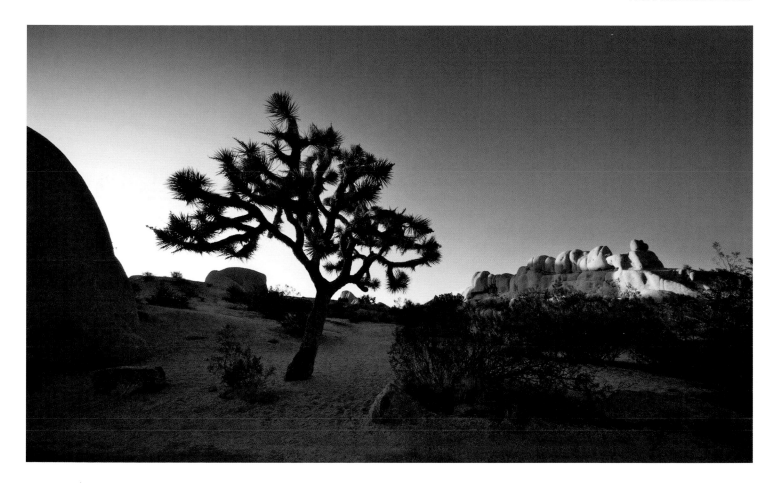

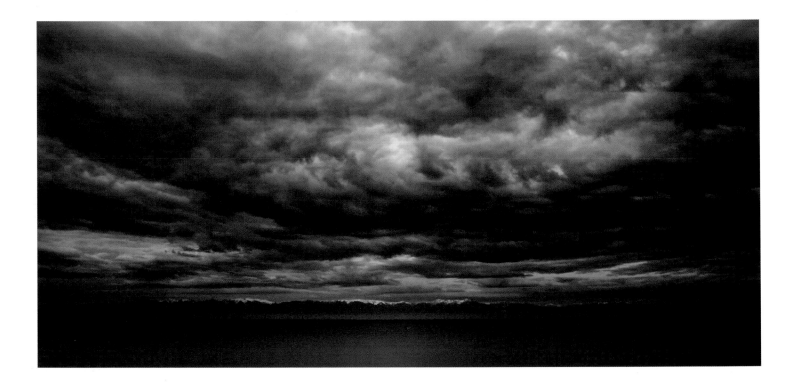

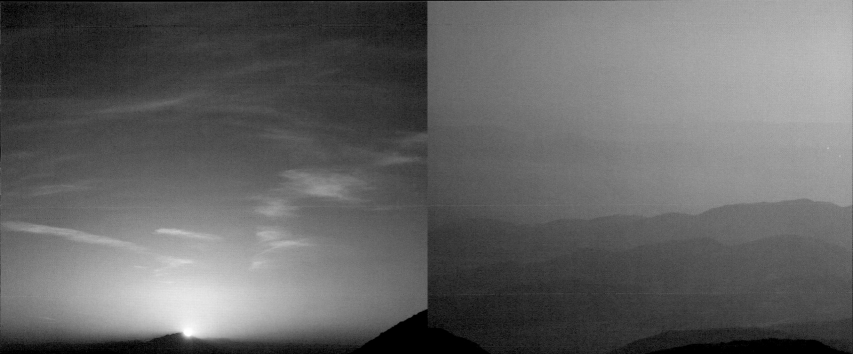

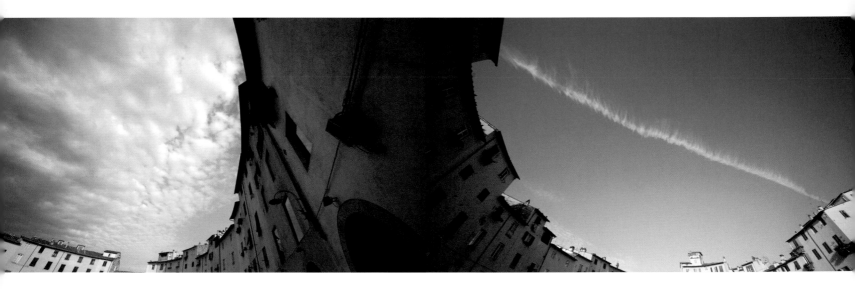

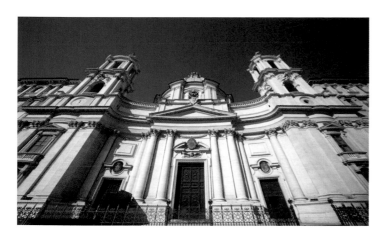

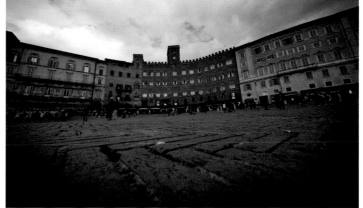

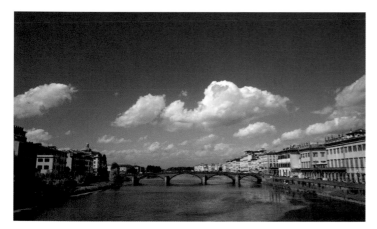

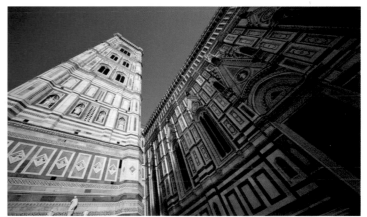

Many of the images in this chapter were taken using a digital SLR fitted with a 12-24mm wide-angle zoom lens. Lenses such as this are ideal for capturing expansive scenes. Their ability to gather huge swaths of earth and sky into a frame (without an undue amount of distortion) is remarkable.

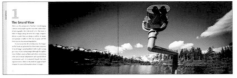

4 5

Thematically, the mounted binoculars in this image help establish a sense of viewer participation. They also play a compositional role as they direct attention toward the photogenic mountain in the background. To capture this point of view, I had to lie on my back and steady my head with one hand while operating the camera with the other. Be resourceful and tenacious when it comes to finding effective vantage points from which to shoot; capitalize on conceptual and compositional bonuses whenever you can.

Originally shot in RGB color, this photo was converted to grayscale using a CHANNEL MIXER adjustment layer in Photoshop. The "monochrome" option was highlighted in the mixer's controls; the red channel was set to 100%; the green and blue channels to zero. You may wish to favor the green or blue channel for your photo—every image is affected differently by these controls. Take a look at pages 160 -161 to get an idea of the range of outcomes that can be expected when converting a photo to black and white in this way.

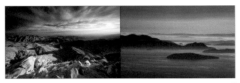

6 7

Islands in the Straight of Juan De Fuca in Washington state. This shot was taken from a lookout called Oyster Dome—accessible only by a trail that includes 2000 feet of elevation gain. It's a fine way to spend a warm spring or summer day—out walking or hiking with your camera. Hiking shoes, comfortable clothes, a hat and a small backpack (to hold items such as a coat, camera supplies and some snacks) are often all that's needed for a pleasant and productive day of sightseeing and image collecting.

A group of colorful boats lie moored in the jade-green bay of Vernazza, Italy. Shooting the scene from a low angle allowed the inclusion of elements that were both near to, and far from, the lens. A vantage point like this enhances an image's projection of depth. Fortunately, there was a dock that extended some distance into this bay. Thus, I was able to get a shot of this beautiful town and its bay from the sea's perspective without renting a boat or going for a swim. Opportunism is an oft-repeated theme in this book.

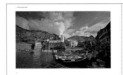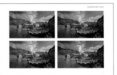

8 9

Consider your options once you've decided to download a photo to the computer in preparation for presentation. How about heightening the natural colors in the image? What about muting the hues, tinting the image or converting the scene to black and white? What other digital treatments and special effects could be considered?

A collection of seaside shots. The photos on this page were taken under what could be considered camera-friendly conditions: the light was ample and the weather cooperative.

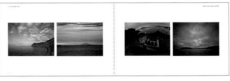

10 11

These two photos, in contrast with the pair opposite, were taken in less-than-ideal conditions. The image on the left was recorded in near darkness by setting the camera on a tripod and using a long exposure (10 sec.). The photo at right was shot in dim light while shielding the lens from rain. The point of this page-to-page comparison? To serve as a reminder: Take advantage of your digital camera's disk space—accept the prevailing conditions and make adjustments on the fly until you get something you like.

When possible, consider taking a landscape photo from a point of view that puts the foreground in shadow. This can lend attractive qualities of depth and contrast to an image (while also allowing the photographer to spend time in the cool shade while he works). If the photo is shot so as to avoid overexposure in its brighter areas, you may need to use a tool such as Photoshop's SHADOW/HIGHLIGHT adjuster to bring out sufficient detail in the image's shadow regions.

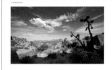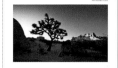

12

The gangly form of a Joshua tree is silhouetted against an early morning sky in Joshua Tree National Park, California. The afternoon temperatures in "J Tree" can easily exceed 100°F—a good reason to concentrate on pre-sunrise and post-sunset photos if you happen to visit this spectacular preserve during its warmer seasons.

13

Originally, I had planned on visiting this overlook to capture a shot of field, sea and mountains. My plans changed, however, the moment I got a look at the spectacular mass of clouds overhead. In the end, I decided to completely omit the field I was standing in from the composition and devote the majority of the frame to the sky above. I've come to deeply appreciate the mood-altering and aesthetic-enhancing roles that clouds play in the presentation of photographs.

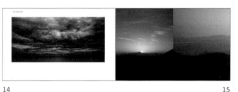

14

Sunset photos populate just about every photographer's photo album—and why not? They are beautiful scenes and worth remembering. Consider taking photos both during sunsets (left) and after (right).

15

The content of this chapter has been mainly devoted to nature-oriented scenes. Here, a reminder that cities, too, offer their share of expansive and intriguing vistas. The two upward-looking photos of an Italian piazza on this page make an interesting pair when joined edge to edge. How about exploring creative ways of combining images when you have two or more you want to present together?

16

A wide-angle lens can be a photographer's best friend when it comes to bringing large city views into the frame. Be sure to investigate different points of view when you are using a lens of this sort: aim upward; shoot level; aim downward; set the camera on the ground (as was done for the photo at upper right). Note the effect these different perspectives have on the horizontal and vertical lines within the scenes you are photographing.

17

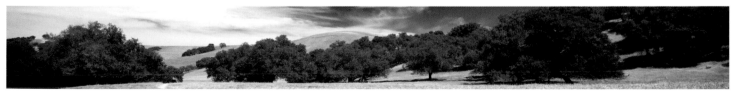

A wide shot of rolling hills, leafy trees and pleasant sky. If you take pictures commercially, consider extreme horizontal croppings like this for web page headers and banner ads.

2

Everyday Scenes

When traveling with a camera—whether around the corner or around the world—it's all too common to find yourself drawn exclusively to views of splendid historical, cultural and artistic significance. And while subjects such as these are worthy of attention and photographing, they may not reflect the authentic, day-to-day character of a place.

If you are interested in gathering images that convey impressions of a place's ungilded personality, get off the tour bus and take to the streets and alleyways. Widen your image-seeking perspective to include scenes of commonplace, everyday life.

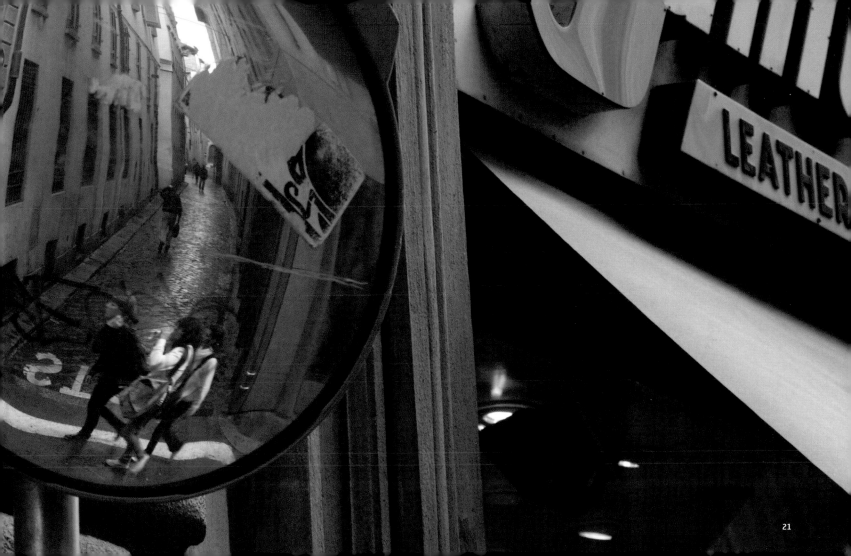

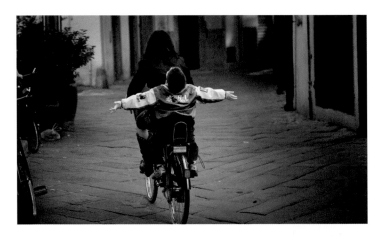

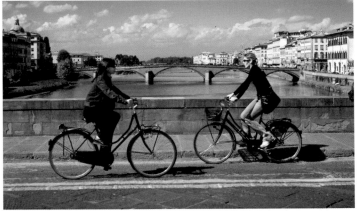

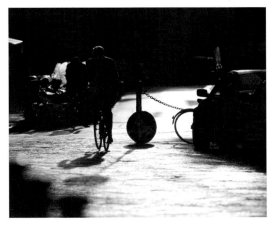

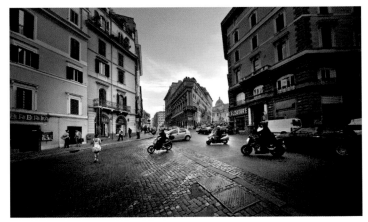

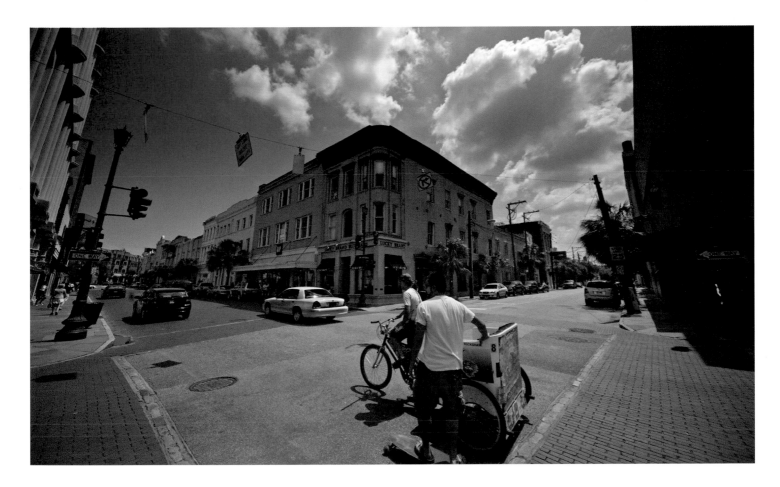

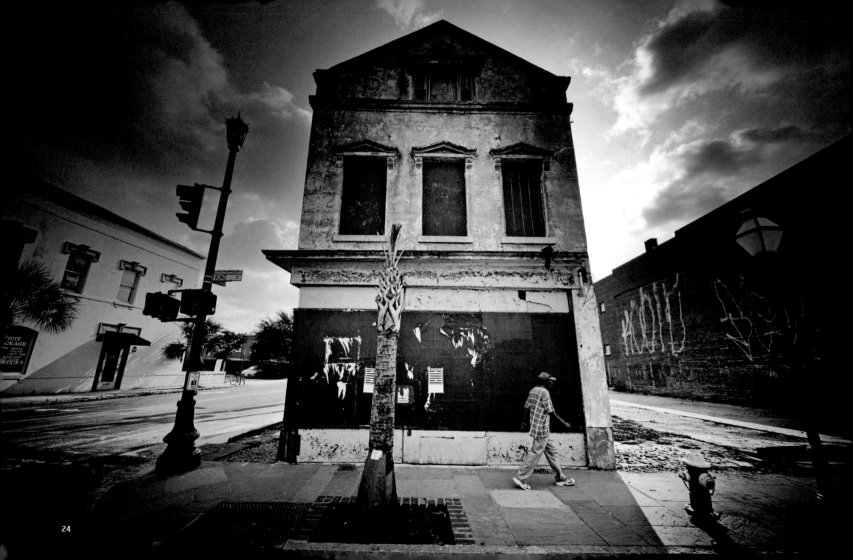

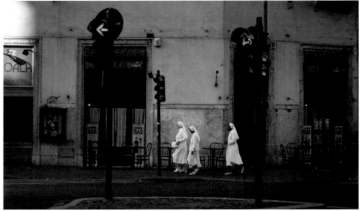

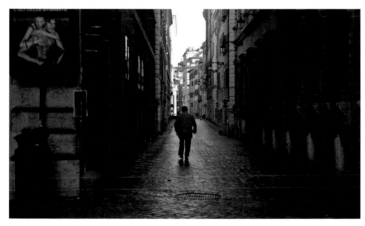

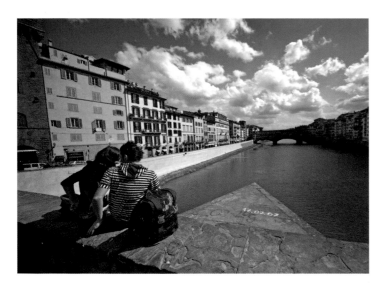

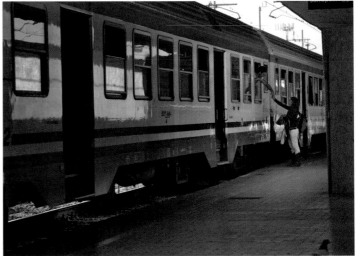

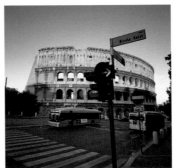

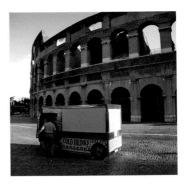

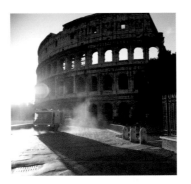

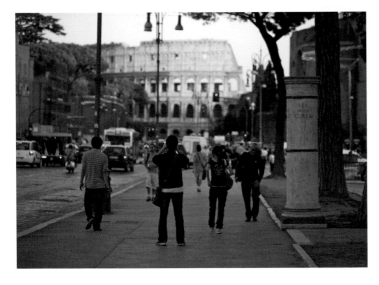

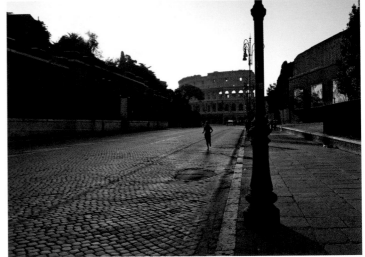

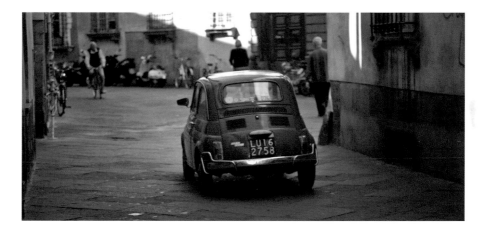

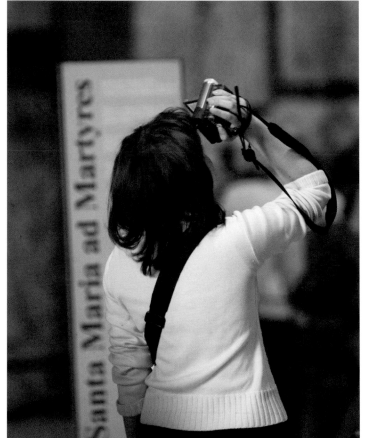

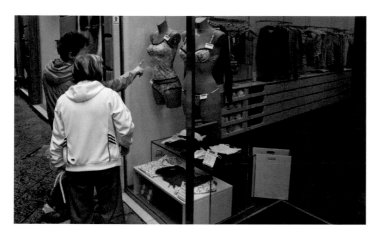

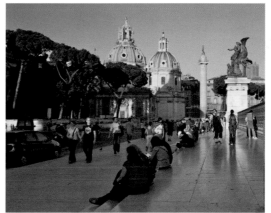

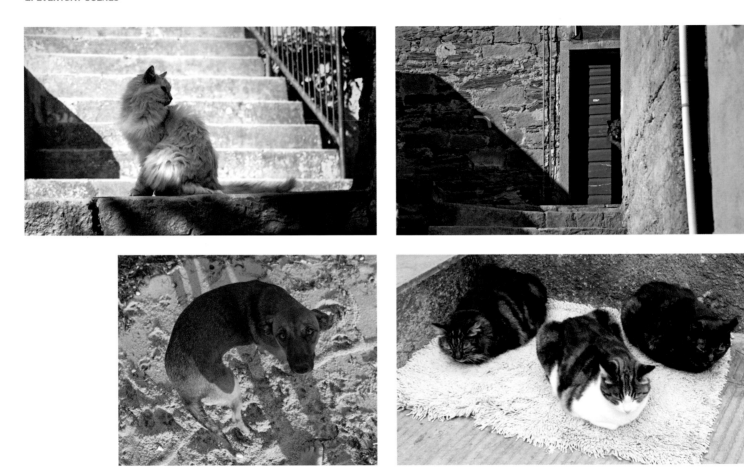

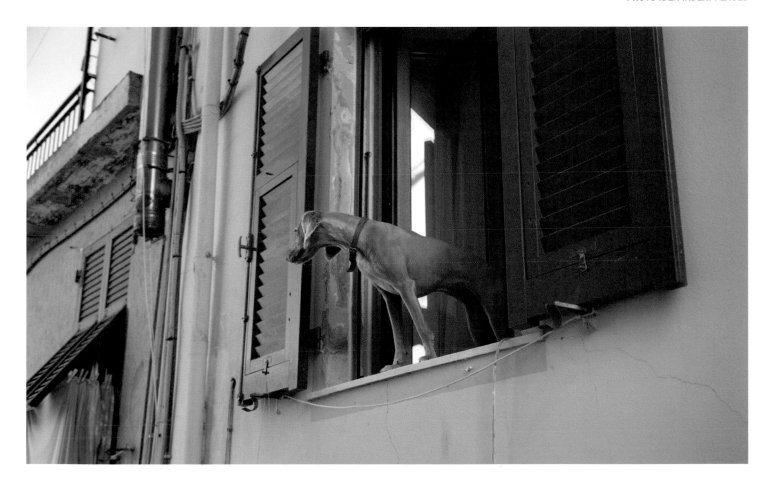

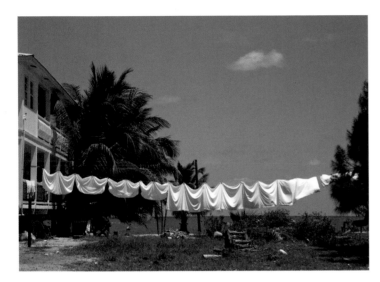

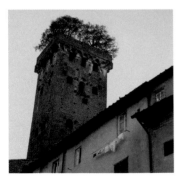

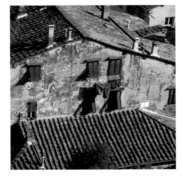

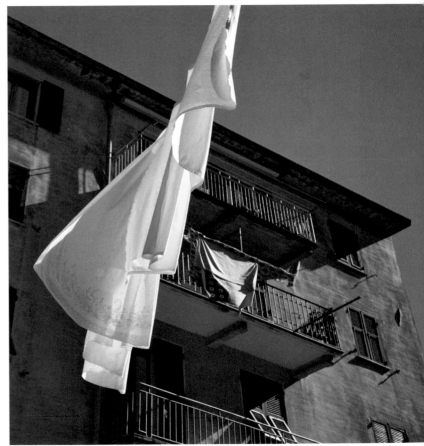

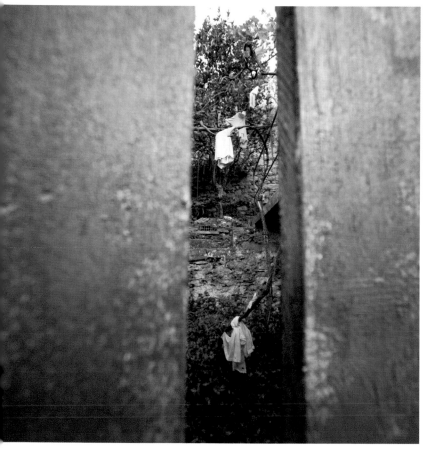

You can hardly step out the door of your home or hotel without running into an everyday scene (in fact, you don't even have to step outside find one—everyday scenes are *everywhere*). Keep a camera accessible so you can snap pictures of ordinary life whenever—and however—you find it. When traveling, consider this idea: spend a photo-intensive afternoon ignoring your destination's major attractions and focus instead on scenes of that place's day-to-day life.

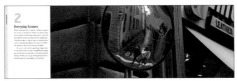

20 21

When I first came across this street-corner mirror, it reflected only the empty alley behind me. I wanted to take a photo of the scene it contained, but felt a human element was needed to complete the image. So I did what I've finally learned is the only thing to do in such situations: nothing. That is, I waited for something photo-worthy to occur. A few minutes later, when this trio of students walked past the mirror's lens, I felt I had what I was looking for and took the shot. Better photos often come to those who wait.

Bikes (both motorized and non) are the common bond in this spread's photographs of everyday life. Keep content-related themes such as this in mind when traveling with camera in hand. Themes can become the bonding agent for collections of photos—collections that could later be used for commercial, fine art or personal purposes.

22 23

Roaming a city with a wide-angle lens gives you a means of capturing large views of streetside action in one click. This shot was taken using a digital SLR fitted with a 12mm-24mm wide-angle zoom lens. For more images taken from streetside vantage points, see Chapter 5, Streetside, on pages 68-77.

This photo, like the one on the previous page, was shot with a wide-angle lens. This sort of lens is able to create a dynamic convergence of perspective within a scene. Note the way clouds, streets and rooflines direct your eye toward the vanishing-point (an artist's term referring to the point at which parallel lines—when viewed in perspective—appear to converge) at the near center of this image.

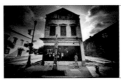
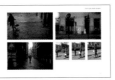

24 25

It's a good idea to keep the camera in rapid-fire mode when traversing a city. That way, if a moving photo opportunity—such as a mohawked skater or a group of nuns on a morning walk—happens by, you can simply aim the camera (or shoot blindly, "from the hip," if there's no time to aim visually) and hold the shutter button down. Let the camera snap away until the moment has passed and afterward choose your favorite image from the batch.

Discretion is the name of the game when it comes to shooting scenes of affection. My personal rules related to photographing people are in full effect when snapping pictures of couples: Only attempt the photo if the subjects are in a public place; ask permission before shooting if there's any chance the subjects will know they're being photographed; and take the shot in such a way that the identity of the subjects will be obscured—particularly if the photo will ever be shown in public.

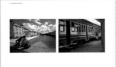
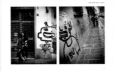

26 27

How about using an intriguing piece of graffiti as a backdrop for your scene of everyday life? Photoshop's DISTORT > LENS CORRECTION > VIGNETTE filter was used to darken the perimeter of these images. This effect lends a feeling of self-containment to a scene.

After you've filled an album or two with images of your destination's significant works of art and architecture, how about using these same landmarks as backdrops for your shots of everyday life?

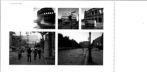

28

29

Can you guess which image was shot in a small Italian town and which was taken in a major American city? Autos and other forms of transportation can make excellent subject matter if you are looking for ways of presenting glimpses of a country's cultural and social conventions.

Since *places* are the focus of this book, most of its images are people-free. This spread is inserted as a reminder, however, that people (fellow tourists included) make excellent additions to your photographs of the places you visit.

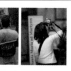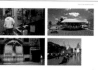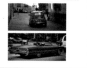

30

31

Images of tourists doing what tourists do best (clockwise from upper left): gawk at window displays; linger in the shade of outdoor bars; hang out at sunset amidst some of the world's great historical sites; and ask probing questions of tourism officials. (For instance, as I was taking this photo, the English speaking tourist in the scene asked the Italian official inside the booth, "So, who's this lady supposed to be, anyway?")

Cats and dogs rarely require model-release forms. This, among other factors, makes other people's photogenic pets great subject matter for images of everyday life.

32

33

Keep your eyes moving and your camera handy when traveling through a town—certain photo opportunities only last a moment. This sleek and inquisitive hound appeared on a ledge over my head as I was meandering through a town in coastal Italy. The dog stayed there only long enough to give its domain a once-over before retreating indoors. Luckily I had my camera where it was supposed to be—on its leash (a.k.a. neckstrap)—and was able to record the scene.

Portraits of laundry from around the globe. The charm of certain everyday activities lies in the fact they are so similar the world over.

34

35

Each of the small images on the right of this page were photographed while taking breaks during this book's image-taking forays. And even though they may not be the most aesthetically compelling shots in this book, they are some of my favorite photographic mementos of time and place. Consider doing the same when you are taking a breather from your tourist duties—capture images of everyday moments from your own life.

3

Habitat for Humans

A region's climate, resources, history, economic situation, belief systems and lifestyle choices are reflected in the way its inhabitants shelter themselves. It's no wonder homes and dwelling places make such promising subject matter for photographers seeking to convey multiple layers of information and impressions through their images.

Use the pictures in this chapter to remind yourself of different ways of capturing and presenting photos of habitat. And remember: Effective images are all about taking your camera to the precise spots where it will record images that are both thematically and artistically compelling—keep your feet moving until you find points of view that excite your eyes.

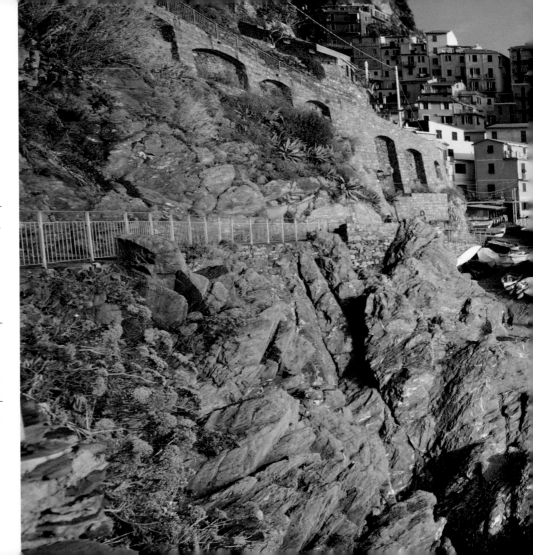

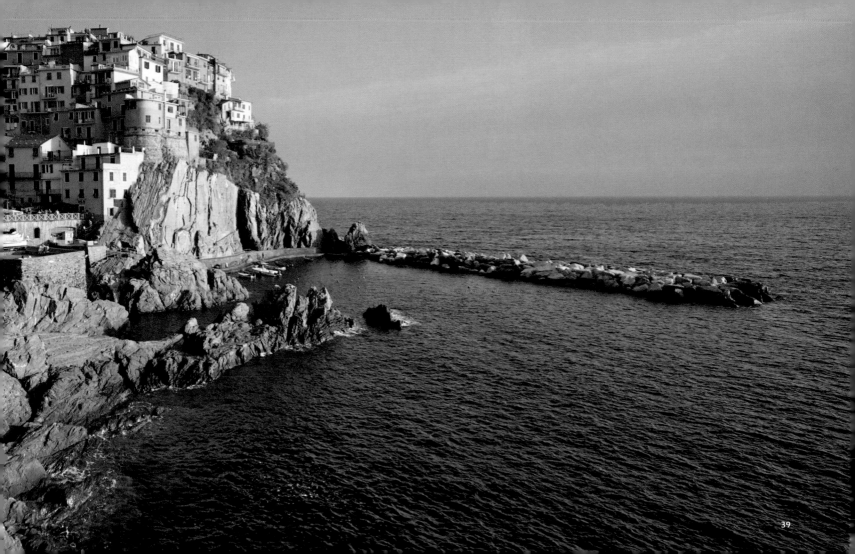

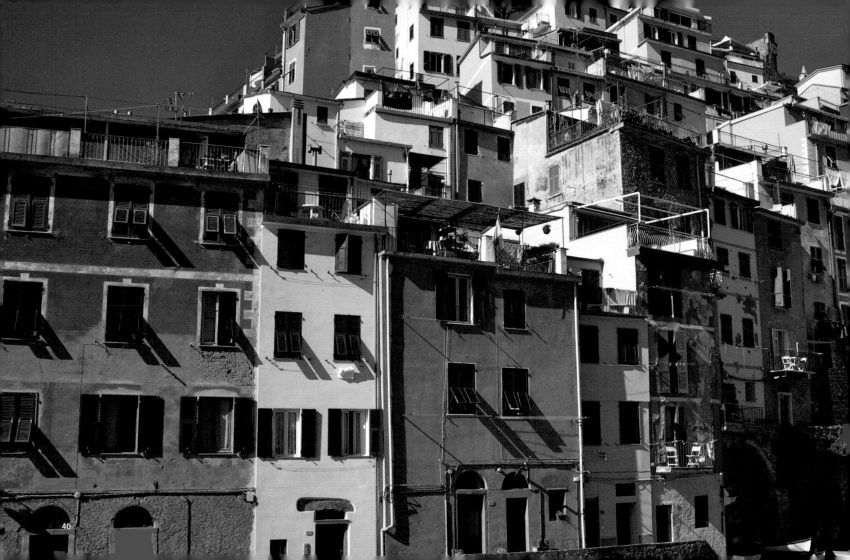

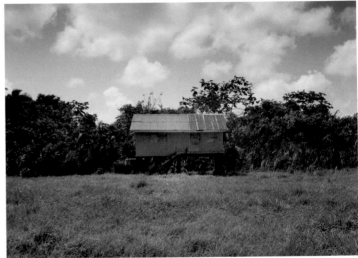

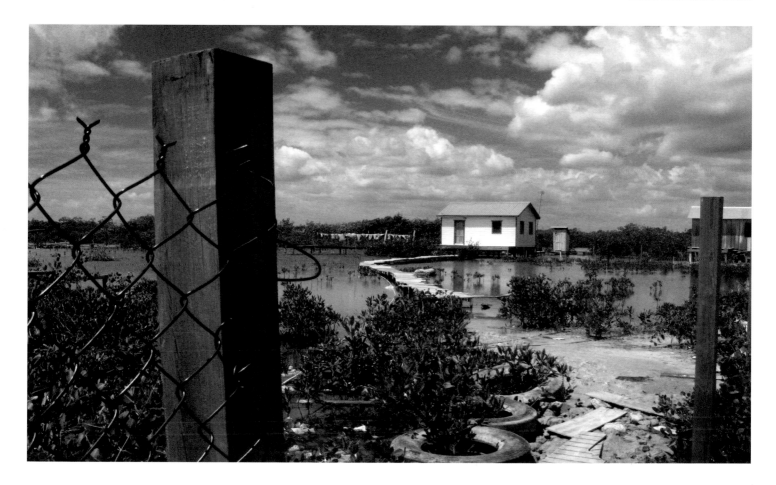

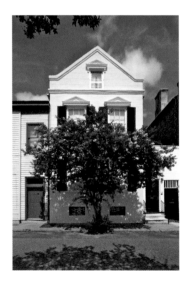 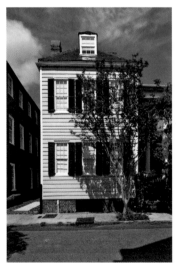 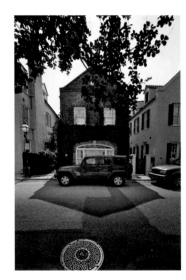 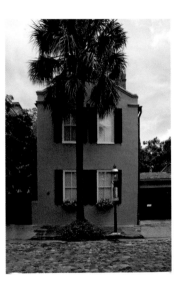

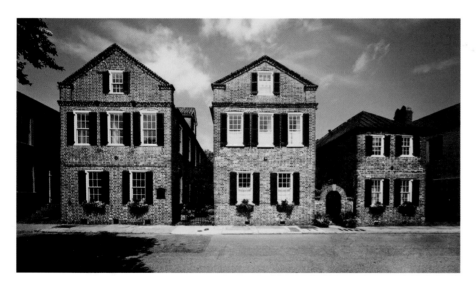

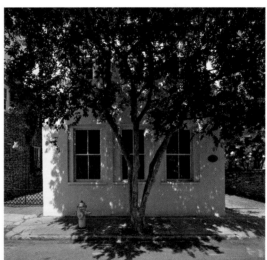

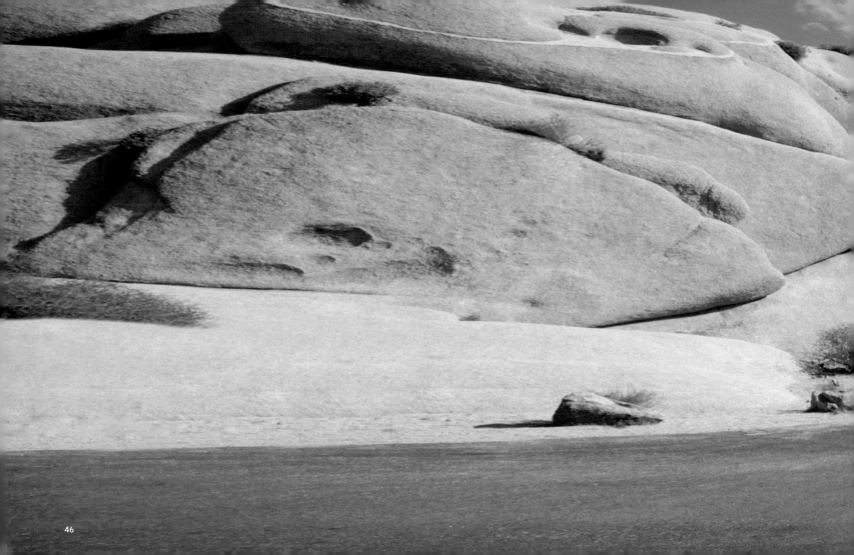

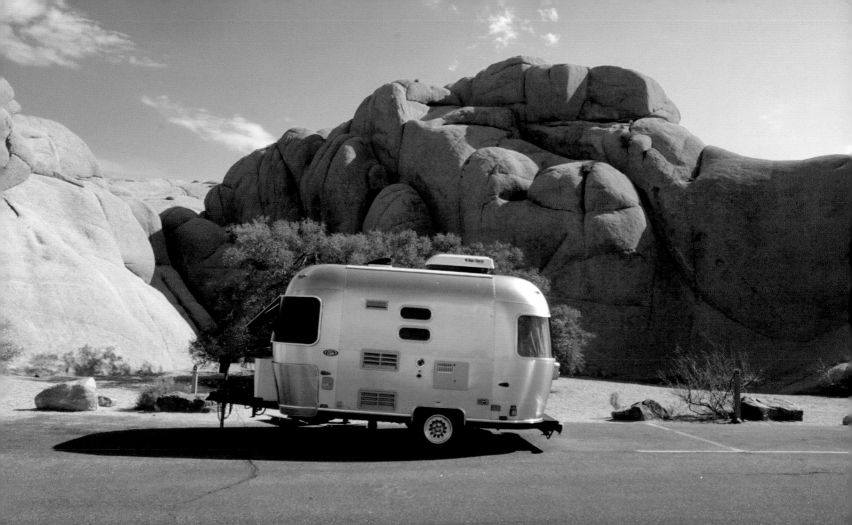

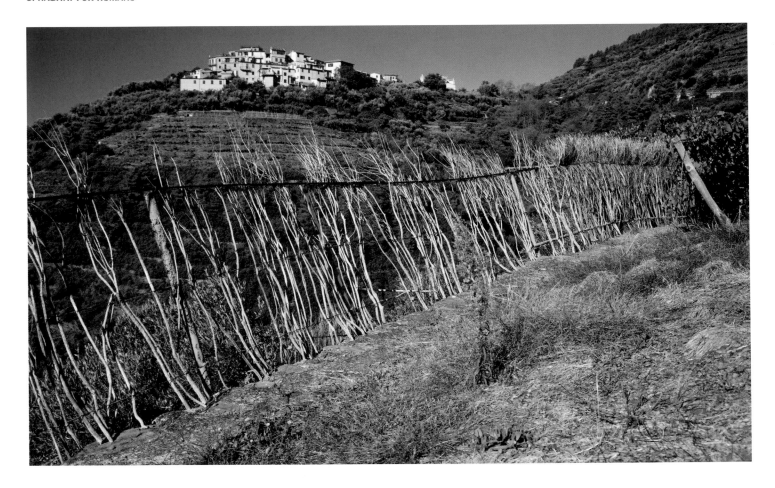

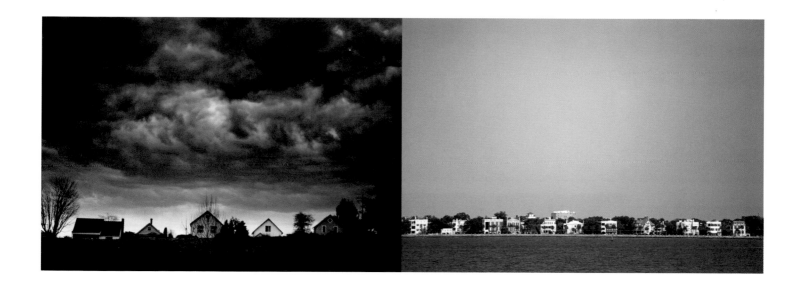

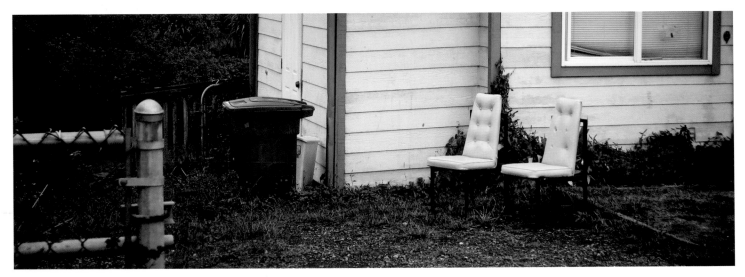

Manorola—one of the five seaside villages that form the Cinque Terre (translated as "Five Lands") on Italy's Mediterranean coast. Brightly painted abodes cling to the contours of each village's rocky shore.

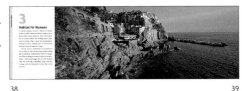

38 39

A 12mm-24mm wide-angle zoom lens was used for this photo. When shooting with a wide-angle or fisheye lens, you may need to keep the line of the horizon relatively near the middle of the scene to keep it from being bent by the lens' optics (see page 282 for a couple of examples of wide-angle scene warping).

The colorful face of Riomaggiore (another of the coastal Cinque Terre villages). A somewhat flattened perspective has been created of this busy scene by zooming in with a telephoto lens from a distant vantage point. Photoshop's HUE/SATURATION and CURVES controls were used to maximize image's colorful and complex forms.

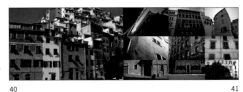

40 41

While visiting a place to take pictures, I prefer exploring its roads, alleys and paths by foot or bicycle. This allows access to—and the time to consider—photo opportunities that would surely be missed if the day were spent whizzing from destination to destination by car or bus. I may cover less ground traveling under my own power but I think the payoff in worthwhile images is a more-than-adequate reward.

"Framing" is a term used to describe the effect that occurs when certain elements of a photo visually surround other elements. Framing can bring a sense of order to a photo and help direct the viewer's attention to your image's main subject. The photos on this page provide two examples of compositional framing: the dwelling in the near image is visually bracketed by neighboring palms; the home in the next image is surrounded by a backdrop of foliage.

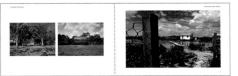

42 43

The vertical posts in the foreground of this image provide another example of framing as they visually brace the house on stilts between them. The dirt trail leading toward the home provides additional compositional help in directing attention toward the scene's focal point.

In Charleston, South Carolina, tall and skinny is an oft-repeated architectural theme. Being from the opposite U.S. coast, I was intrigued by this unfamiliar style of abodes. But the thing that really caught my eye was the single tree planted squarely in front of so many of the homes. I was never quite sure if this was for purposes of privacy, shade, or style. Still, I thought it was a charming and unique application of urban landscaping—and definitely worth photographing—over and over.

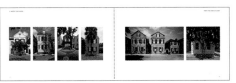

44 45

How about exaggerating the colors in your image? The hues in the large image were altered with a heavy application of Photoshop's PHOTO FILTER effect (set to "deep yellow"). CURVES adjustments were used to heighten the image's contrast. Experiment freely with these (and other) Photoshop effects—hands-on investigation is the best way of finding out how these tools work and what they can do for your photographs.

When looking for examples of habitat, keep your definitions flexible. For some, home is wherever you park it.

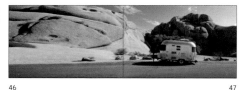

46　　　　　　　　　　47

As if the inherent charm of an old-school trailer sitting in a historic national park wasn't enough to warrant snapping a photo, consider these aesthetic bonuses: harmonious echoes between the form of the trailer and its weathered stone backdrop; subtle contrast between gleaming aluminum and gritty stone; a pleasing ready-made palette of neutral grays, browns and a muted steely blue.

In this spread's photos of habitat, land and sky are allowed to dominate the scenes. Emphasizing aspects such as these are a good way of establishing the context in which certain dwellings exist. Another reason you might want to downplay the visual presence of your main subject is to make room for theme-setting elements such as the oppressive bank of clouds above the strip of homes in the center image (see the opposite paragraph for more information about these particular clouds).

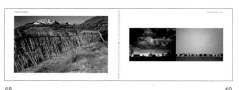

48　　　　　　　　　　49

The clouds in the center image were borrowed from the photo on page 14. Why? To generate a sense of drama within the scene and to serve as a reminder that digital effects can be used to radically transform any image. This is one of the few examples of significant digital manipulation in this book. And while I've got nothing against cyber magic of this sort, I wanted the main focus of this book to be on the creative, contextual and aesthetic considerations that apply to all forms of photography—digital or film. -

The two larger photos on this spread share common themes of *ordinary life* and *pink kitsch*. The pink hue in these images has been emphasized—and other hues muted—using Photoshop's HUE/SATURATION controls.

50　　　　　　　　　　51

How about taking a string of photos that document the street you live on? The images could be expertly joined using on-camera or digital photo-merging tools. They could also be connected in a more casual manner—as demonstrated here.

Some photographers spend their careers focusing on day-to-day neighborhood material. And why not? Art is all about connection, and rare is the viewer who can't connect to some concept of "home."

4

Architecture and Skyline

The impression a city cuts from the sky is its visual signature to all who approach. A city's architectural and geographic features—whether planned, improvised or *au naturel*—combine to create a skyline as unique to that place as fingerprints are to its human inhabitants.

Notice the vantage points chosen for the photos featured in this chapter. Some of the images were taken from deep within a city or town; others were captured from the outskirts. Notice also how skyline itself has been downplayed in some shots by giving foreground or background elements greater visual presence in the scene's composition. Explore variations such as these when you are taking photos of architecture or skyline (or anything else, for that matter).

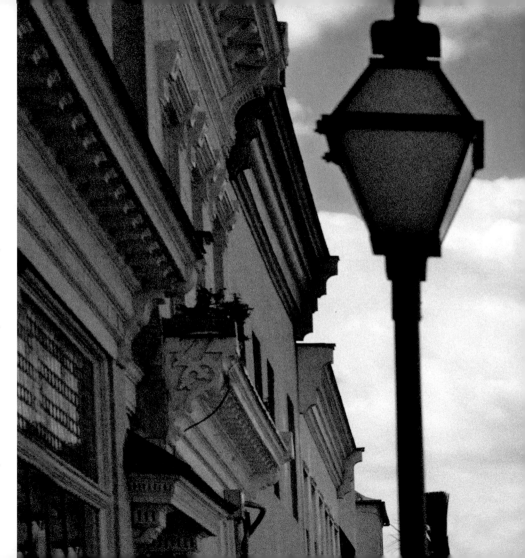

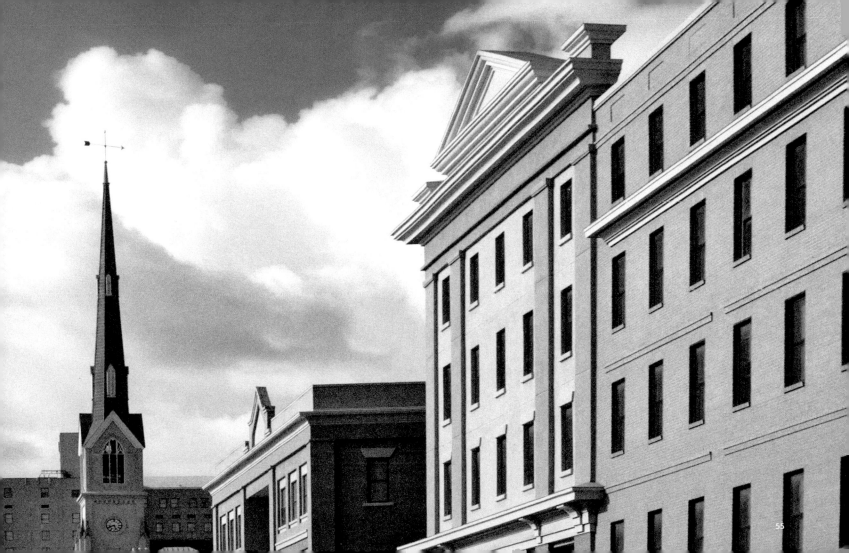

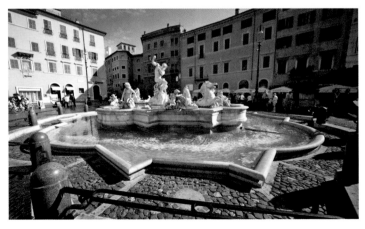

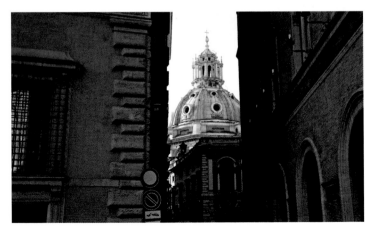

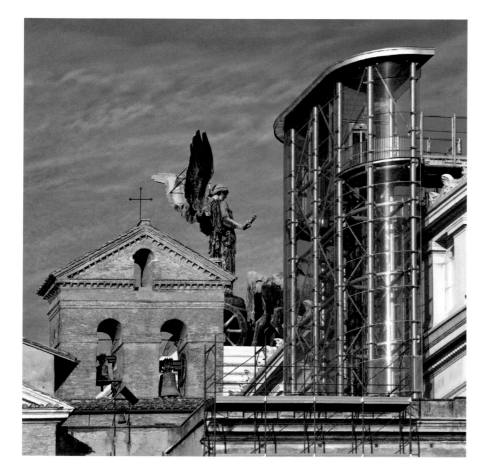

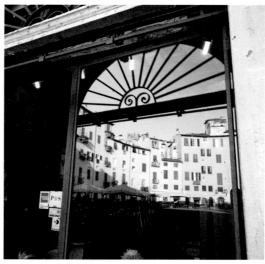

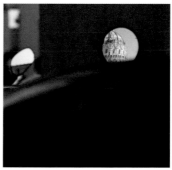

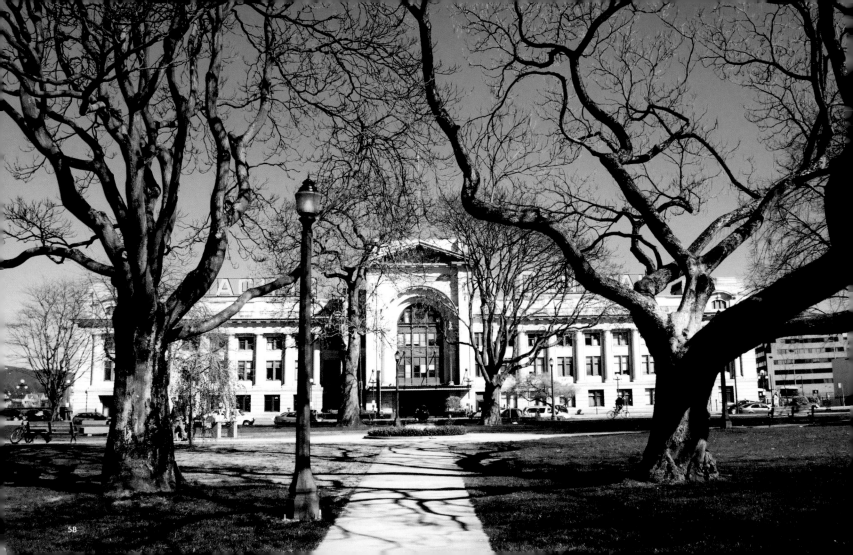

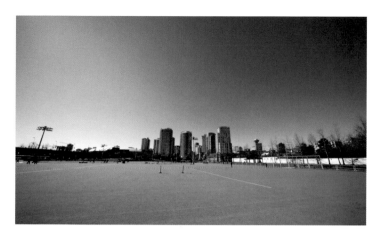

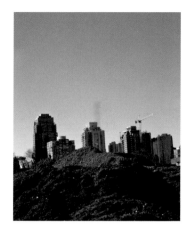
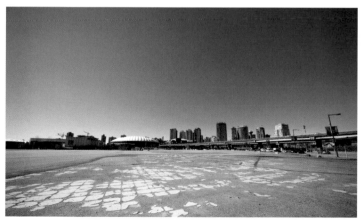
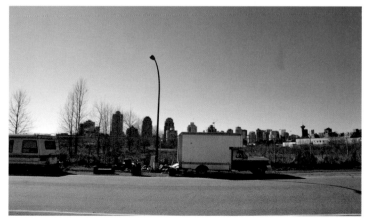

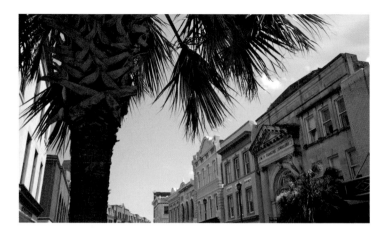

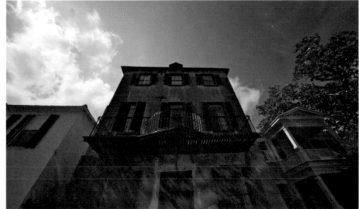

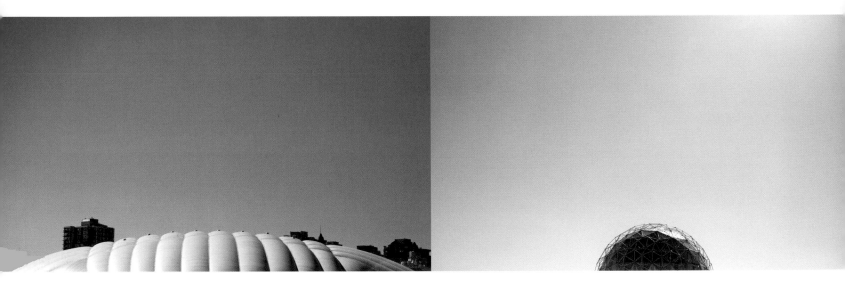

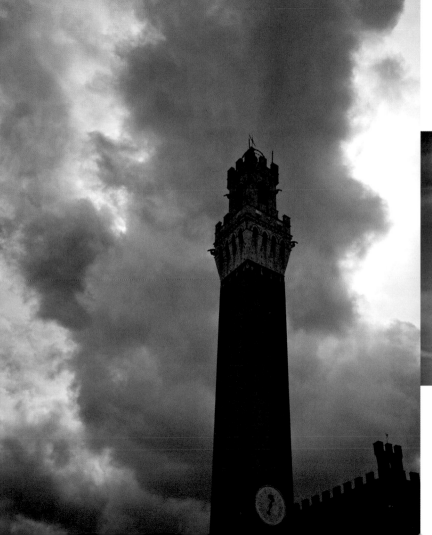

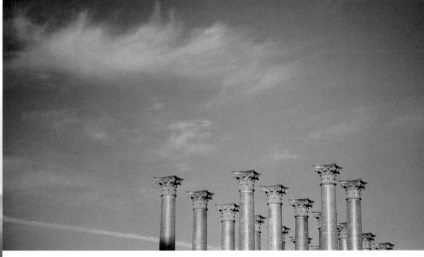

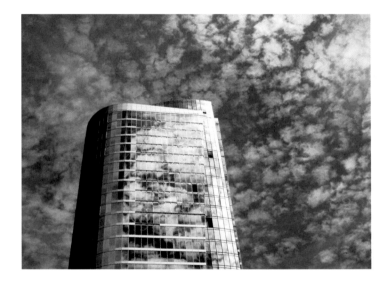

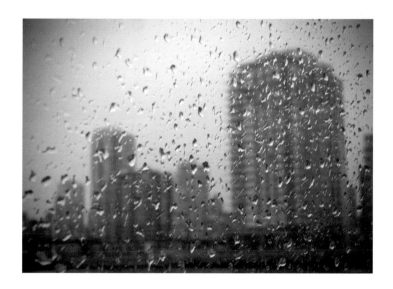

Streetside buildings and a lamppost impose their forms against billowing clouds in Charleston, South Carolina. When shooting pictures of Charleston's historic buildings, I usually found it was necessary to aim the camera slightly upward—and thus avoid the inclusion of modern automobiles—if I wanted preserve the scene's conveyances of an earlier era.

54

55

Originally shot in RGB color, this photo was converted to black and white by selecting its red channel in Photoshop's CHANNELS palette and then converting the image to grayscale. Afterward, an archival look was introduced to the scenery by adding faux film grain with the NOISE filter.

It can be difficult recording scenes that aren't filled with masses of tourists and locals in a city as busy and populated as Rome. If you want to take a photo that's not teeming with people in a place like this, try waiting for an ebb in the flow of humanity—a momentary clearing in the crowd. This may take some time (and patience) so go ahead and snap a few images while you wait. Use this downtime to double-check the composition of the scene you're waiting to shoot and to make sure your camera's functions are properly set.

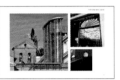

56

57

The large image on this page features a slice of skyline containing examples of the very old, the merely old, and the brand new. Keep your eyes open for interesting era-based juxtapositions such as this. The small photos at right illustrate something else that's worth looking for when you're traveling with camera in hand: interesting reflections. In these images, skyline is reflected in a shop window and a motorcycle mirror.

The walkway at center of this image provides a nice compositional bridge between the contrasting forms of the animated branches in the foreground and the stolid building behind. The sky in this photo was selected using Photoshop's MAGIC WAND tool (an easy task since the sky was the only blue that appeared in the image). Once selected, its original hues were replaced with a blue-green gradient. The sky's selection was then inverted and used as a mask to convert the rest of the image to grayscale.

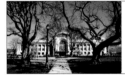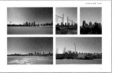

58

59

In these photos, the foreground has been allowed to dominate the composition while a city's skyline (Vancouver, B.C.) has been relegated to backdrop status. Consider investigating outlying views when photographing skylines—views that include intriguing coalitions of subject matter and theme.

Take a look at the compositions of the two smaller photos on this page. The top image is asymmetrical; the bottom is basically symmetrical. Either compositional approach is valid. Asymmetry tends to convey notes of drama. Symmetry tends to suggest a static, imposing feeling. Be ever-aware of the effect an image's composition has on its presentation of content and conveyance.

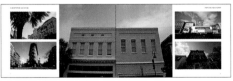

60

61

At center: a pair of conjoined buildings that can't seem to quite agree on any of their respective details. Top right: A classic American streetscape—interrupted by the bold form of a passing delivery truck. Bottom right: Sunlight cascades over the top of an aging facade. The subtle curtain of rainbow light at the bottom of this image is the result of lens flare—an effect that sometimes occurs when shooting toward the sun. Lens flare is one of those photographic "flaws" you may wish to allow when it adds interest to an image.

A couple of futuristic domes peek up from the bottom of this page's photos. On the opposite page, at far right, columns of ancient heritage reach toward passing clouds. When composing images of skyline, consider allowing the *sky* strong compositional priority over the *lines* (and curves) below. Images such as these—images that hint at subject matter rather than reveal it—can intrigue viewers with their sense of untold meaning.

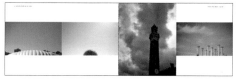

62 63

This page, left: A column of clouds rears up dramatically behind the bell tower in Sienna's Piazza del Campo. This scene presented itself while I was taking a sit-down break on the brick steps of the Piazza del Campo. I didn't have to move an inch to align the pillar of clouds behind the brick tower—all I had to do was lift my camera and take a shot. The moral of the story: Some photo opportunities have to be earned—others give themselves away. (It's just a matter of having your eyes open and your camera ready to receive them.)

A skyward view of this building's mirrored exterior yields reflections of the mottled clouds above. To enhance the presence of the clouds against the sky—and within the building's form—the image's contrast was heightened using a CURVES adjustment layer in Photoshop. The photo was then tinted by adding a SOLID COLOR adjustment layer, set to "soft light."

64 65

A moody image of skyline taken from behind the rain-splattered window of a passenger ferry outside Vancouver, B.C. A pocket camera was used to record this photo, and to make sure it focused on the raindrops near the lens (as opposed to the buildings in the distance), its super-macro setting was selected before shooting.

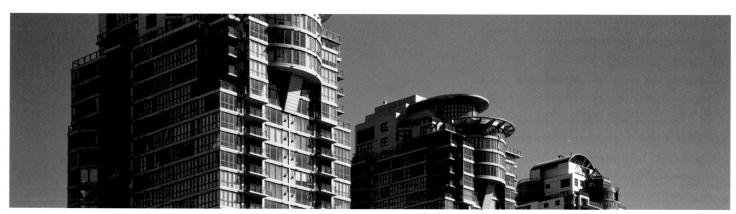

How about spending a day in the modern quarter of a nearby city and collecting artful images of buildings and architectural details?

5

Streetside

Streetside is both ordinary and absorbing. Streetside is where all sorts of people and their vehicles converge with all kinds of places to go and things to do; streetside is where people socialize, eat, argue, kiss and come and go from places of work and play; streetside is like the banks of a turbid river—it acts as a depository of both treasure and waste; streetside is among the first of a place's micro-environs to reflect its cultural and economic states of being.

It's all too easy to overlook photo opportunities in our daily surroundings. Streetside—an environment which many of us navigate daily—is used here to demonstrate the rich image-capturing potential that often exists right outside the door of our home, hotel or hostel.

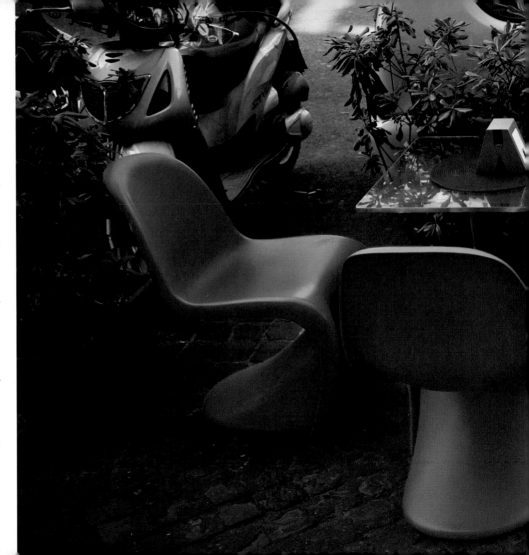

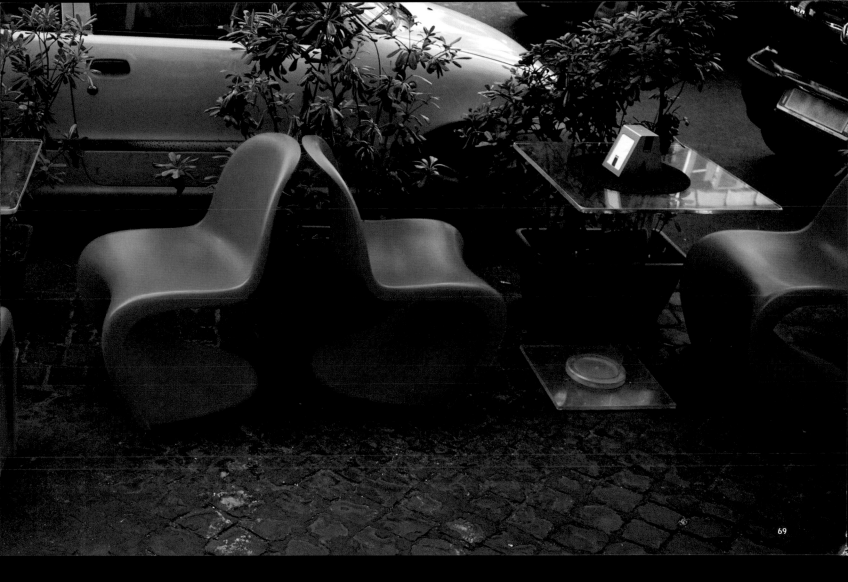

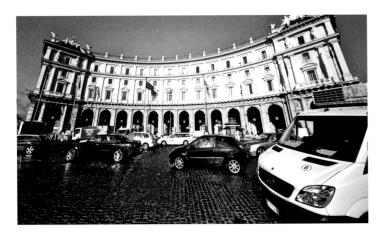

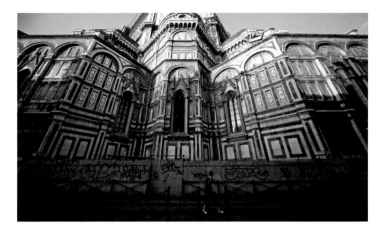

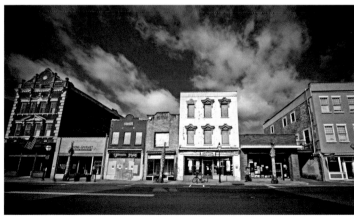

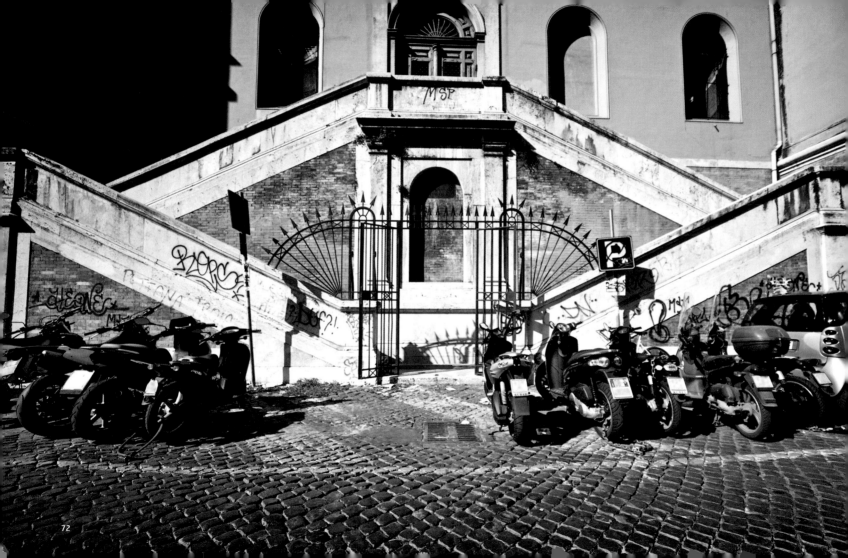

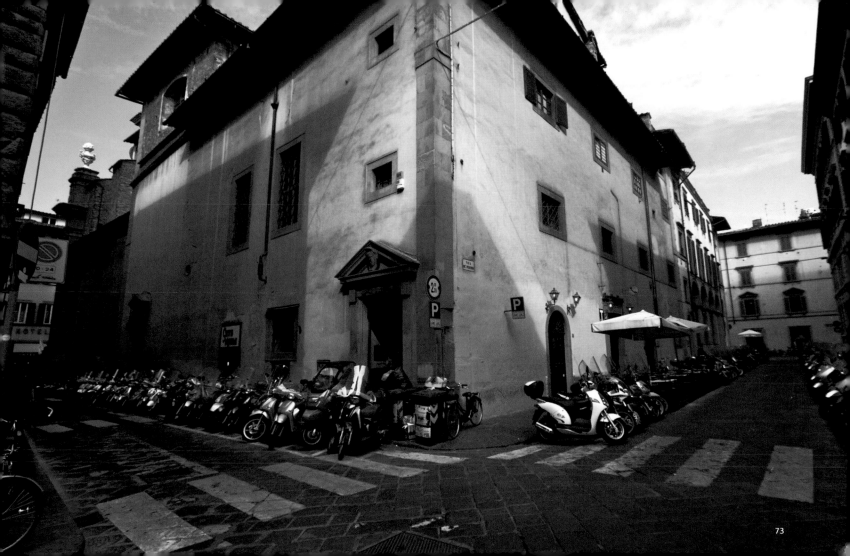

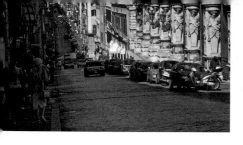
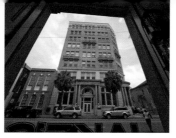
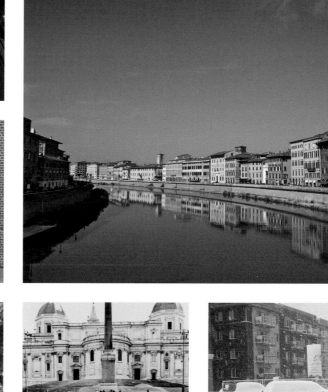

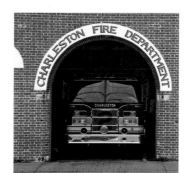

When happenstance provides a ready-to-go composition of flowing lines and eye-catching color, take advantage: take *pictures*. Streetside—with its endlessly varied visual offerings—is as good a place as any to hunt for readily available, artful photo opportunities.

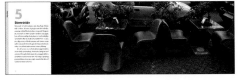

68 69

To emphasize the vivid color and curvaceous lines of the chairs in this scene, the hues elsewhere were converted to a palette of cool grays. Given the chairs' distinctive hue, this task was easily accomplished using Photoshop's color-sensitive MAGIC WAND tool and a HUE/SATURATION adjustment: First, the MAGIC WAND tool was used to select the chairs' forms; next, this selection was inverted to select all area outside the chairs; finally, this new mask was used to define the target for a color-canceling HUE/SATURATION adjustment.

Photoshop's HUE/SATURATION controls were used to intensify the saturation of hues in this page's image of a lively Roman commute. Conversely, in the lower photo, the saturation was reduced to nil to dramatize the subdued appearance of this streetside scene.

70 71

At top, a graffiti-covered fence in front of Florence's spectacular Duomo provides an interesting juxtaposition between old and new. No such juxtaposition exists in the lower image (taken in Charleston, S.C.)—this streetside scene looks much the same today as it did in decades past. Scenes of yesteryear can still be photographed in certain modern-day cities—as long as you can find points of view that exclude present-day references (contemporary looking people, autos, etc.).

Emblazoned with graffiti and enclosed within a spiked wrought-iron fence, this Roman apartment building makes an apropos post-modern backdrop for the inevitable gaggle of mopeds chained outside. The photo's feeling of no-nonsense urbanity was emphasized by converting the image to grayscale, increasing its contrast (using CURVES controls) and giving it a warm tint with a PHOTO FILTER adjustment (set to "sepia").

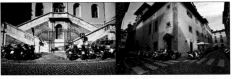

72 73

If you've witnessed what car drivers go through to navigate traffic (or to find parking) in a major Italian city, you'll understand the popularity of mopeds and motorcycles in these places. There were easily a hundred two-wheeled vehicles parked around this block in downtown Florence. A 12-24mm wide-angle zoom lens was used to take in this convergence of stone-cobbled streets and automobile alternatives.

A collection of streetside scenes from three continents, four countries and eight cities. When visiting any place, think of its streets as more than the access routes that lead to its famous destinations. Thoroughfares *are* destinations for photographers looking for rich and varied scenes of life.

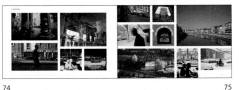

74 75

The tinted images on this page were created by first desaturating their colors by isolating one of their RGB channels in Photoshop (see page 24 for more information about this grayscale conversion method) and then by adding a SOLID COLOR adjustment layer. This adjustment layer was given a light blue-green tint and set to "multiply" using the layer's pull-down menu.

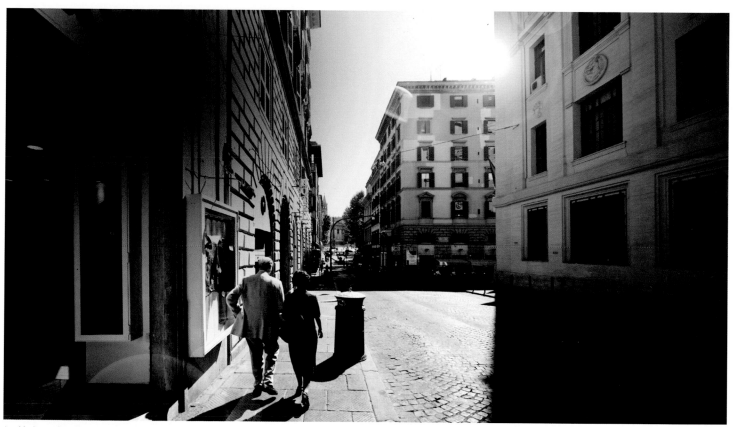

An elderly couple walks arm-in-arm along a cobbled Italian street. I followed them for a minute or two—waiting until they stepped into a dramatic swath of afternoon—before taking this shot.

6

Signage

Signs are like strange (and sometimes beautiful) growths sprouting from enormous unseen organisms—root networks with names like "commerce," "communication" and "caution." And just as a botanist might collect leaves and blossoms to catalog an area's biologic diversity, a photographer could likewise gather images of signage to document the complexion of a region's commercial occupations and its cultural diversions.

Use the pages ahead to whet your appetite for beginning—or expanding upon—your image collection of signage specimens (as well as their evolutionary relative, graffiti) from where you live and wherever you travel.

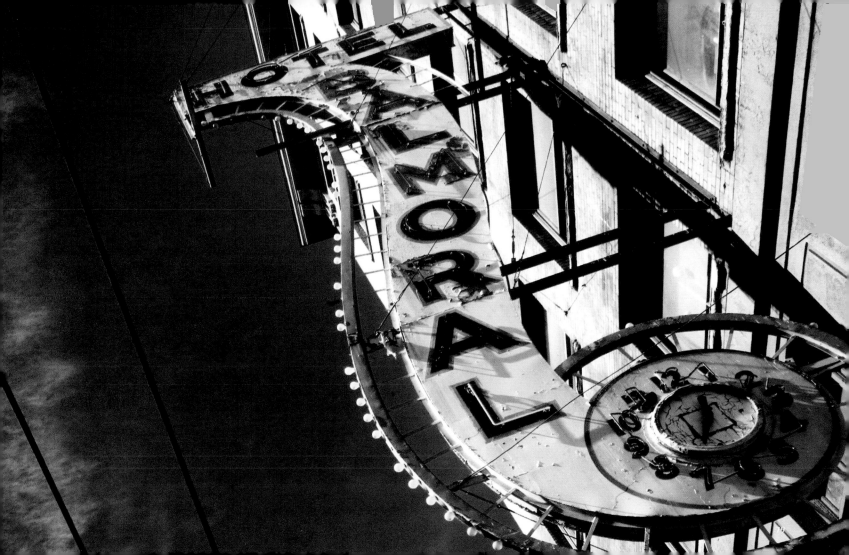

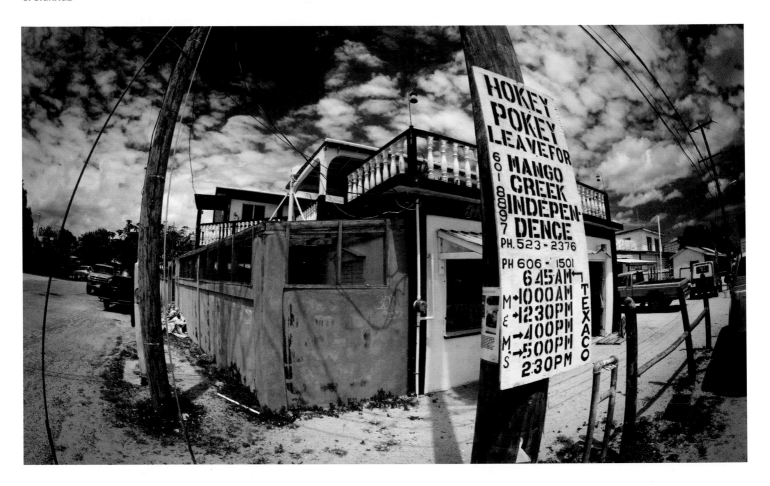

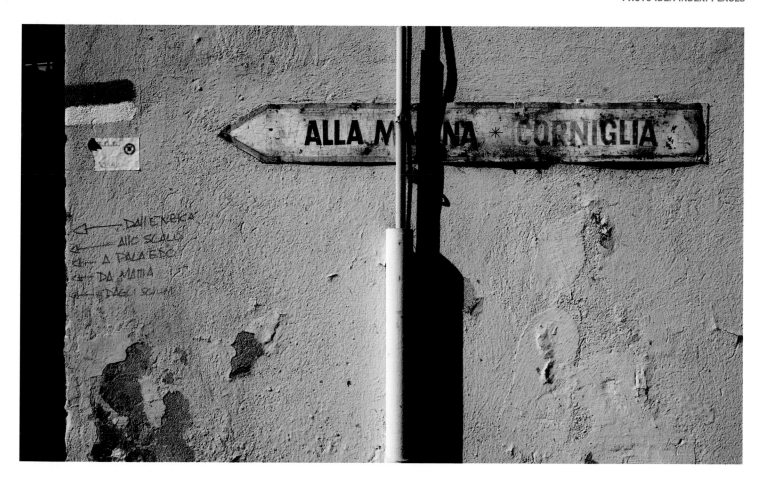

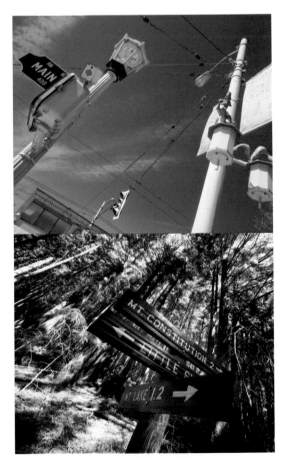

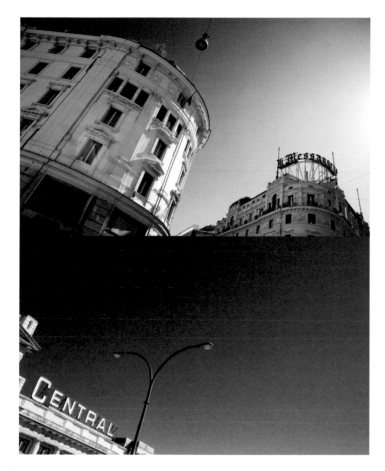

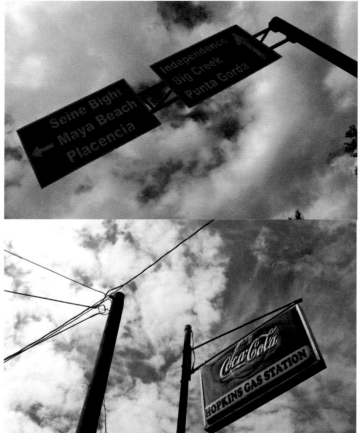

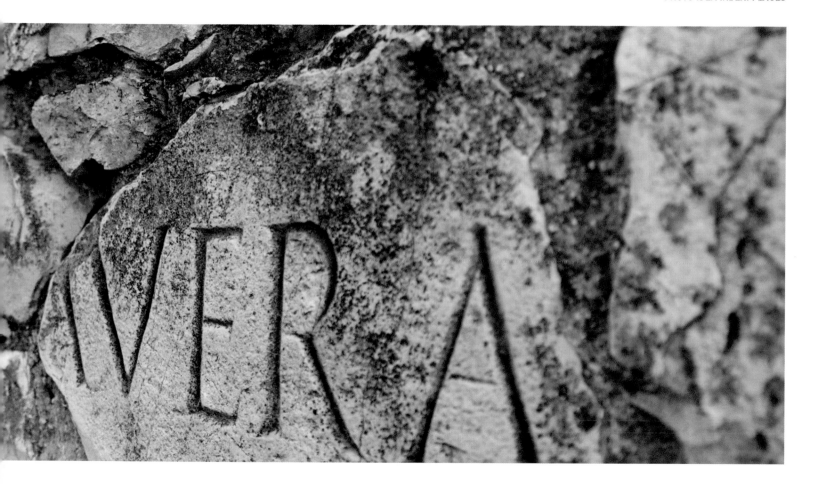

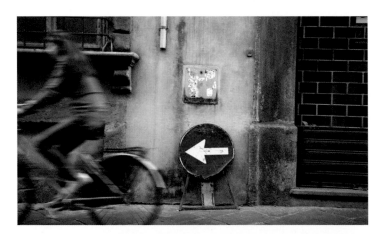

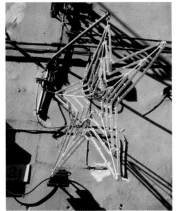

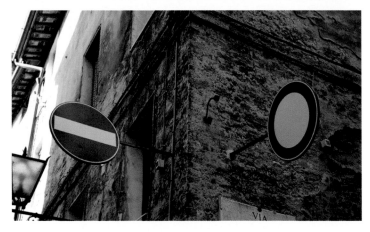

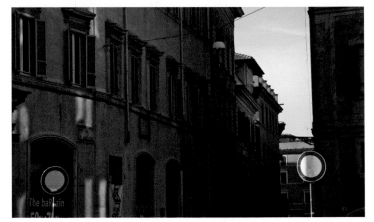

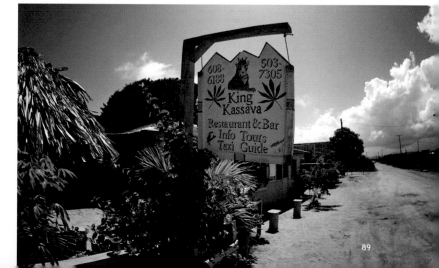

89

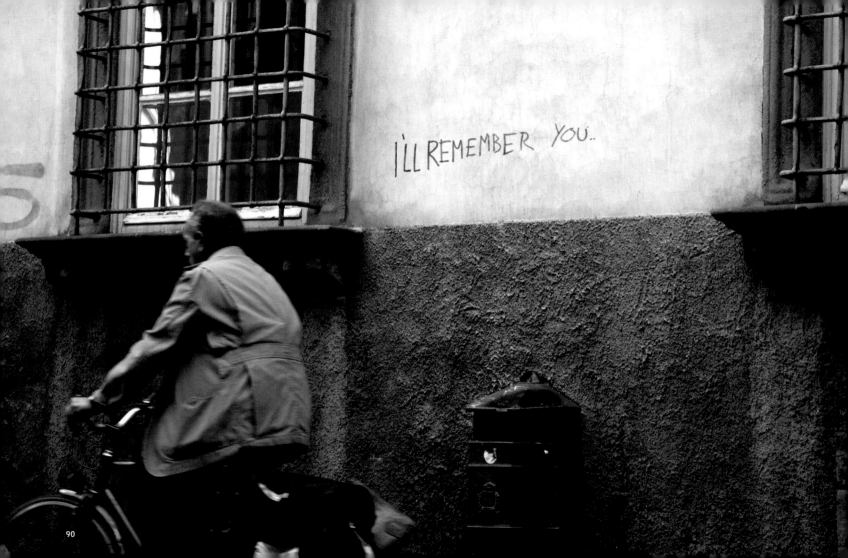

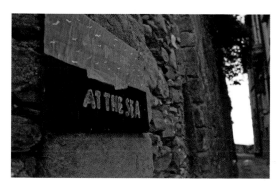

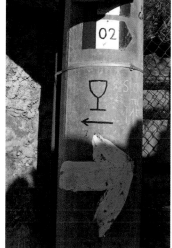

A broken-down clock at the bottom of this ornate and cleverly constructed marquee emphasizes its frozen-in-time demeanor. Consider spending time taking pictures of historic signage in the aging quarters of cities that have been around for an era or two.

78

79

Telephone wires are among the first things many photographers remove from their images (I've digitally deleted more than a few during my time). I had already begun removing the wires in this shot with Photoshop's CLONE STAMP and PATCH tools when I realized I was ruining some of the image's appeal. In this case, I decided that the strong linear presence of the wires was a compositional bonus since they helped emphasize (by contrast) the swooping curves of the sign. The lesson: One photo's bane might be another's boon.

A hand-crafted bus schedule sign in Placenia, Belize. Shot with a 15mm fisheye lens, the photo has a snow-globe-like appearance (minus the snow). The image was converted to black and white by isolating its red channel in Photoshop (see page 18 for more information about this method of converting color images to grayscale). The warm tint of the scene was produced by applying a colored PHOTO FILTER adjustment.

80

81

Hand-lettered footnotes accompany this aging directional sign in Manorola, Italy. Taken with a non-scene-distorting lens, the flat-tened look of this image appears in stark contrast to the depth-amplifying perspective of its neighbor. When out taking pictures with a digital SLR, I like to carry—at minimum—one standard and one wide-angle lens. (A telephoto lens is also added to my bag if I think it may be needed and if I feel like carrying the extra bulk.)

An assortment of signs from cities around the world. Considering focusing on signs as focal points of images— or using them as visual garnish within a larger scene.

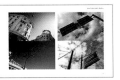

82

83

Take advantage of the creative points of view offered by overhead signage. What about making clouds or empty sky the dominant element in some of your images of elevated signs?

A crumbling, stone-carved street sign on a wall in Assisi, Italy. A sign such as this is a fine indicator of the passage of time and the character of its environs (even if its usefulness as a geographic aid has eroded).

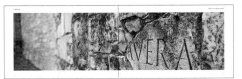

84

85

The shallow depth of field in this image focuses attention on the letters in the foreground. The shot was taken with an f/4.5 standard zoom lens—a lens not necessarily known for its depth of field control. If you are shooting a modestly-sized object, depth of field *can* be coaxed from a standard lens (even those on many pocket cameras) by zooming the lens to its maximum, opening the aperture as wide as possible, and stepping just far enough away from the subject to allow it to fill the frame.

Explore vantage points! This page presents a trio of photos taken of one neon sign in Florence, Italy. A 300mm telephoto lens was used to shoot the far left image from the top of Giotto's Tower (featured on page 318). The other two photographs were taken from much closer range using a standard lens.

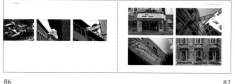

86 87

Many old signs, like many old people, have countenances like books—full of stories and filled with character(s).

Instead of avoiding streetside symbols when framing a shot, how about intentionally including them as colorful accents—or even focal points—within your scene?

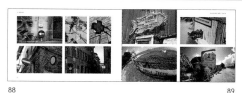

88 89

Hints of local flavor (and sometimes humor) are often revealed through a place's hand-crafted and improvised signage. Each of these images were shot in coastal towns in southern Belize.

Here's another example of an activity I like to describe as "stalking opportunity." While taking photos one morning in Lucca, Italy, I came across a wall bearing this handwritten sentence. Intrigued, I took up position across from the wall, prepared my camera and waited for a photo-worthy scene to present itself. A few lesser photo opportunities had already come and gone when this gentleman rode into the scene on his three-speed bicycle. Finally, I decided a sufficiently poignant moment had arrived and I took this shot.

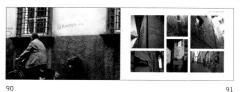

90 91

Be on the lookout for examples of informal signage—including what might be considered the most informal (and often among the most expressive) of all: graffiti.

Again, the reminder: Keep a pocket camera with you at all times! (You never know when you'll come across a scene that includes a symbol directing attention to a word of personal significance.)

7

Roads and Paths

The roads and paths on which we travel can be surprisingly photogenic. Visually, roads and paths are able to lend all kinds of positive compositional traits to an image as they curve, meander, slice and sometimes barrel their way through a photo opportunity. And, because of the deep familiarity most people have with all forms of thoroughfares, roads and paths are a subject that can be included in images to effectively convey all sorts of themes associated with travel, transport, homecoming, escape, freedom and change.

Take advantage of the convenience of roads and paths as photographic subject matter: Make your camera a regular companion on your journeys to just about anywhere you go.

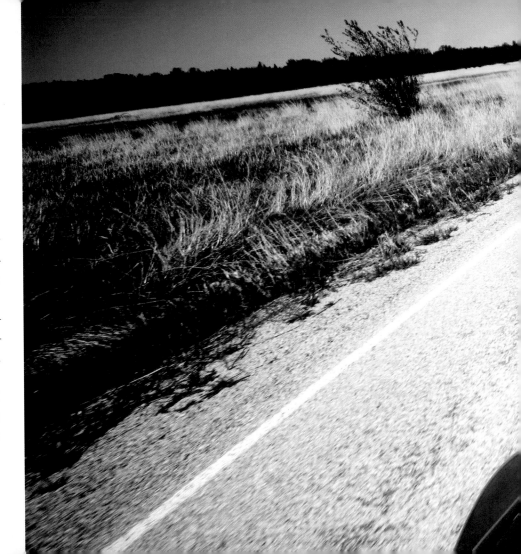

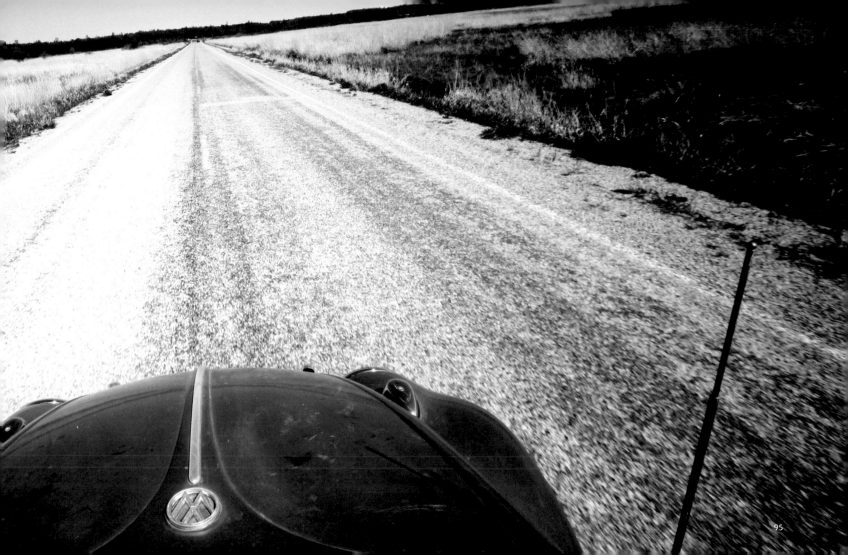

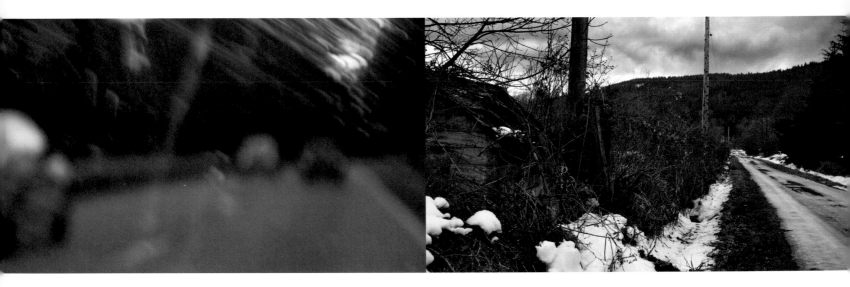

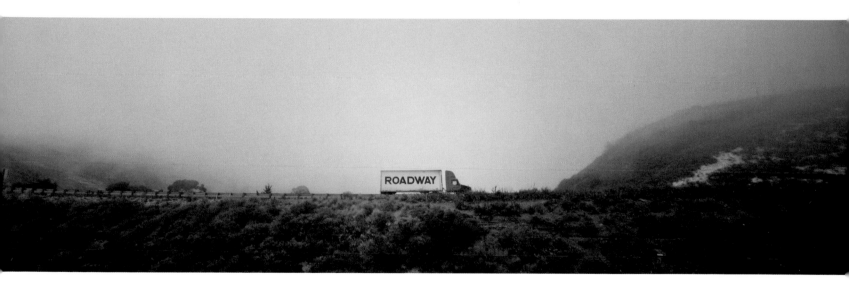

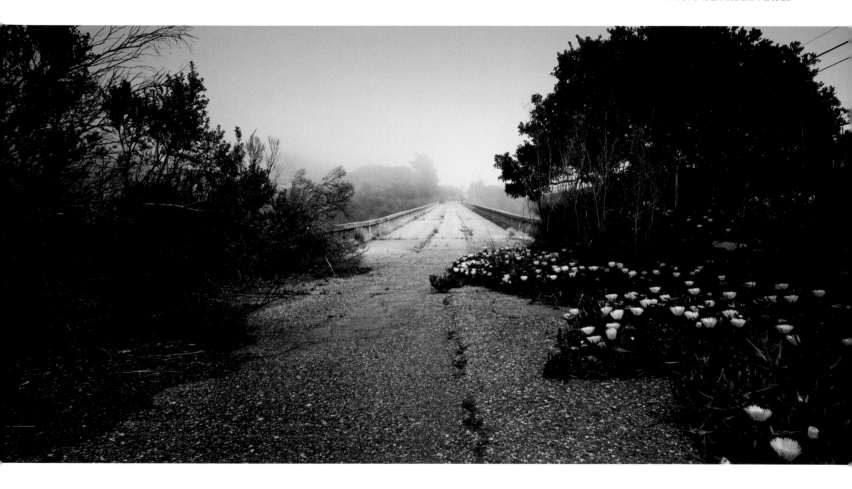

99

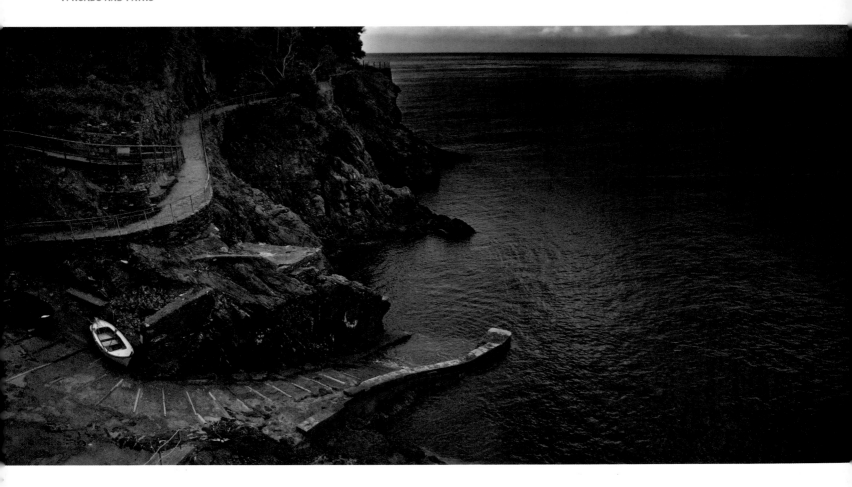

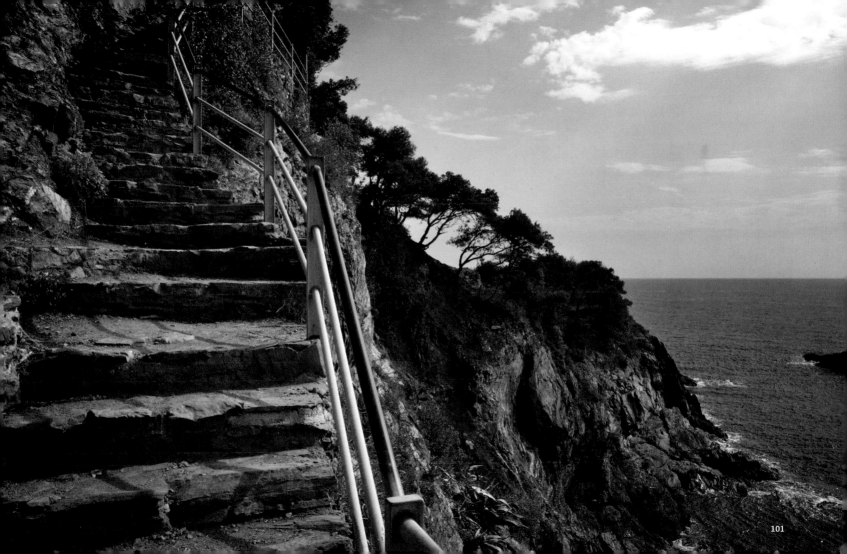

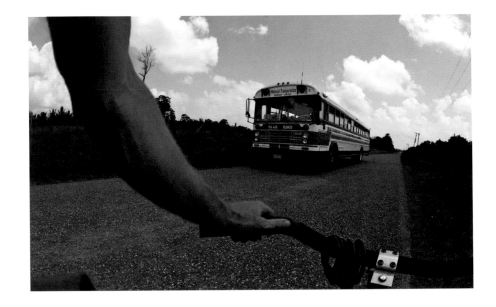

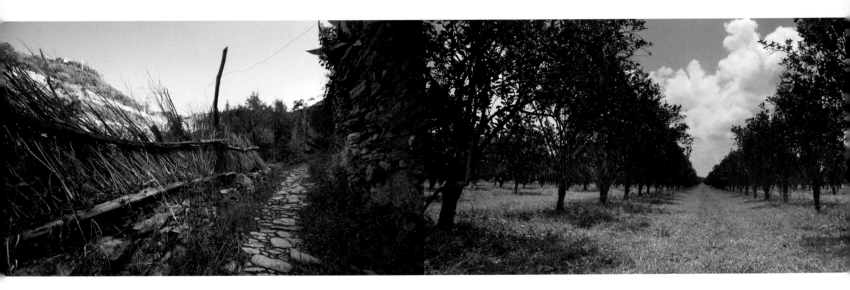

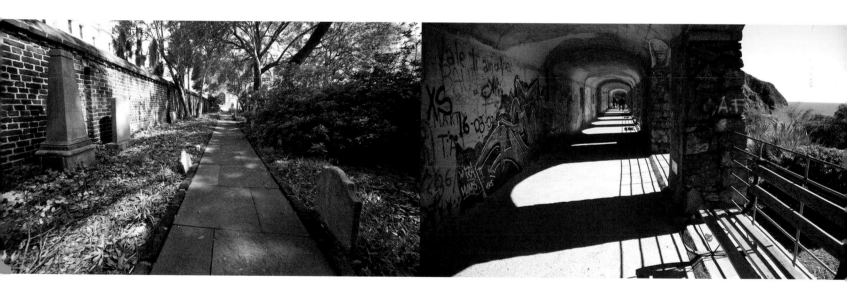

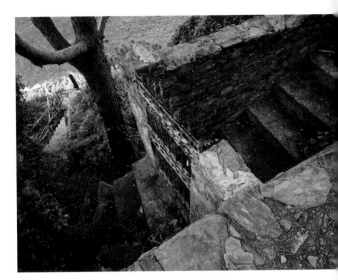

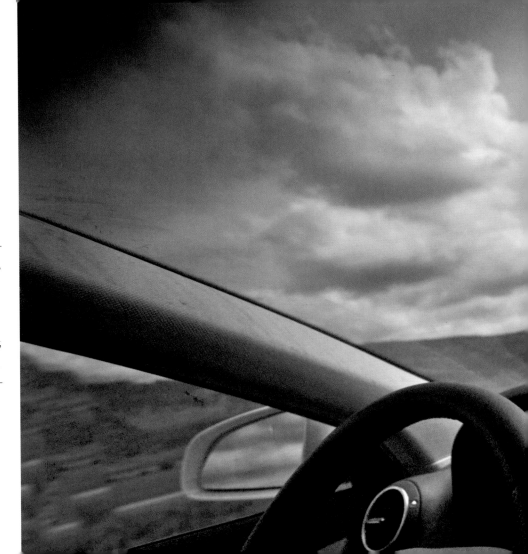

8

Getting There

No matter where you are, you had to get there somehow. The images on the pages ahead are meant to serve as reminders of the photographic potential of the trip itself—whether the "trip" is to the grocery store or around the world—and whether by car, train, plane, boat, bike, wheelchair or foot. In this chapter, the *journey* is the destination.

The majority of the images in this chapter were taken using a pocket digital camera. The portability, versatility and (relative) expendability of take-along digicams makes them ideal tools for capturing spontaneous images of life on the go.

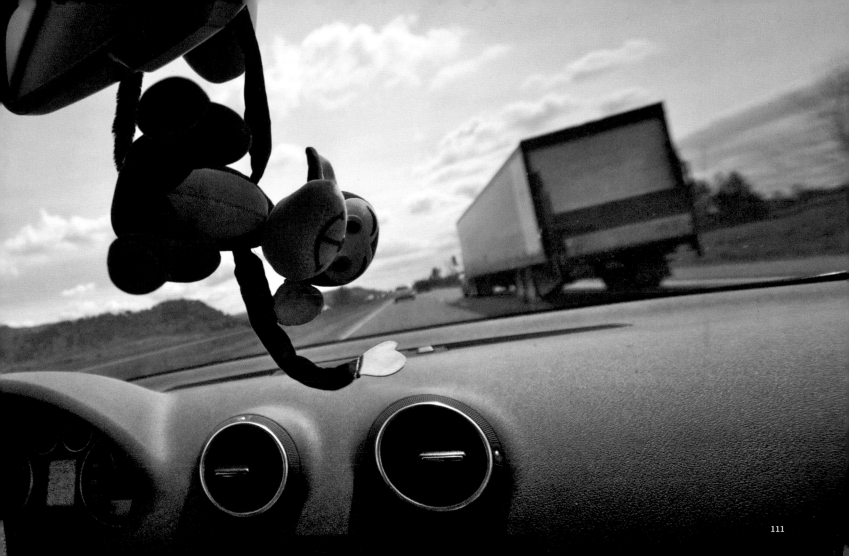

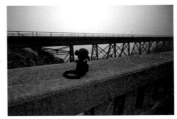
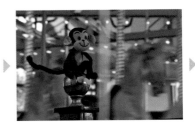

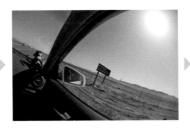

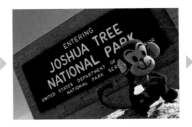

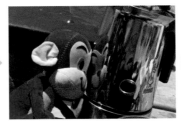

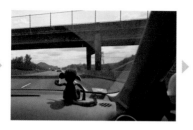 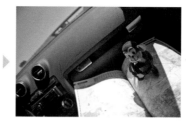 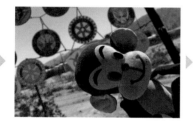 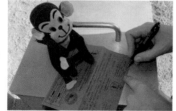 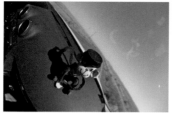 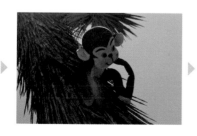 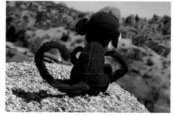 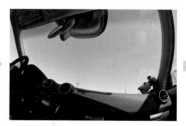

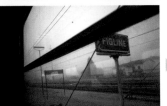

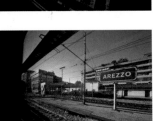
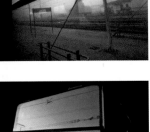

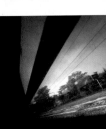

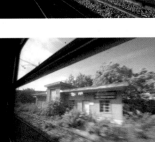

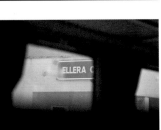

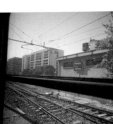

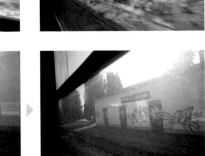

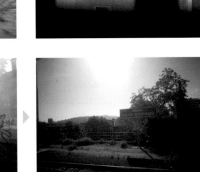

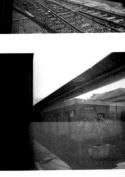

114

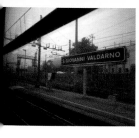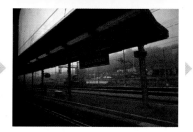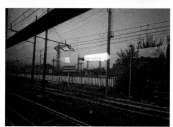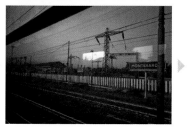

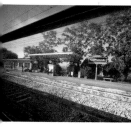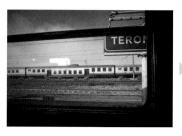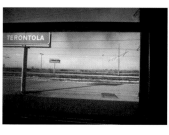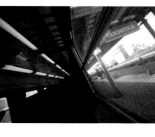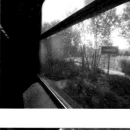

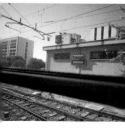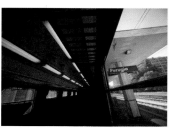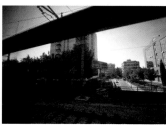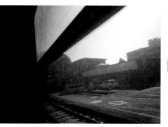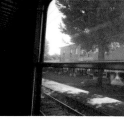

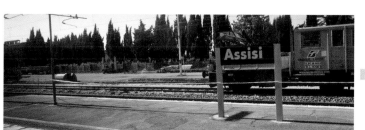

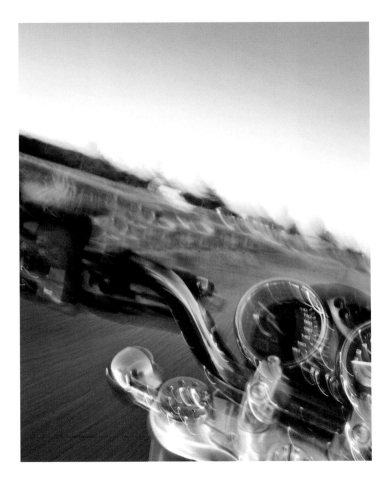

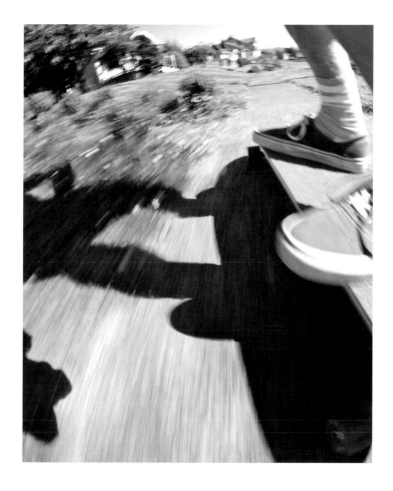

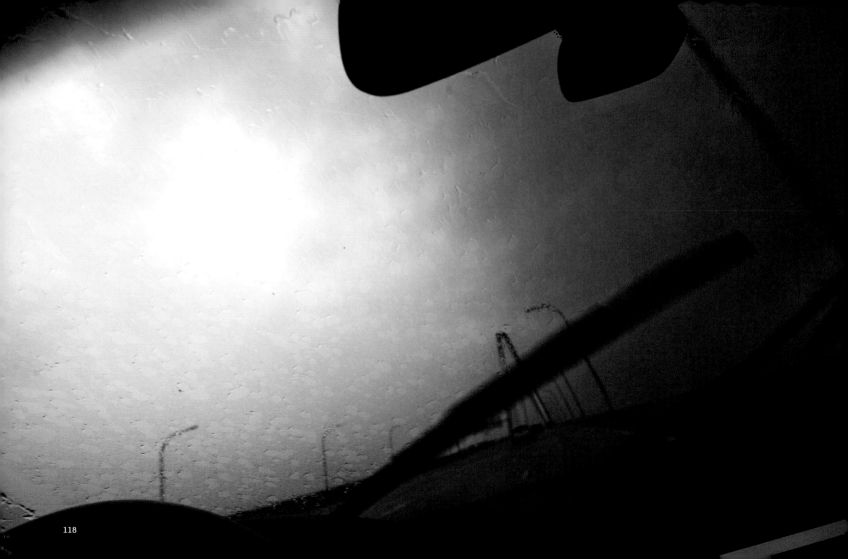

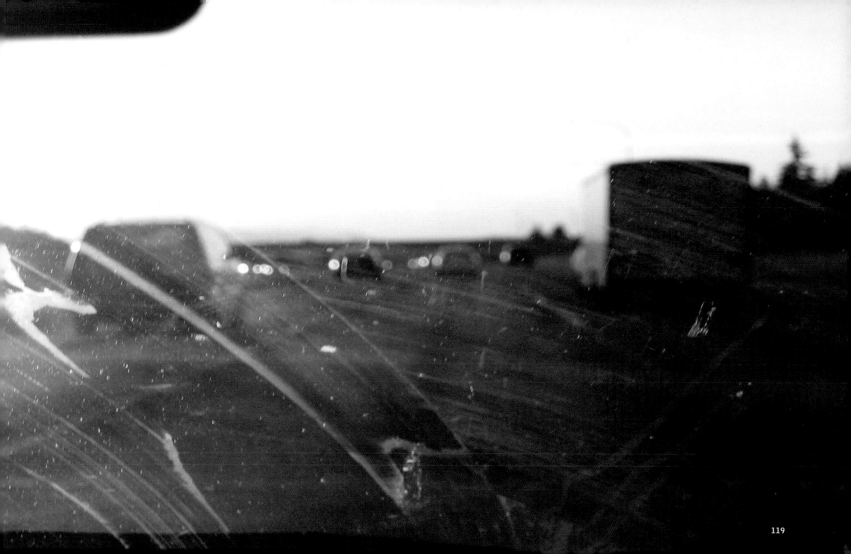

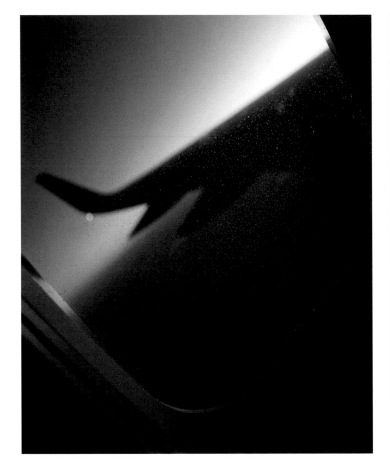

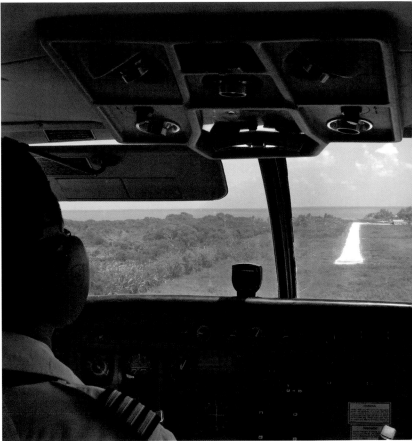

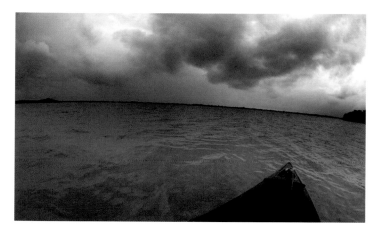
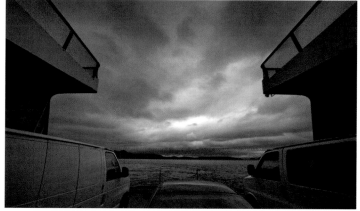
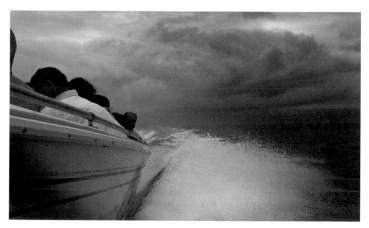
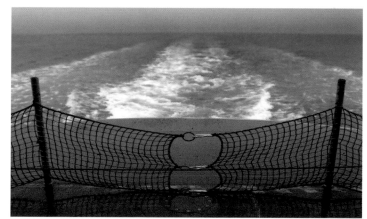

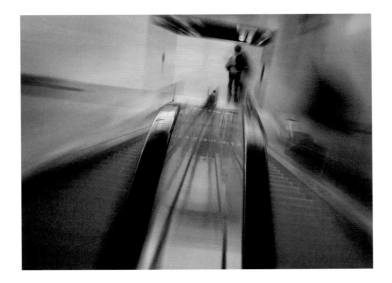

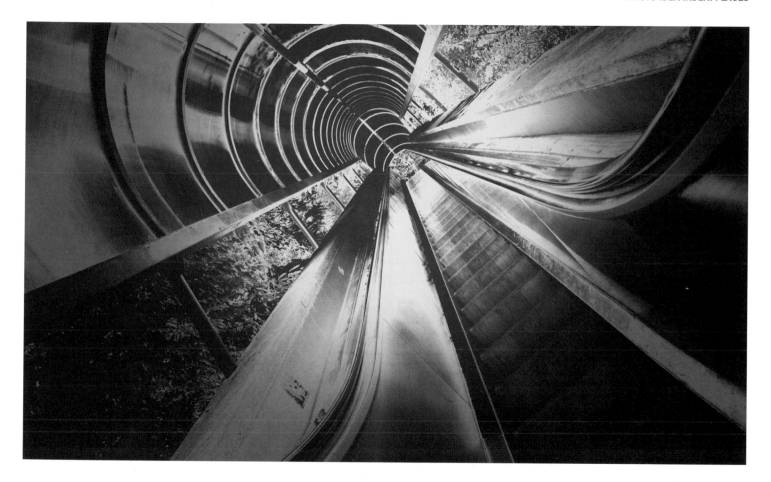

The ultra-wide field of view of a 15mm fisheye lens makes it a good tool for shooting in cramped environs (such as the front seat of a car). The small red primate hanging from the car's rearview mirror is Archie B. (pronounced "RGB"). Archie served as a traveling companion during a road trip to Joshua Tree National Park and is featured several more times on the following spread.

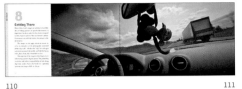

110 111

The extreme difference between the amount of light outside and inside a car presents a challenge when it comes to properly exposing all areas of a photo such as this. In situations like this, it's virtually impossible to record an image whose light and dark are both properly exposed. Aim for compromise by narrowly avoiding over-exposure in the brighter areas of the shot, and later, use Photoshop's SHADOW/HIGHLIGHT and CURVES controls to bring out details in the darker areas.

Here, Archie B. is featured in a variety of places along the way to and from Joshua Tree. How about bringing a mascot of some sort with you the next time you take a road trip? Snap pictures featuring your mascot whenever and wherever the mood strikes.

112 113

In these images, a HUE/SATURATION adjustment layer was used to convert all colors—except those related to the monkey's red hue—to grayscale. To do this, each color—except for red—was selected through the HUE/SATURATION panel's pull-down menu and their saturation levels were reduced to -100.

Faced with a two-hour train ride with nothing to do but sit and look out the window? How about pulling out your pocket camera and documenting your journey? This strip of photos was taken during a train ride from Florence to Assisi. Each photo features the name of a station the train passed though (often without stopping—hence the blurred shots) along the way.

114 115

As you can see, technical perfection was NOT a priority (or necessarily a possibility) during this photo-taking spree. Since I never knew when certain station signs would fly past the train's window, many of the shots had to be taken without time to properly aim or prep the camera. That was fine with me—I'm a big fan of off-the-cuff photography. I enjoy the true-to-life impressions of blurred, skewed and distorted images. What's your take on this kind of image?

If you're inclined to assume some risk while collecting images, consider hanging a camera around your neck, strapping it to a helmet or gripping it tightly in an available hand and snapping some photos while on the go.

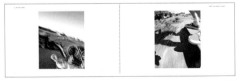

116 117

The squarish shadow at the lower left of this image is from the handheld SLR I was holding in my left hand while rolling down the sidewalk on a skateboard. I twisted the camera's neckstrap tightly around my wrist to keep it (relatively) safe while shooting. The camera was set on continuous-shooting mode and I kept the shutter button pressed for several seconds at a time while moving. That way, I had plenty of images to choose from afterward.

This image, taken while at the wheel of car heading into a heavy rainstorm, provides a first-person impression of moderately heightened drama in the midst of everyday life. Since I was driving at the time, I didn't use the camera's viewfinder while taking this shot. The camera was simply aimed in the general direction of the windshield while the shutter button was pressed (over and over). Digital cameras are perfect for this kind of on-the-go shooting since you can painlessly delete shots that didn't work out.

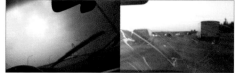

118

119

The glare on a well-traveled windshield helps establish the familiar passenger-seat vantage point from which this photo was taken. It's the sense of familiarity in a shot like this that appeals to many viewers—the simple sense of, "Hey—I've been there…" There are many moments in a typical day where simple photos of everyday life can be captured—as long as you've established a habit of keeping a camera handy.

Impressions of flight. For the near photo, the camera's lens was focused on the plexiglass window of an airliner whose blurred wing can be seen outside. The neighboring image was taken from a second row seat of a single engine plane as it made its descent toward a dirt runway in a Belizian jungle. I selfishly scrambled for a seat with a view on this small jungle-hopping plane—knowing that rare and good photo opportunities were bound to arise.

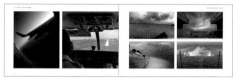

120

121

Water crossings, clockwise from top left: a shot taken during a canoe paddle in a muddy bay near Hopkins, Belize (storm clouds had just appeared and a few minutes later the camera had to be wrapped and stowed for protection from a tropical downpour); the view from the fore deck of an auto ferry; a perspective recorded by extending the camera overboard to arm's length during a speedboat ride; a view of the propeller's wash from the steel-plated aft deck of an auto ferry.

Photoshop's BLUR › ZOOM filter was used to emphasize connotations of movement and urgency in this shot of a figure exiting an escalator.

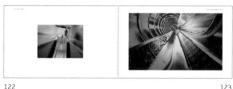

122

123

It took a bit of waiting to find a moment when this outdoor escalator was free of passengers. Still, I decided it would be worth the wait to catch a non-cluttered shot that emphasized the converging perspective of these steps, railings and roofing. To enhance the metallic and subtle otherwordly quality of this scene, the image was colorized using a gradient map adjustment layer in Photoshop.

Like to hike? Wear your camera around your neck whenever possible when hiking (as opposed to storing it in a bag or pack). Convenience is key when it comes to capturing fleeting photo opportunities.

9

Alleys and Backlots

The content and presentation of the images in the pages ahead might run contrary to some readers' notions of photo-worthy material. On the other hand, many readers will likely be pleased to find they are not the only ones who find intrigue and beauty in places other than those visited by the majority of camera-carrying tourists and locals.

This chapter, and the two that follow, are meant to encourage those photographers who feel comfortable roaming alleys, backlots and side streets to do just that. As those who already spend time collecting images in such environs can attest, there are few better places to go to expand one's appreciation for the extra-ordinary appeal of ordinary scenes.

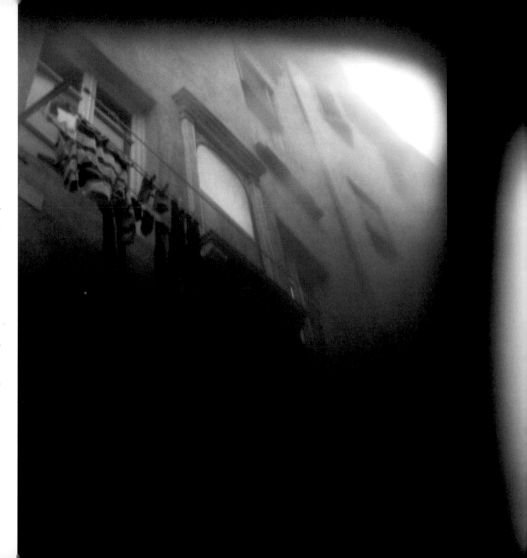

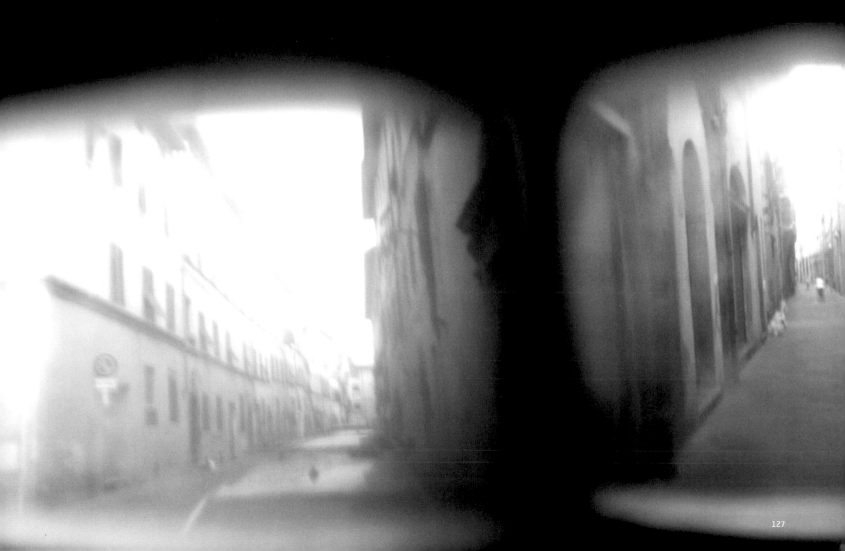

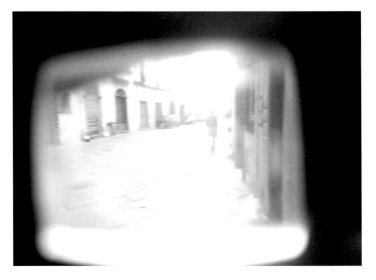

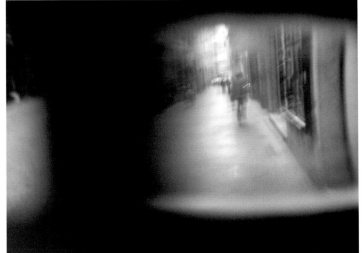

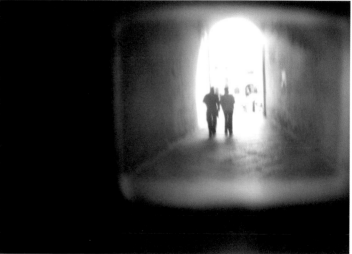

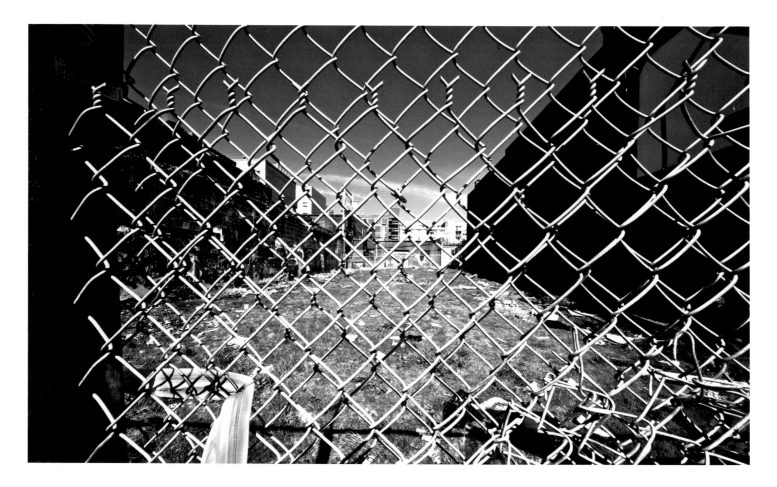

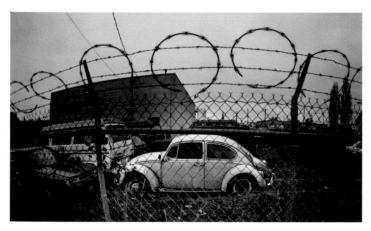

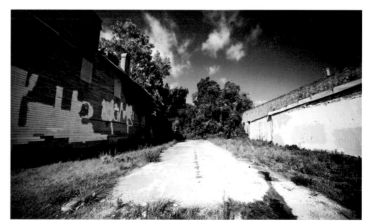

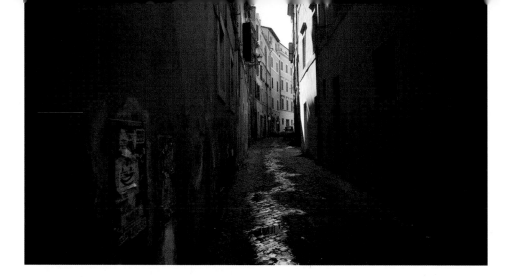

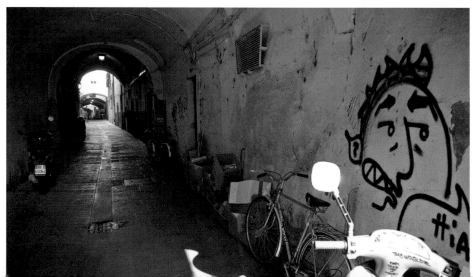

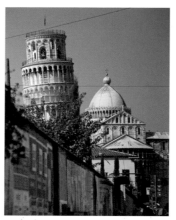

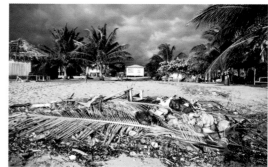

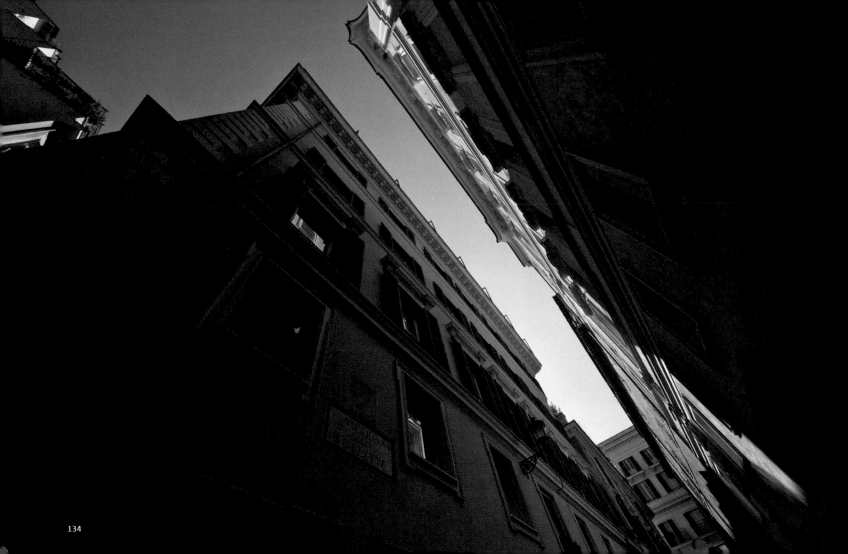

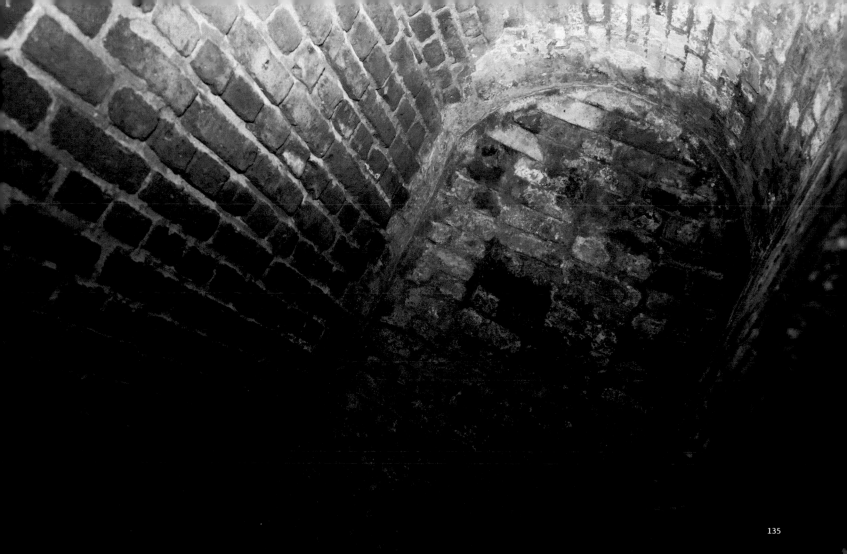

An author's personal preferences are bound to expose themselves sooner or later in a book such as this. My attraction to scenes that include beautiful examples of discarded things and deserted spaces are especially evident in this chapter and the next. Perhaps it's the camera's ability to capture aesthetic beauty in scenes and situations usually labeled "ugly" or "mundane" that draws me in. Who knows? And what about you? How attracted are you to the (so-called) unattractive?

126

127

Tired of taking perfect photos with your hi-tech pocket camera? Here's a technique that will delightfully degrade the quality of your images: Aim the lens of your pocket digital camera through the small plastic viewfinder of a cheap thrift-store camera. Zoom the lens of the digi-cam and hold it slightly away from the plastic viewfinder you're aiming through to get the kind of retro-style results shown on this spread. Experiment with different zoom, focus and exposure options.

More examples of the alternative shooting technique used for the previous spread's photos. For lack of a better way to describe it, I'd say there's a "memory-like" quality to this type of indistinct and impressionistic photo.

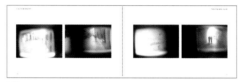

128

129

Want some more alternative shooting ideas? How about aiming your digital camera through a telescope, pair of binoculars, pair of eyeglasses, magnifying glass, kaleidoscope, prism, piece of colored glass, sheet of bubble wrap, folded wad of plastic wrap, clear light bulb or marble?

So what if the subject matter in this photo happens to be a fenced, vacant and trash-strewn lot—it still amounts to rich photographic composition of line, color and texture. To exaggerate its in-your-face presentation, this image's hues and contrast have been exaggerated using Photoshop's HUE/SATURATION and CURVES controls.

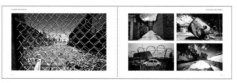

130

131

After being desaturated through the application of a CHANNEL MIXER adjustment layer (a method described on page 18), these photos were tinted by adding an orange SOLID COLOR adjustment layer. The pull-down menu for the SOLID COLOR adjustment layer was set to "overlay" ("soft light" could have been selected for a more subtle effect) and its opacity was reduced to 30%. When tinting a photo in this way, try out a variety of hues in its SOLID COLOR adjustment layer before deciding what works best for the image.

A fascinating shadow-free quality of light often exists in alleys and naturally-lit tunnels. Most (or all) the light in these environs arrives bearing hues borrowed from the walls, floors and other reflective surfaces from which it came. Note the rich colors in the upper image. Even in shadow, this ally's warmly painted walls glow with the colors reflected between them. The lower image, though less intensely colored than the shot above, exhibits a pleasantly mild ambiance of mostly indirect light.

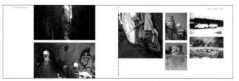

132

133

A variety of back-alley and back-lot images. No doubt, the Leaning Tower of Pisa has been photographed from more flattering points of view, but if originality is the goal, why not take its portrait (or that of any famous landmark) from a behind-the-scenes perspective? These two vantage points caught my attention as I approached this most famous of landmarks via a route not usually taken by tourists.

Don't forget to consider upward-facing perspectives when photographing from back alleys. Take a look at Chapter 23, Up (pages 312-325), for more examples of skyward views.

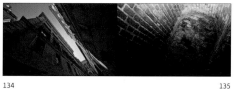

134 135

Dead end. The only light at the end of this tunnel was from the camera's flash. This photo was taken in a zero-light situation. While using my camera's flash to guide my way through an unlit underground passage in historic Charleston, S.C., I realized it was time to turn around after this photo was snapped.

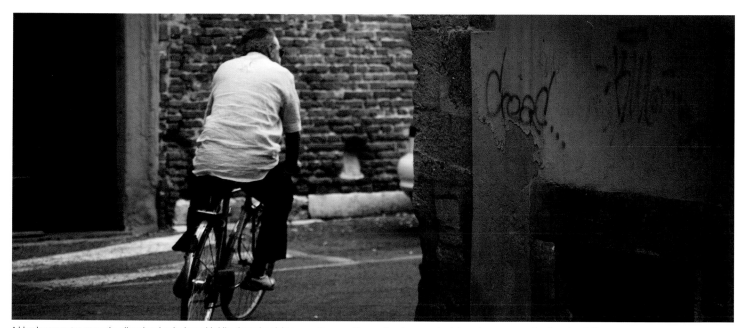

A bicycle commuter scans the alley ahead as he leans his bike through a tight corner. Human actions and gestures can lend dynamic conveyances to otherwise static scenes.

10

Desolate Places, Empty Spaces

The more time you spend in places devoid of inhabitants or visitors (the definition of a *desolate* place), the more likely it is your appreciation for these environs will grow. What's more, beautiful and intriguing images, taken in locations not usually known for their photogenic offerings, have the ability to pique the curiosity of viewers who may not have had the chance to ponder such visuals.

So how about it? How about bringing your camera to a desolate place—or an empty space—and being the first to document sights and scenes that may have never before been lovingly viewed through the lens of a camera?

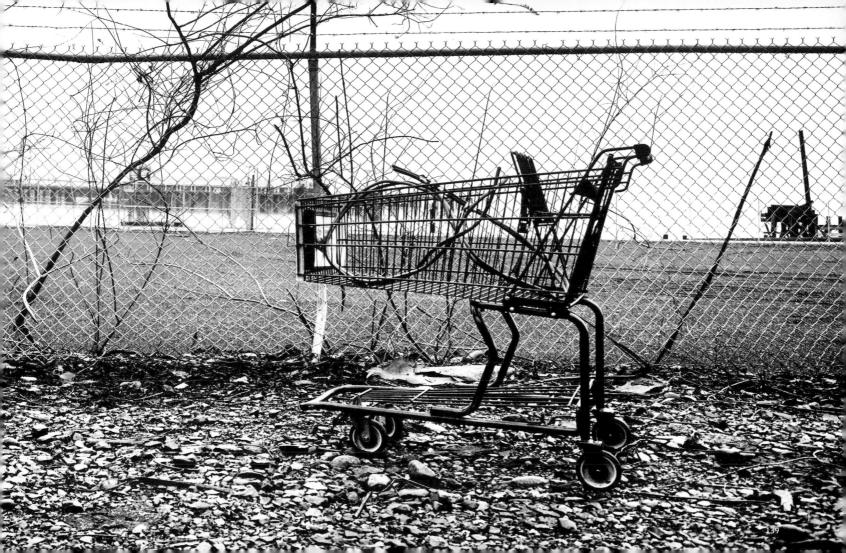

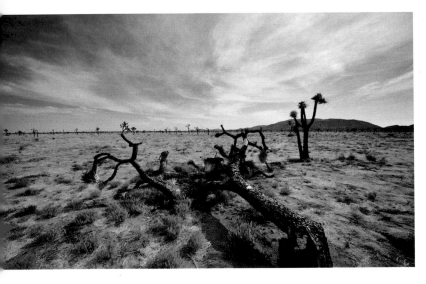
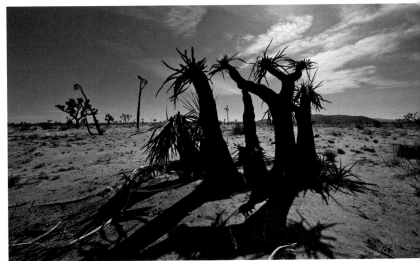

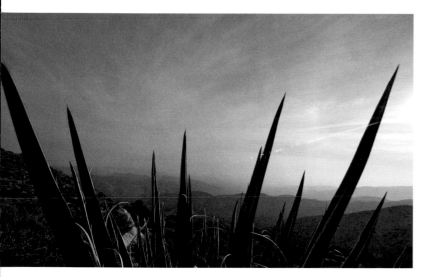

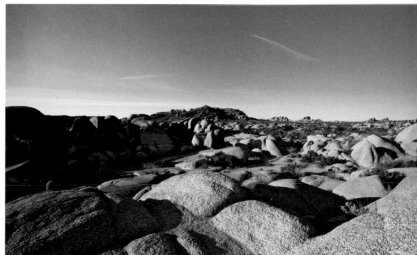

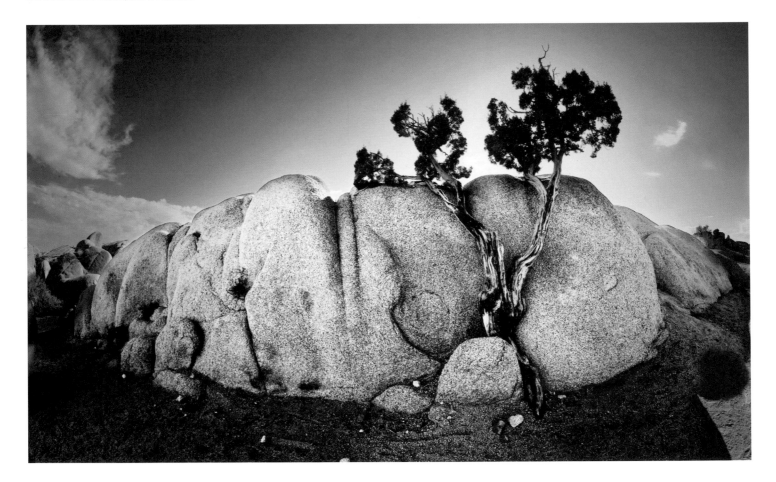

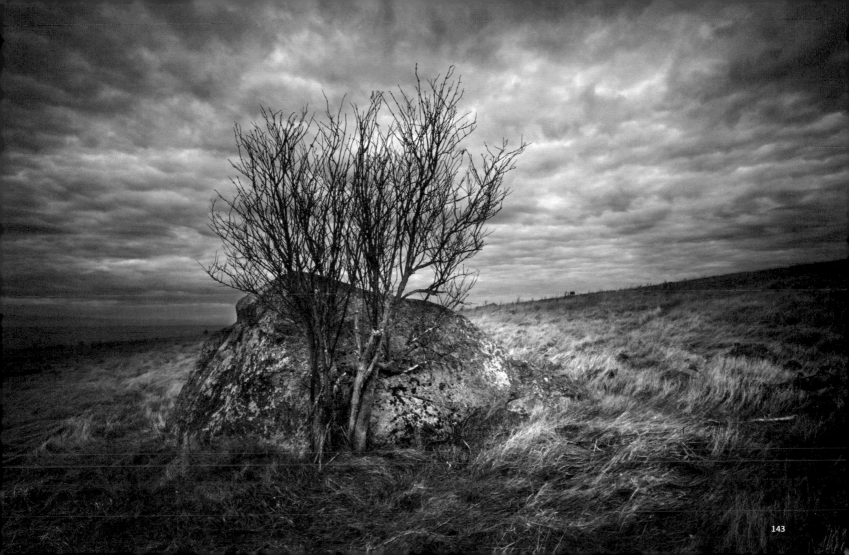

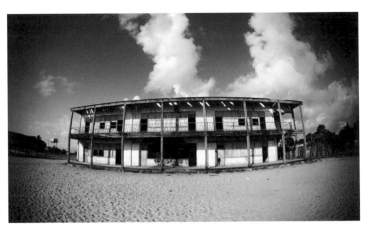

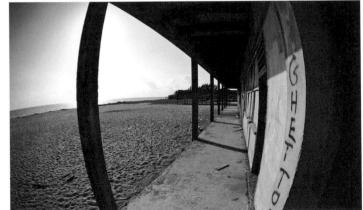

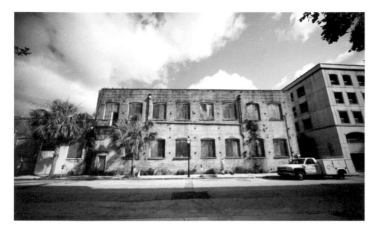

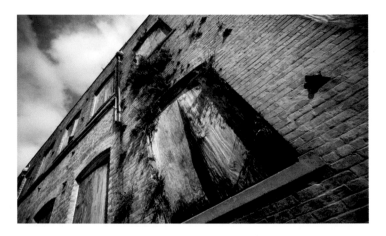

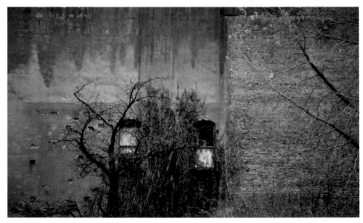

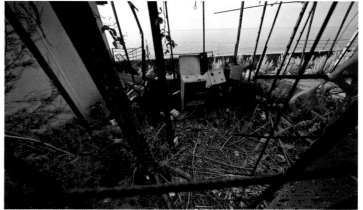

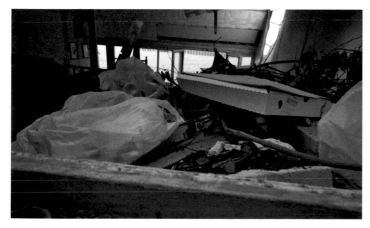

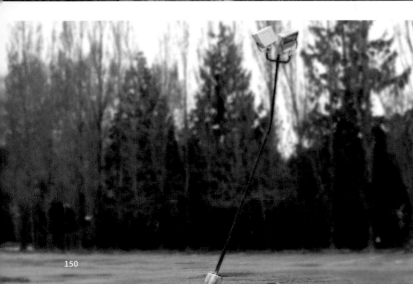

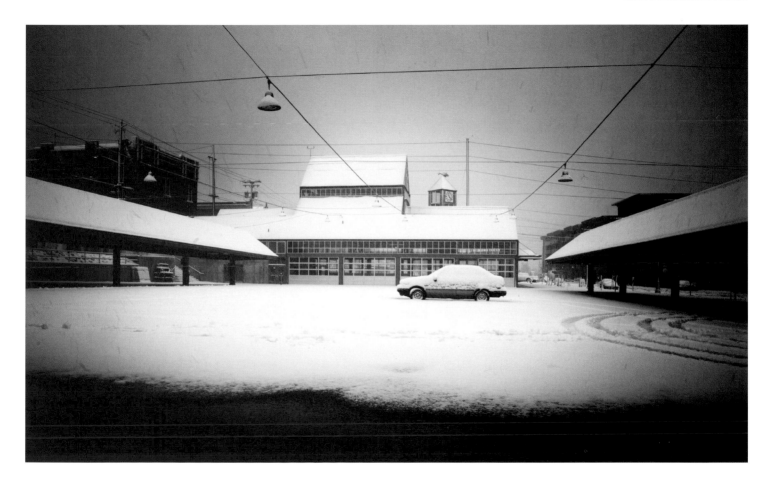

A shopping cart and an industrial site—both abandoned—provide the foreground and background elements of this bleak image. The scene's stark and gritty qualities were highlighted by desaturating its colors and boosting its contrast levels using Photoshop's CHANNEL MIXER (using a technique described on page 18) and CURVES controls.

138　　　　　　　　　　　139

One bonus of photographing scenes of bleakness is that they are usually found in places free of tourist throngs. The crowd-avoidiance strategies described on page 66 never came into play when collecting material for this chapter.

This series of images was taken in Joshua Tree National Park in southern California. The extreme heat and scarcity of water means vegetation does not always win in its battle against the elements and other forms of life.

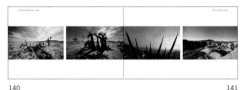

140　　　　　　　　　　　141

If you enjoy road trips and camping, how about embarking on a picture-taking adventure to a wild and remote destination? You could choose to go to a lively place where plants and animals thrive, or you could aim for a landscape where emptiness and desolation are the prevailing themes. Which appeals more to you?

Benevolent rocks. Though meager, the shelter provided by the large stones in these two images is just enough to allow a few trees to cling to their existence amid challenging environs. Images such as these can be used to convey themes of survival and hope as well as loneliness and despair.

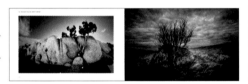

142　　　　　　　　　　　143

These two images have been given subtle color tints following their conversion to black and white. The tints were applied using Photoshop's PHOTO FILTER controls. The far image was given a cool tint by selecting PHOTO FILTER's "cyan" option; "sepia" was chosen to add a warm tone to the near image. Investigate the effects of different colors and levels of opacity using the pull-down menu and sliding controls within PHOTO FILTER before deciding which effect best suits your photo's presentation.

As a rule of thumb, it's usually best to avoid allowing significant areas of white or black into an image when adjusting its levels. In this case, both white and black areas *have* been allowed since their contrast-heightening presence amplifies the menacing undercurrents emanating from the ominous symbol in this railyard sign. Trust your instincts to tell you when "rules" of photography should be broken and when they ought to be obeyed.

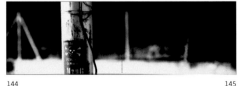

144　　　　　　　　　　　145

Being what I call a "graphic designer who takes pictures" (vs. a "card-carrying photographer") I'm always on the lookout for symbol-bearing images that could be used as a backdrop or featured photo in a poster, brochure, book, page layout, ad or website. An image such as this, for instance, might be used as part of an edgy contemporary band's CD packaging—lyrics could be printed in white against the photo's darker regions.

Abandonment is the theme on this spread. If you're willing to step away from the path beaten by the typical camera-carrying tourist, photographs such as these are out there for the taking.

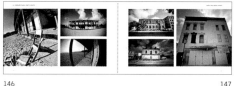

146 147

Theme-driven compositions. The centered position of the buildings in several of this spread's images conveys a static, non-dynamic feel—appropriate given that the run-down buildings are no longer spirited components of their communities. The points of view chosen for the two photos with non-centered compositions (opposite page, left and lower left) were selected because they brought significant theme-bearing elements to the fore of the scene.

On this page, images of vegetation reclaiming lost territory as trees, vines and plants encroach on the brick-and-mortar facades of disused buildings. The picture at top presents itself through dramatic angles and bold colors. The lower photo is a flattened, monochromatic composition of texture and form. A reminder: Explore different vantage points when you are looking through the viewfinder, and different effects when you are finalizing your images with the computer.

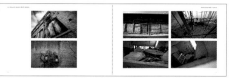

148 149

Its tenants long gone, a dilapidated guest villa in coastal Italy still houses the trappings of better times. Subject matter like this might not be high on the list of picture-taking priorities of many travelers. Still, it is descriptive of true life, and therefore worthy of capture and presentation. The two shots at bottom were taken by holding the camera high overhead and aiming through breaks in the structure's wall. I didn't know what I was photographing until I checked the LCD after each shot.

Once you arrive at your destination, how about taking a few shots in the parking lot before you hike off to take pictures elsewhere? Parking areas can be a great source for unidealized images of simplicity and emptiness.

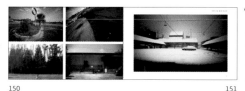

150 151

"Fall-off" is the term for the darkening effect that some lenses produce around the edges of an image. Some photographers consider lens fall-off universally undesirable. Others welcome the effect in certain cases, since it illuminates and draws attention to the center of a scene. Fall-off can be removed using controls within Photoshop's DISTORT>LENS CORRECTION filter. It can also be added using these same controls—as was the case with this image.

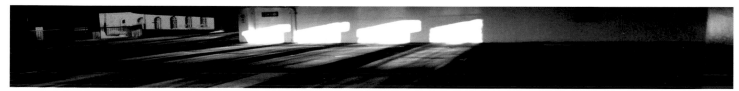

The setting sun creates a stark composition of light and shadow against the interior forms of a vacant parking garage.

153

11

Industry

How about seeking images in the industrial environs of the cities and towns where you live or vacation? Subject matter of an industrial or mechanical nature is more than capable of offering photographers all kinds of aesthetically intriguing and attractive content. Furthermore, the metaphor-rich potential of things like gears, gauges, levers, train tracks and smoke stacks can be employed to infuse images with strong thematic implications. For these reasons and more, photos of industrial scenes and their inner workings make good candidates for both commercial and fine arts applications.

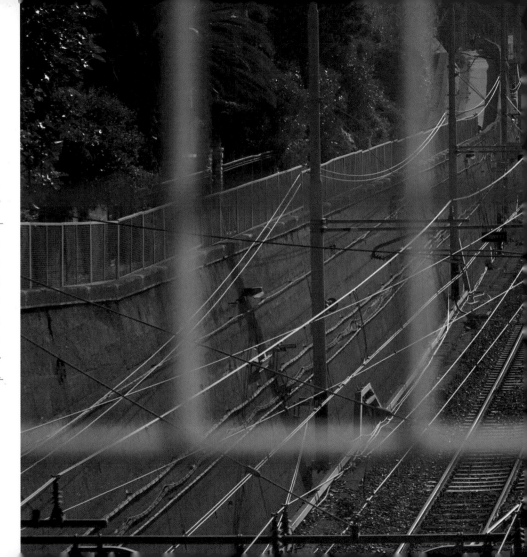

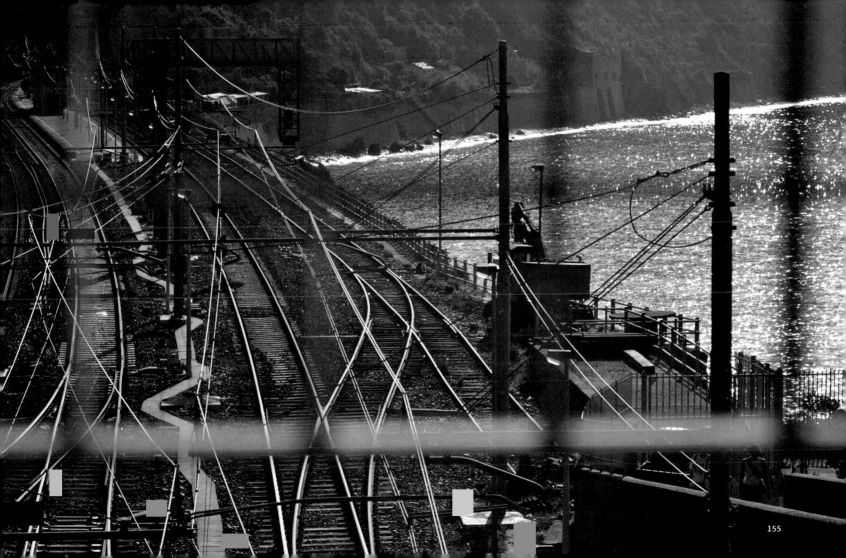

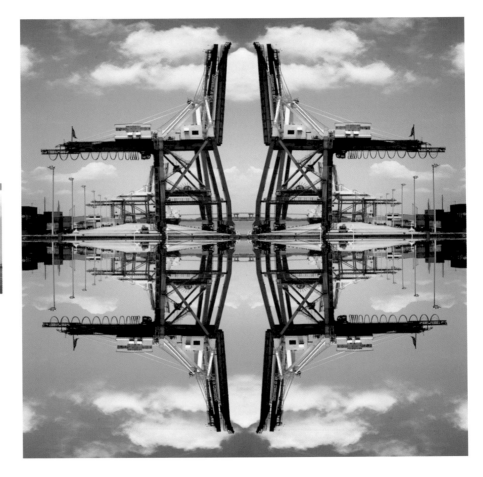

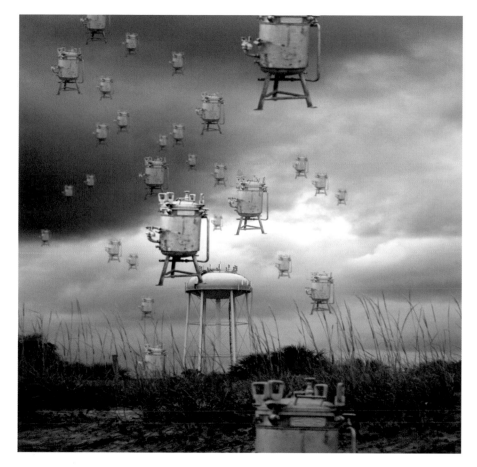

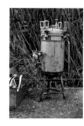

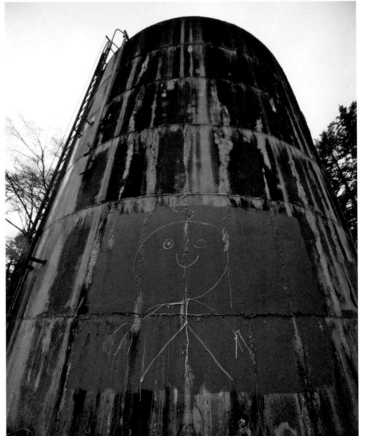

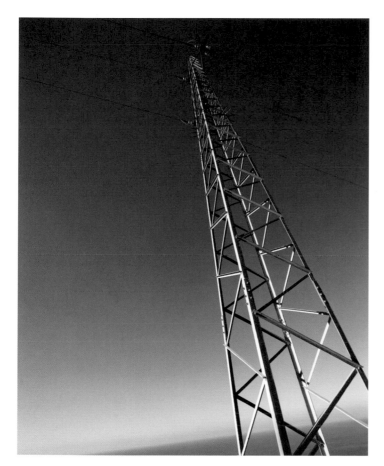

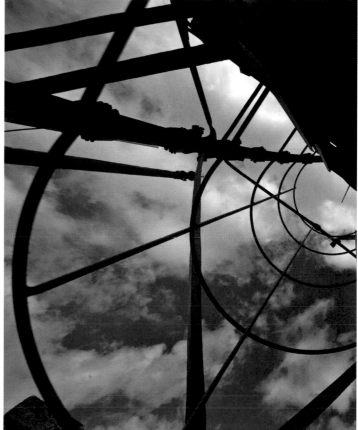

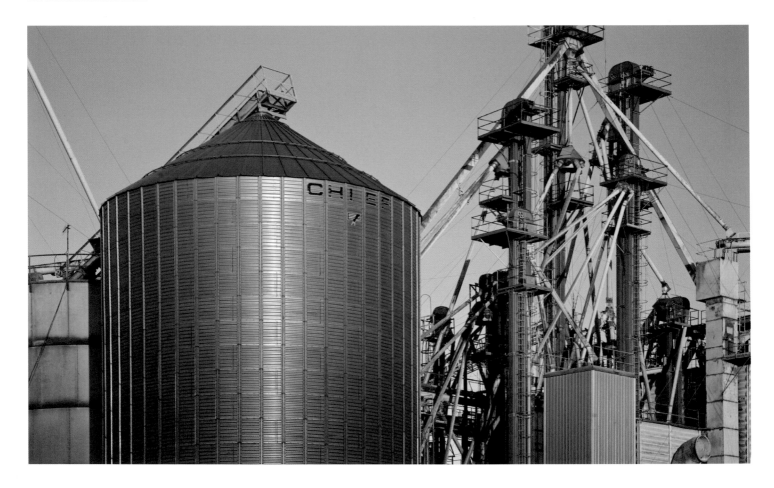

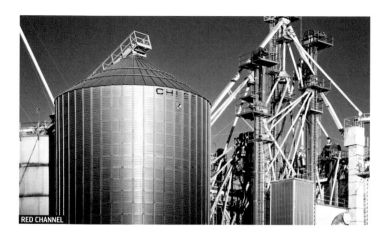

RED CHANNEL

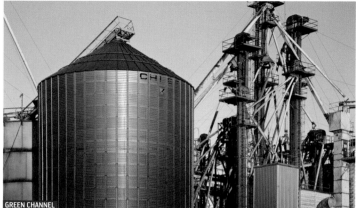

GREEN CHANNEL

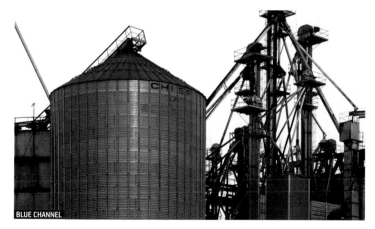

BLUE CHANNEL

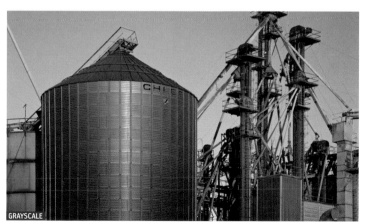

GRAYSCALE

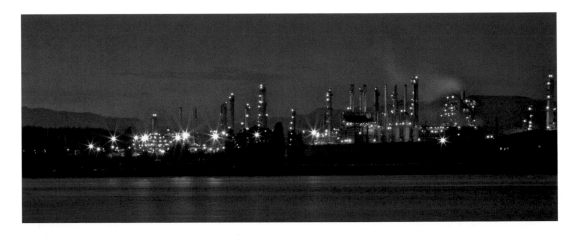

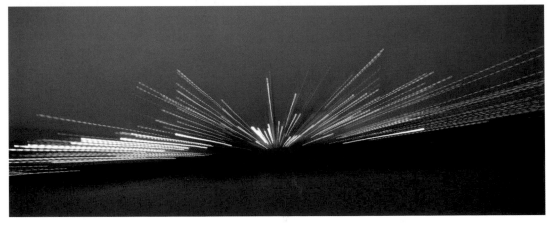

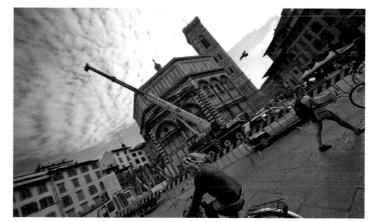

Late afternoon sun highlights a graceful and intricate tracery of steel tracks and wire lines in a coastal Italian train yard. Considering the subject matter, the photo is surprisingly easy on the eyes. Time of day and weather conditions are major theme-establishing factors when it comes to taking photos of industrial scenes. Either can have a big influence on whether a shot comes across as beautiful or ugly; engaging or menacing.

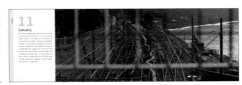

154 155

What do you think of the out-of-focus railing taking up space in the foreground of this shot? Personally, I think the scene would fall apart without it. A few reasons why: the grid-like effect of the railing puts a note of order into an otherwise sprawling composition; the blurred steel bars add an additional layer of industrial connotation to the shot; and the near proximity of the railing to the camera's lens projects a feeling of involvement between the viewer and the image's content.

Industrial kaleidoscopery. The highly functional—and sometimes peculiar—forms of industrial implements can make good material for Photoshop play. The geometric design on this page was constructed by reflecting the original photo along both a horizontal and vertical axis. The hues in the resulting image were altered using COLOR BALANCE controls. *Note: The small images on this spread are pre-Photoshop; the large ones are post-Photoshop.*

156 157

The Mothership Summons Its Armada To Earth. After selecting the unique apparatus in the right-most image using Photoshop's LASSO tool, it was then added to the neighboring scene. There, it was cloned, resized, and repositioned numerous times. (Some of the landing craft were blurred to increase illusions of depth and realism within the scene.) The contrast in the compiled image was heightening using CURVES adjustments; HUE/SATURATION controls were applied to lend a more surreal appearance to the image.

Rust and deteriorating paint in the near image mark the outlines of a former staircase on the exterior of an aging water tower. The flattened, abstract look of this scene is reminiscent of an artist's painterly composition. And speaking of artists and their compositions—I came across a bona fide work of originality painted onto the side of another water tower one day while driving (this page, right).

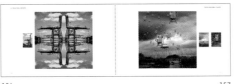

158 159

Communication towers offer all kinds of interesting perspectives and compositional opportunities. Structures such as these also lend themselves well to communicative design projects (ads, posters, etc.) because of their eye-catching forms and natural association with themes of connectivity and technology.

If you're a fan of richly varied visual compositions, be sure to check out industrial sites for subject matter and photo opportunities. The diverse forms of this mechanized grainery provide a generous study of agreeable contrasts: lines vs. curves; busy vs. plain; bright vs. dark, narrow vs. wide; angles vs. perpendiculars; textured vs. flat. A complementary palette of blue and orange tones add still another level of harmonious contrast to this image.

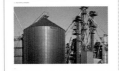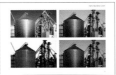

160 161

The method of converting color photos to black and white described on page 18 involves isolating a single channel from an image's RGB palette as the basis for its grayscale conversion. Take a look at the photos on this page (and the labels attached to each) to get a better idea of the options that become available when converting an image to black and white in this way. Also included on this page is a showing of the image after it has been converted using Photoshop's GRAYSCALE menu command.

To take in enough light to record the top image on this page, the camera was placed on a tripod and its exposure was set for ten seconds. A happy result of this lengthy exposure was that the waves in the bay were softened into a blur containing reflections of the refinery behind. The lower image was shot from the same vantage point while manually zooming the 75-200mm telephoto lens during a similarly long exposure.

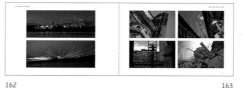

162 163

Ever visited a famous landmark only to find it was under renovation or obscured by construction equipment? Don't let that stop you from snapping a few photos—the juxtaposition between ornate and industrial forms might just add up to a photo of interest (or at the very least, a photo to accompany a humorous or heartbreaking story of a disappointing day during your travels).

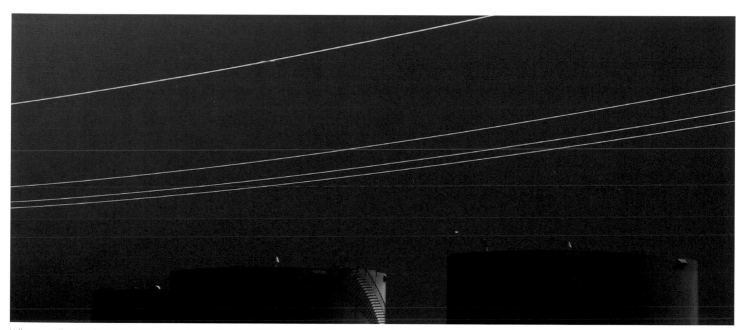

Yellow power lines arc through a vibrant red sky above a trio of industrial storage tanks. The surrealistic colors in this scene were generated by applying Photoshop's GRADIENT MAP controls.

12

Fun Places

Usually, when we go to a fun place, it's with friends or family, and we end up taking pictures of our companions having a good time in that place. And there's nothing wrong with that. But, since this is a book about *places*, the main focus of this chapter is on the backdrops, shapes, colors, mechanics and aesthetics of environments where fun happens. The moral of the story is this: The next time you're at place of fun, remember to take pictures of both the people you're with and the details of the place you're in.

The photos in this chapter were taken during one 13-hour period at a local fair. How about undertaking on a similar project and spending a day in a fun place taking pictures and enjoying yourself?

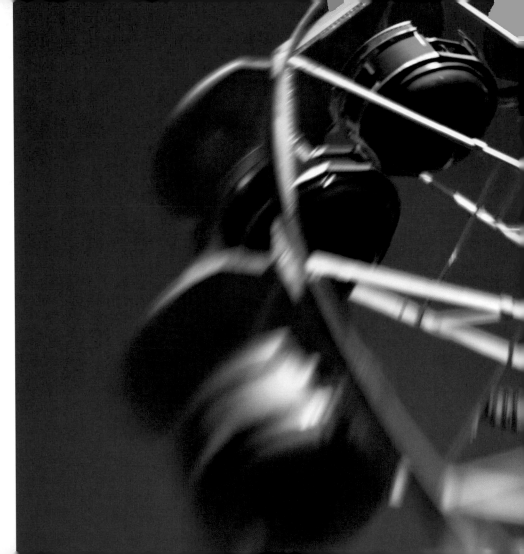

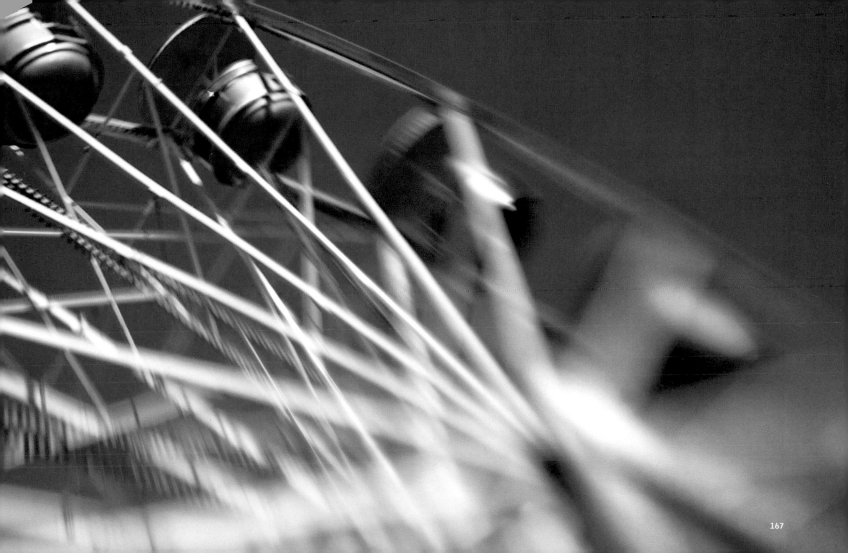

167

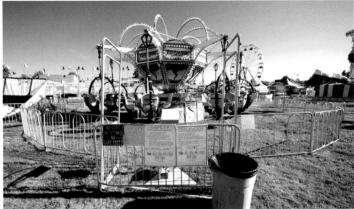

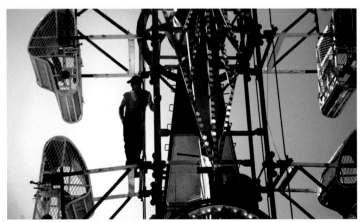

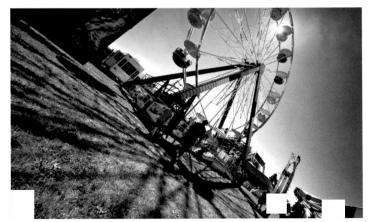

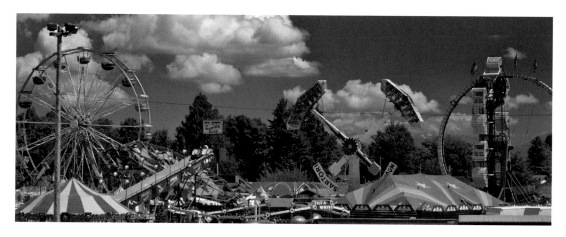

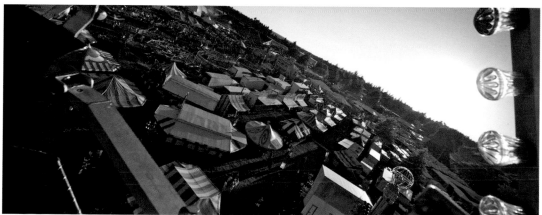

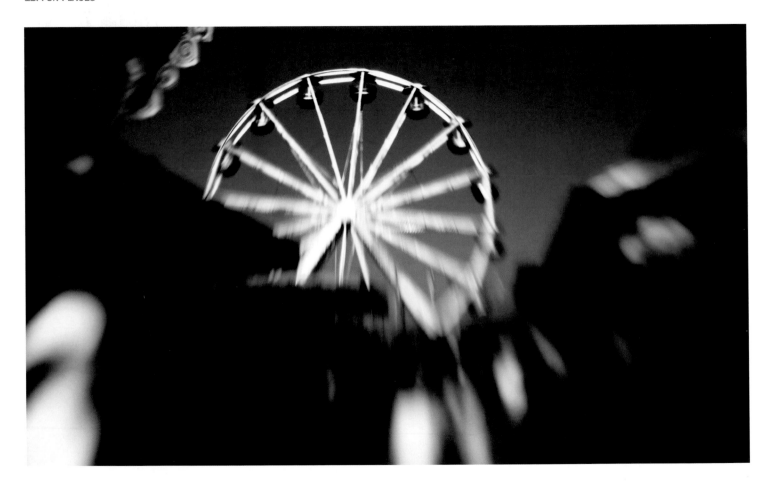

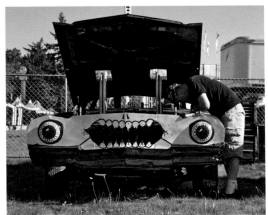

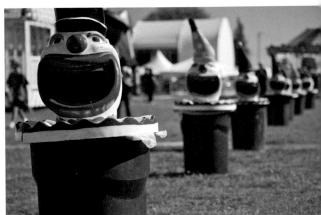

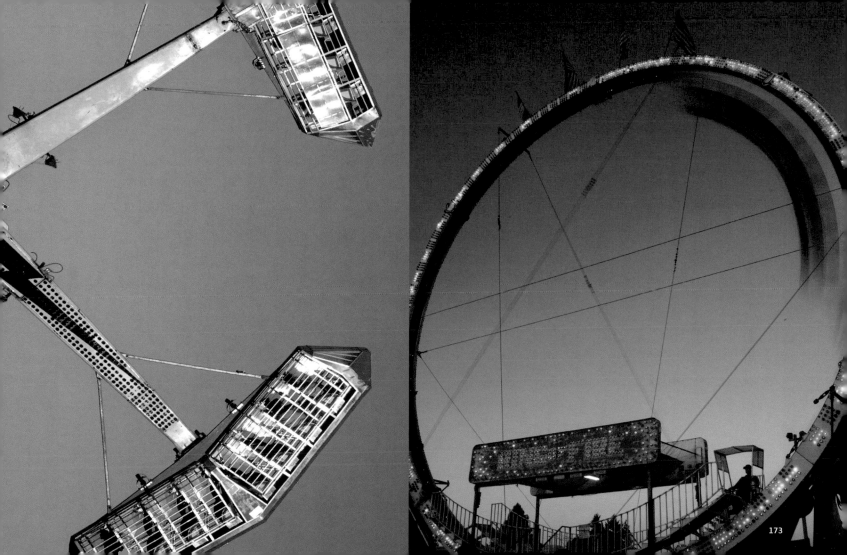

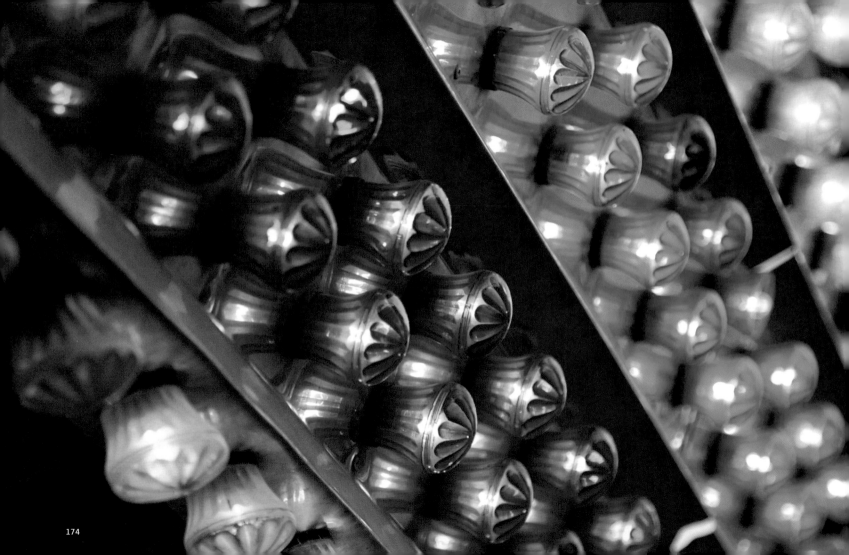

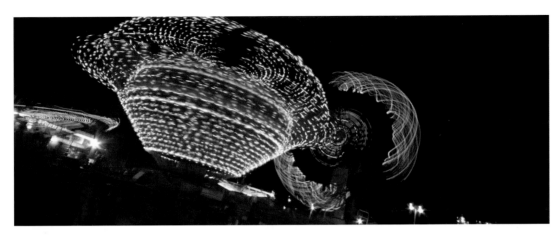

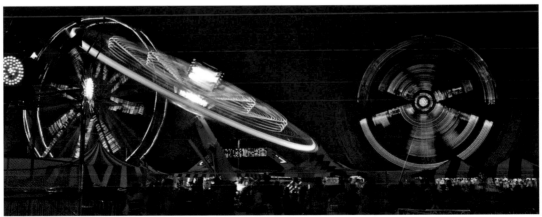

This photo was shot using a digital SLR fitted with a "Lensbaby®." A Lensbaby is a special lens with a flexible mount that can be bent and tilted to alter the way it focuses. Photos shot with this kind of lens are reminiscent of images taken with a toy camera or a Holga® with an imperfect plastic lens. Lensbabies are fun to use and give the photographer a nice break from the exacting results usually expected from traditional lenses.

166

167

Hi-tech digital cameras pair perfectly with lo-tech and experimental lenses since they let the photographer review their work on the fly. If you are interested in intentionally imperfect photos, search the Internet for the latest buzz surrounding alternative lenses and innovative shooting techniques—and speaking of which, check out the pinhole images on page 171.

As mentioned in this chapter's introduction, I spent one full day at a fairground collecting images for this chapter. To ensure a broad range of subject matter, lighting and photo opportunities, I arrived at the fair at sun up and left long after sundown. These shots were taken first thing in the morning—when the fair's amusements were still at rest and before the crowds arrived (more photos of this nature can be seen in Chapter 20, Out of Season, Off Hours, pages 272-285).

168

169

Once I arrived at the fairgrounds, it didn't take long for me to realize that there were no hills or high buildings from which to take panoramic shots of the grounds. I was able, however, to take the stairs to a high row of seats in the fair's grandstand to shoot the upper photo on this page (taken with a 75mm-200mm telephoto lens). To capture the pseudo aerial perspective in the lower shot, I purchased a ticket on the ferris wheel and took a ride with my 12mm-24mm wide angle lens just as the sun was setting.

While at the fair, I decided to spend time playing around with a couple of lens alternatives. The blurred photo on this page was recorded by taking advantage of the flexible mounting tube of a Lensbaby. The image's colors were enriched, and its contrast strengthened, using Photoshop's HUE/SATURATION and CURVES controls.

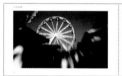

170

171

The two images on this page were recorded by using a digital SLR as a pinhole camera (see page 311 for more about digital pinhole photography). Since pinhole shots require long exposure times, anything that is not stationery within a scene becomes blurred. These shots were taken with the camera mounted on a tripod so stationery objects would remain in relatively sharp focus. After shooting a pinhole image, consider desaturating its colors (as with the image on the left) or amplifying them (right).

Details of the day. If you're spending a day in a place taking pictures, remember to keep your eyes open for the smaller photo opportunities that intrigue you, convey your personal impression of that place or simply appeal to your sense of aesthetics.

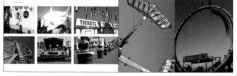

172

173

Machinery designed to dazzle. The photograph at left was converted to grayscale using the channel isolation method described on page 12. The image at right was shot at twilight by setting the camera on a tripod and using a slow shutter speed (about 1/4 second). This exposure was just long enough to take in enough light to record the photo *and* to create a blur of the amusement ride's looping car.

Near page: bulbs at rest. Far page: bulbs in motion. As much as I enjoy the sun, I could hardly wait for it to set and for the fairground's lights to come on. Here are three of my favorite shots of the hundred or so I took from the time the sun went down until a few minutes before the fairground closed.

Intricate and dazzling geometric shapes are generated by the spinning bulbs of various amusement rides. The effect seen here was simple to capture: the SLR was set on a tripod to keep it steady while a long exposure time (about 15 seconds) was selected to record the tracings of swirling and spinning lights.

174 175

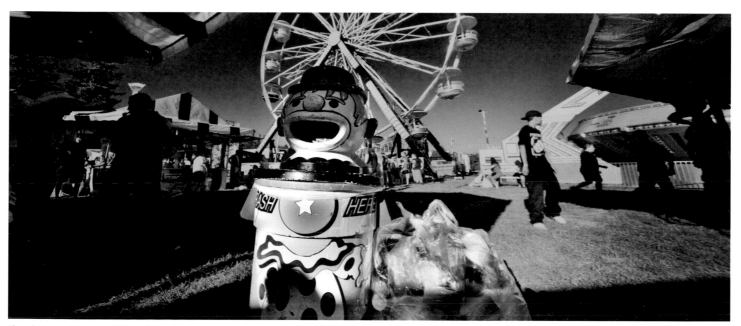

If you find you're the only one taking photos of certain things at a fairground, congratulations! You're on track to gathering an album of images that won't resemble anyone else's collection.

13

Cemeteries

Cemeteries tend to keep a low profile (literally and figuratively). They are all too easy to overlook, by-pass and ignore. And since cemeteries are known for being visited under less-than-ideal circumstances, they don't normally draw hordes of happy visitors to their entrances.

All this, believe it or not, makes cemeteries prime candidates for an image collection. Why? Because they are full of scenes and details that are beautiful, poignant, intriguing *and* unfamiliar in the context of our everyday existence (and as any collector knows, the value of a collection is often determined by the aesthetics and rarity of its content). Another thing that makes cemeteries—in some form or another—great subject matter for a collection is that they are pretty much everywhere (after all, cemeteries are nearly as certain as death).

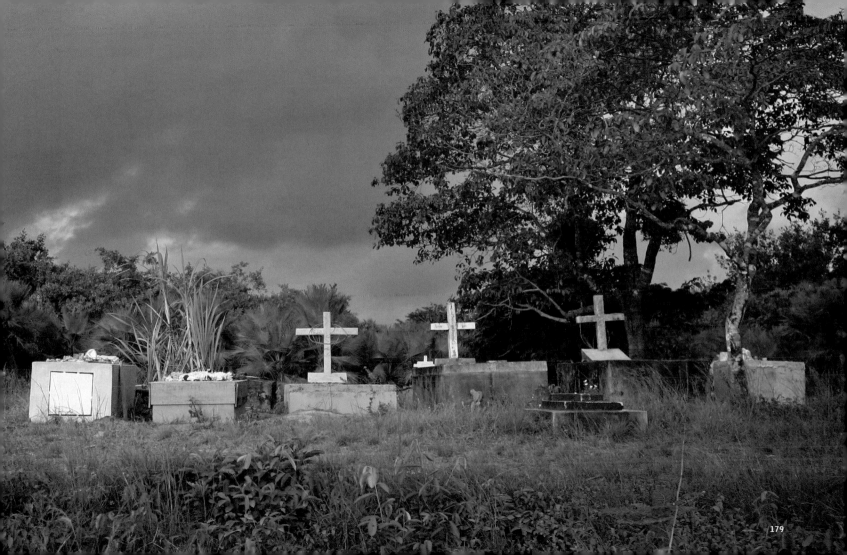

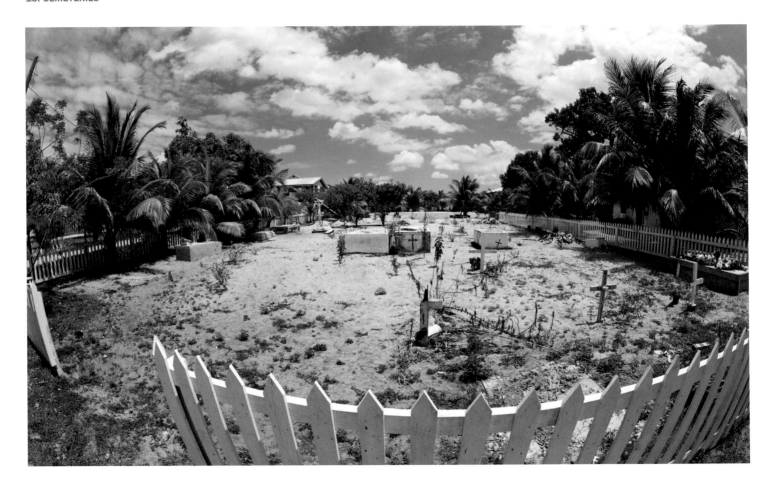

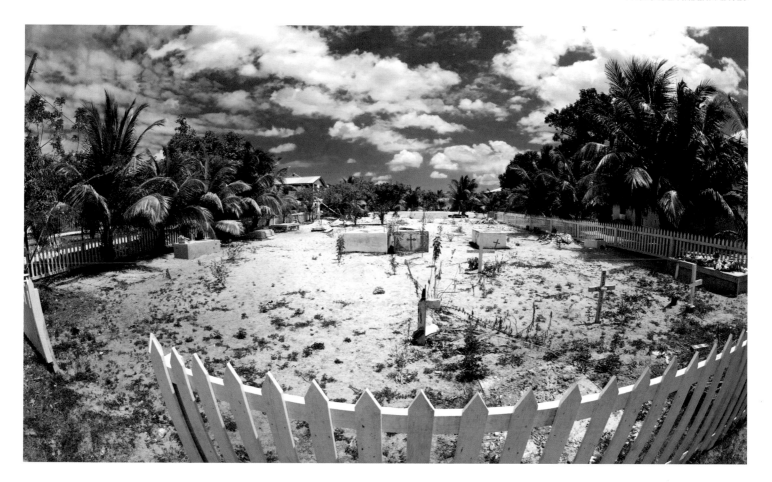

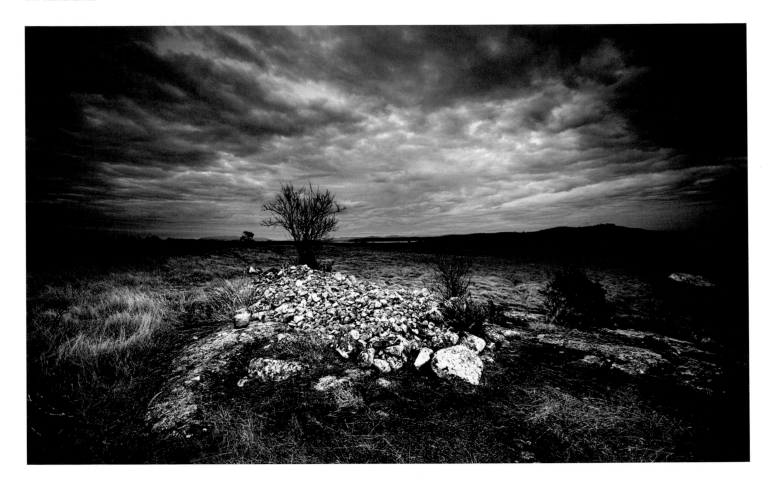

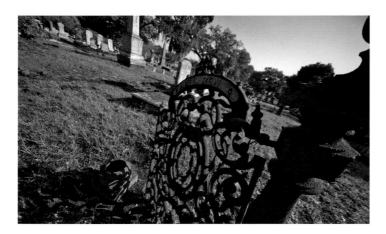
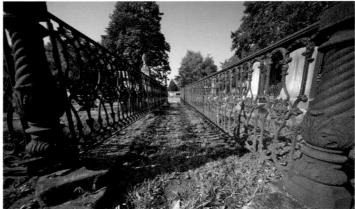
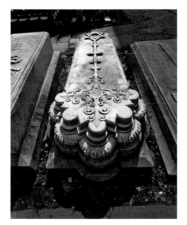
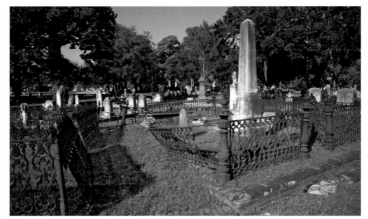

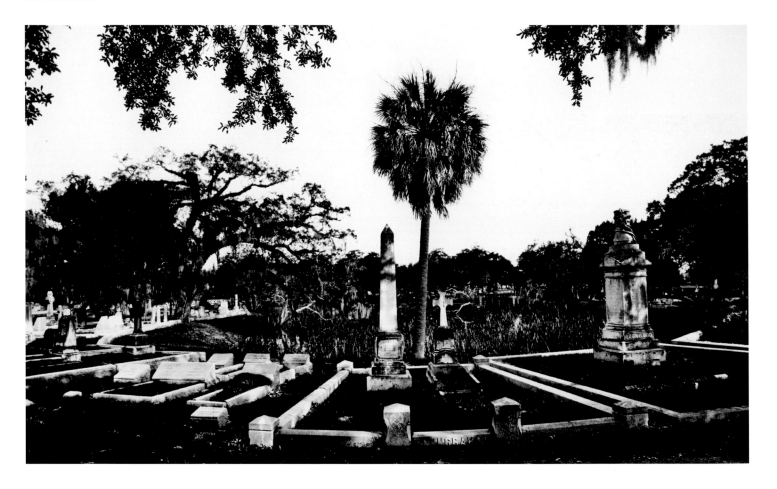

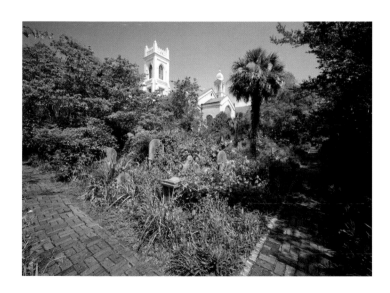

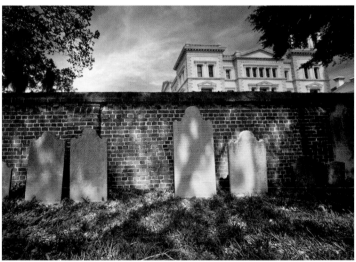

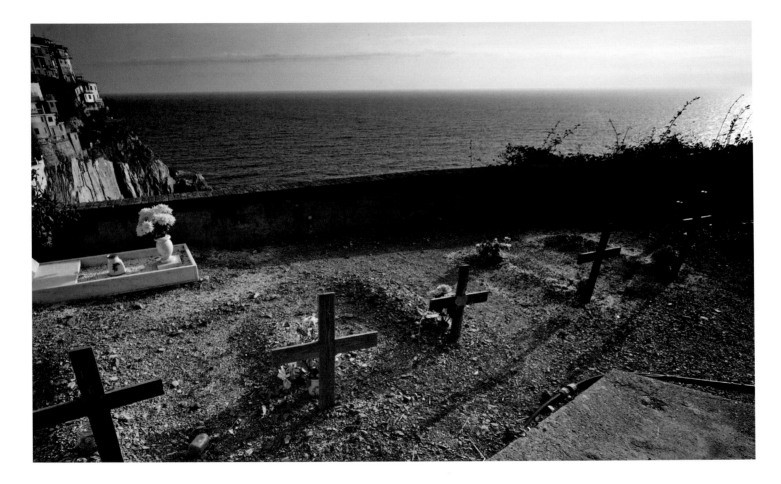

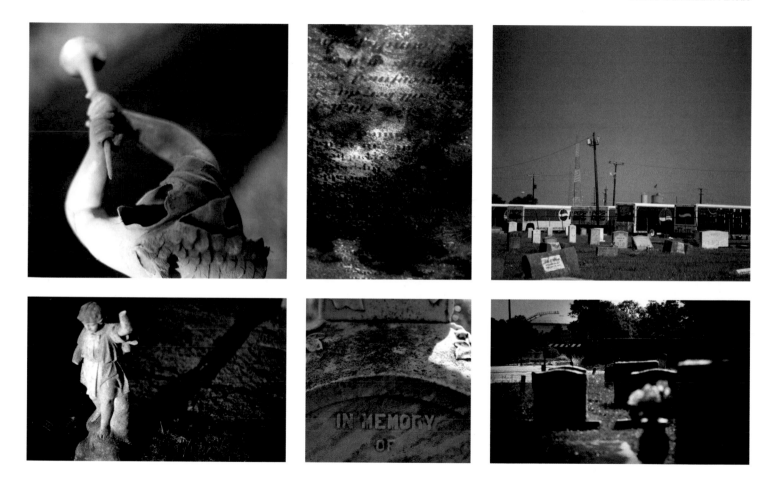

Morning sun illuminates colorful above-ground graves in coastal Belize. It's common to inter coffins in surface-level concrete blocks in places such as this, where hurricane conditions and severe flooding sometimes play havoc with sandy soil.

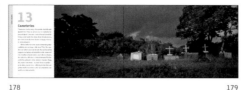

178 179

Issues relating to trespassing and respect are foremost in my mind when it comes to photographing burial sites. Personally, I try to get a sense from locals as to the propriety of treading in places such as these. If I come across people who are at a cemetery to mourn or pay respects, I usually leave and come back another time. How about you? What are your thoughts about taking photos in places that might be considered sacred by yourself or others?

Color vs. grayscale. Block the view of one of the images on this spread with your hand or a sheet of paper while looking at the other. Then switch. What differences in thematic projection between the two do you sense? In what kinds of situations would you prefer presenting an image in black and white? In color? If you shoot your photos digitally, keep your options open—record all your photos in color and decide later if you want to convert any to monochrome.

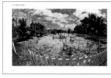

180 181

A 15mm fisheye lens with a 180° field-of-view was used to capture this scene. If you are able to afford multiple lenses for your SLR, one such as this is a good thing to have around when you come across subject matter that calls for an exceptionally wide view. Many fisheye lenses are relatively affordable and most are compact enough to be easily added to your carry-along bag of gear.

I came across this mound of stones in a historic military garrison on San Juan Island in Washington state. The site is near the epicenter of the Pig War between the U.S. and Britain (a war in which the only casualty was a single runaway pig). In truth, I don't know whether the mound is a grave (though if it is, perhaps it covers a certain pig...) or merely a pile of stones. In any case, I decided to include it here since it reminded me of the makeshift burials commonplace during the early days of westward expansion.

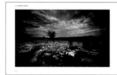
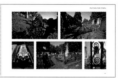

182 183

This page: images of stone and iron ornamentation from cemeteries in historic Charleston, South Carolina. Take your time when accumulating images of detail. Hunt carefully for points of view that will present your subject in a descriptive and intriguing manner.

Photoshop's CURVES controls were used to push the contrast in this photograph to extremes. In terms of its composition, take note of the foliage along the top of the image. Notice how its presence helps hold the content of the scene together by acting as a natural frame. Whenever the opportunity presents itself, consider including framing elements such as these in your photographic compositions.

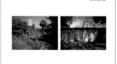

184 185

More examples of compositional framing are evident in this page's images. The brick walkway in the far image does a nice job of bracing the scene's central content. The leaves coming in from the upper corners of the near photo help establish a feeling of intimate enclosure, while also keeping the viewer's attention from floating out of the scene. Cover these elements with your fingers for a moment and notice how the composition of the images suffer without them.

An unpretentious cemetery with a grand view of the Mediterranean and the seaside village of Manorola. I was fortunate to chance upon this cemetery during the waning hours of a late summer day when the low sunlight was dramatically extending the cross' shadows and enriching the scene's colors.

In the middle and left columns on this page are details from cemetery statuary and signage. The near column contains two images with mildly irreverent themes: a photo that juxtaposes icons of consecration with icons of pop culture and a photo that pairs sacred ground with a sign which—considering its location—features an ironic message.

186 187

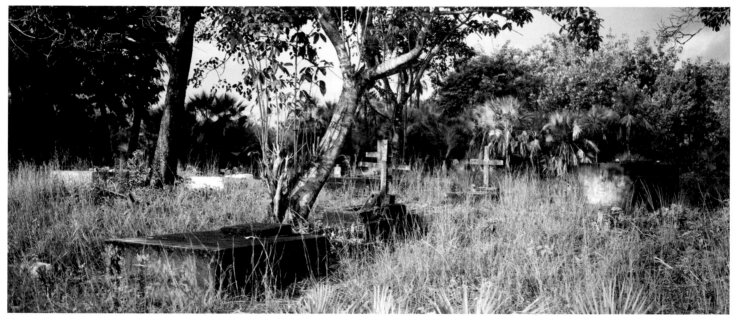

The explosive profusion of plant and animal life—combined with the inanimate presence of death and memorial—was a juxtaposition I came across in many of the village cemeteries of Southern Belize.

14

Beach and Beyond

Explorers, painters, politicians and writers agree—
There's something very special about the sea:

*The sea, once it casts its spell, holds one in its net of wonder
forever.* Jacques Yves Cousteau

*Why do we love the sea? It is because it has some potent
power to make us think things we like to think.* Robert
Henri

*We are tied to the ocean. And when we go back to the sea,
whether it is to sail or to watch—we are going back from
whence we came.* John F. Kennedy

*The loneliness you get by the sea is personal and alive. It
doesn't subdue you and make you feel abject. It's stimulat-
ing loneliness.* Anne Morrow Lindbergh

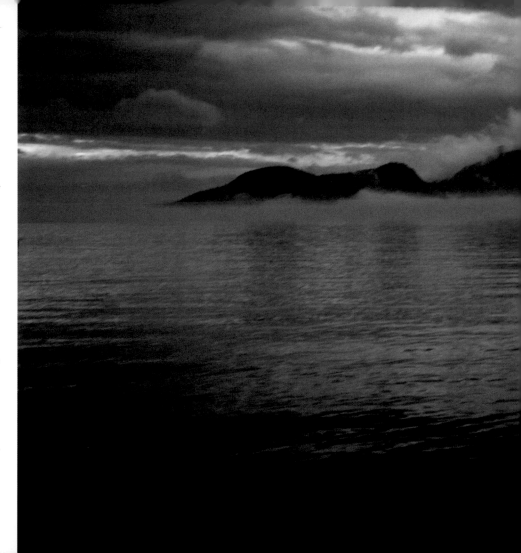

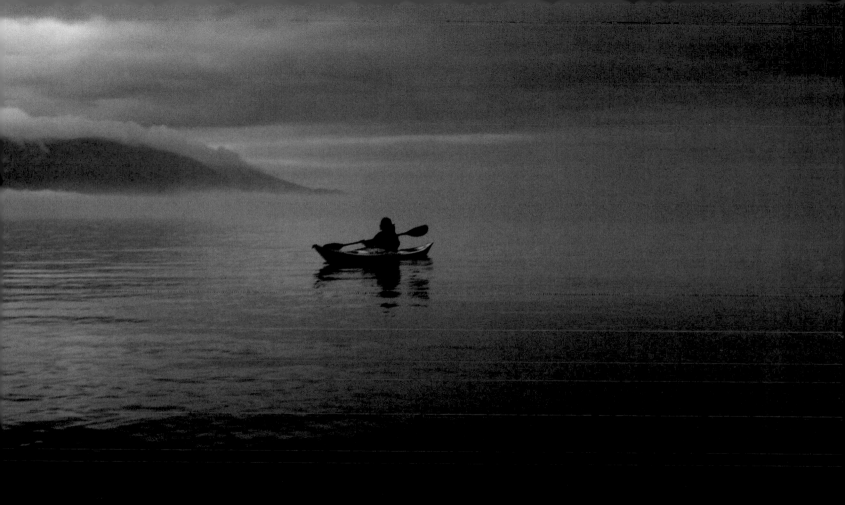

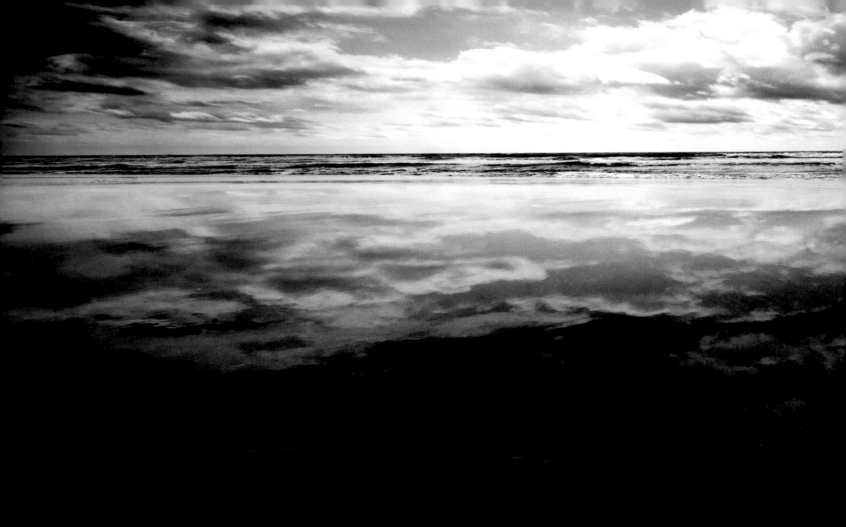

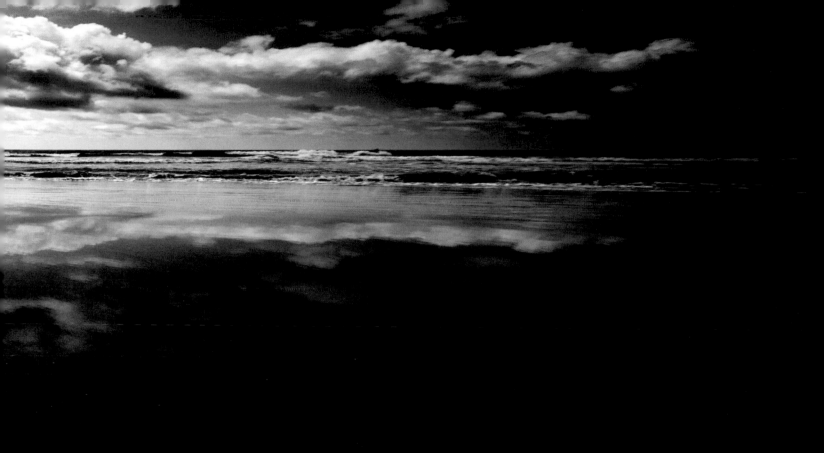

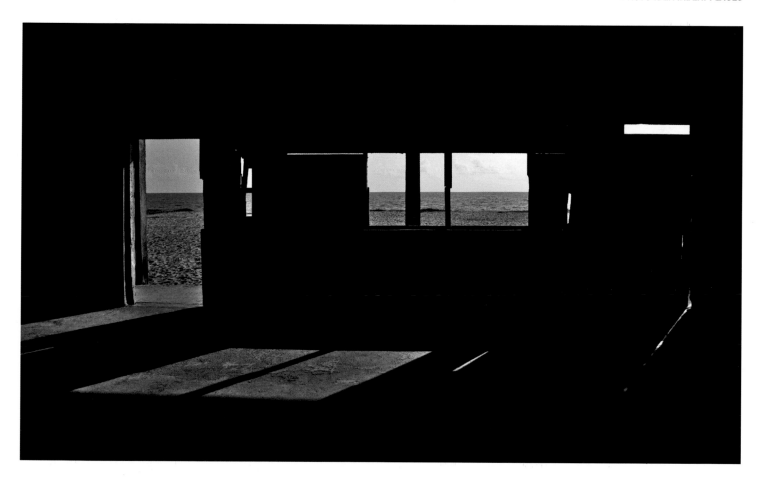

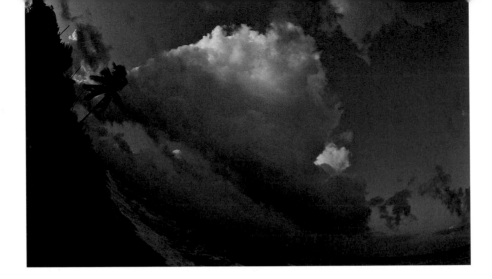

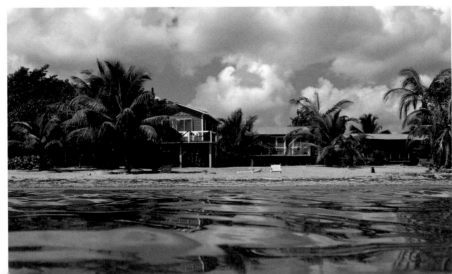

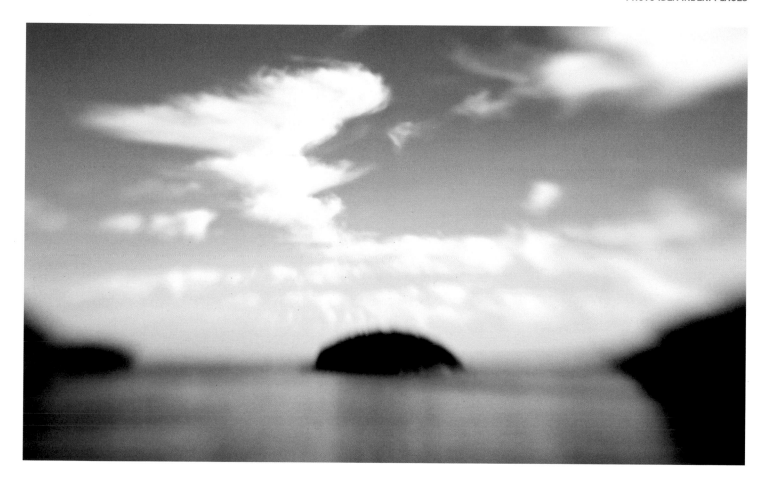

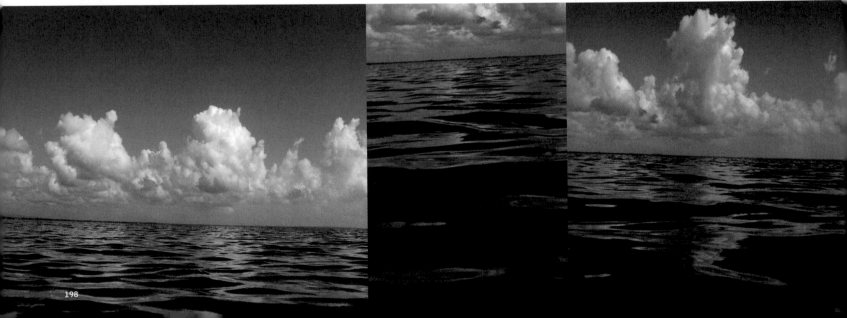

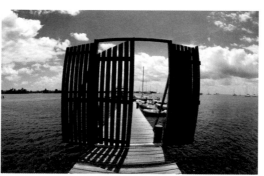
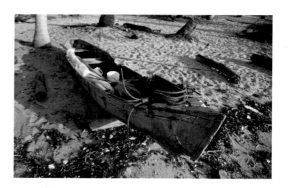
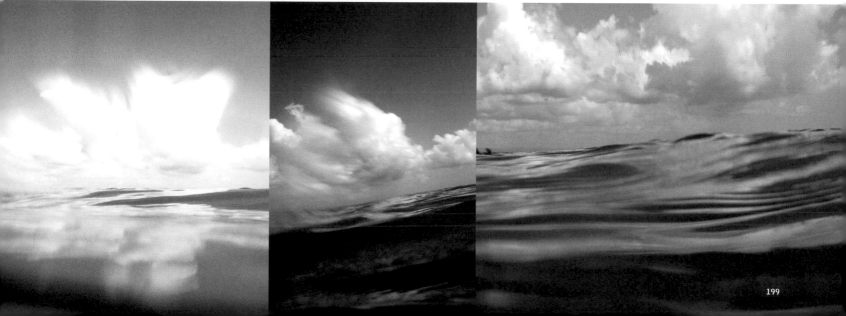

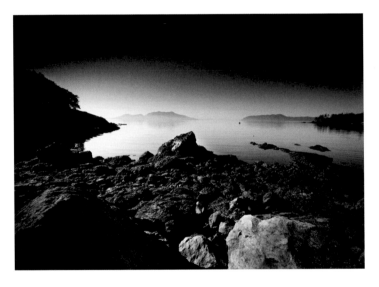

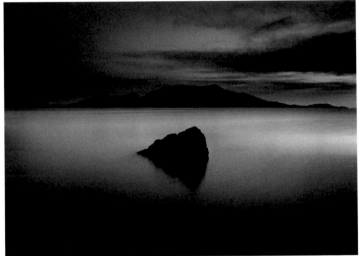

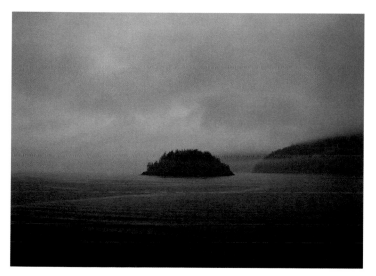
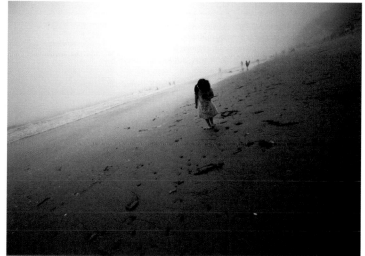

15

Rurality

Rural scenes seem able to cast spells of enchantment on camera-carrying city folk. Picket fences, weathered barns, fields of grain, aging tractors and rusty strands of barbed wire are each capable of charming a city slicker into a snap-happy picture-taking frenzy.

Someday soon, when the weather looks cooperative, consider putting on your walking shoes, packing a lunch and taking your camera out for a day in the country. Walk at a leisurely pace and use each of your senses—smell, hearing, touch and sight—to steer your feet toward photogenic scenes and subjects. If you are using an SLR with multiple lenses, experiment by trying to match your eyes' search for image material with certain lenses: far-away subjects with a telephoto; panoramic vistas with wide-angle; mid-sized scenes and objects with standard; and tiny details with close-up or macro.

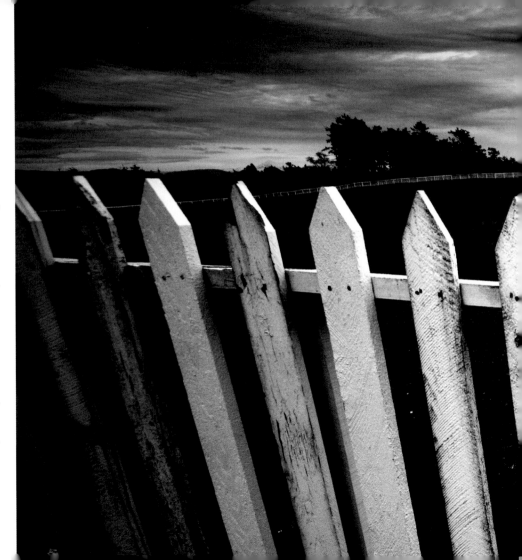

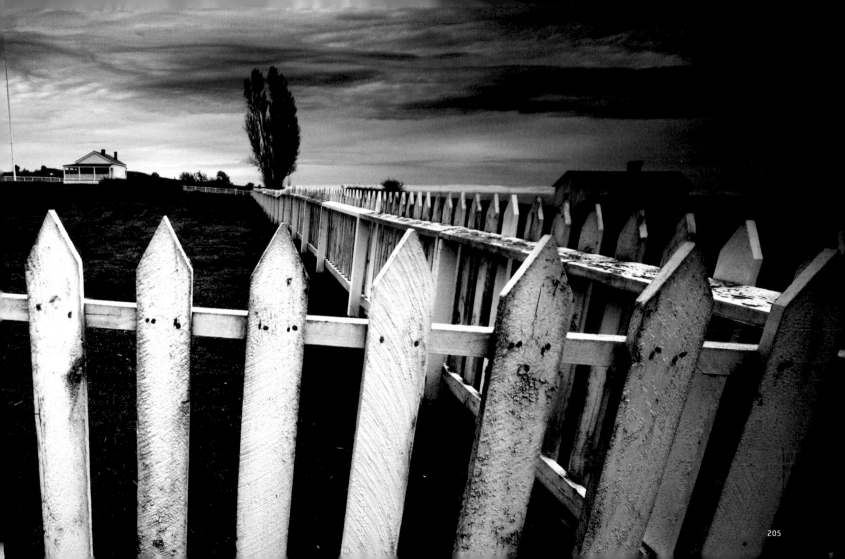

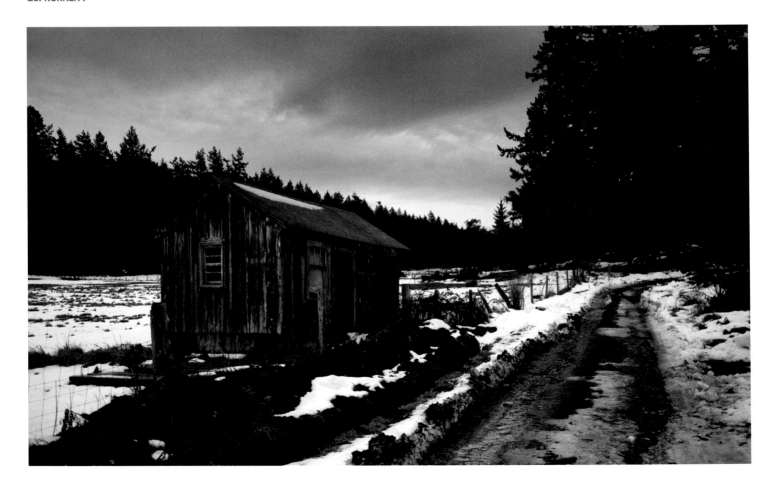

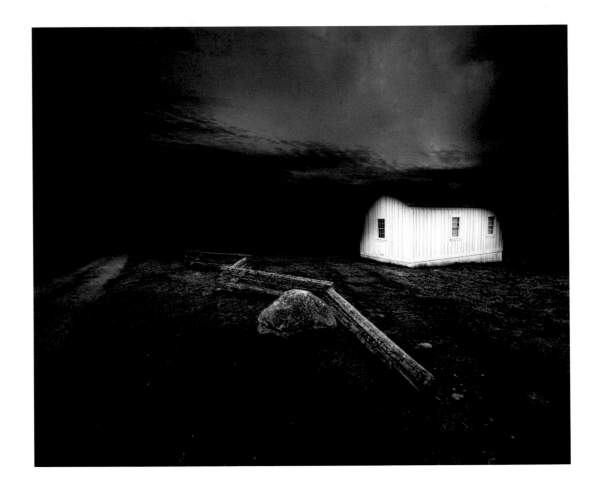

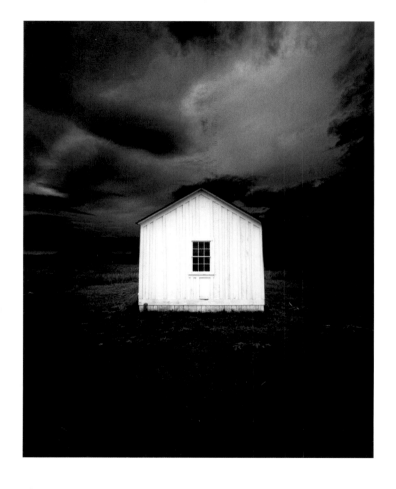

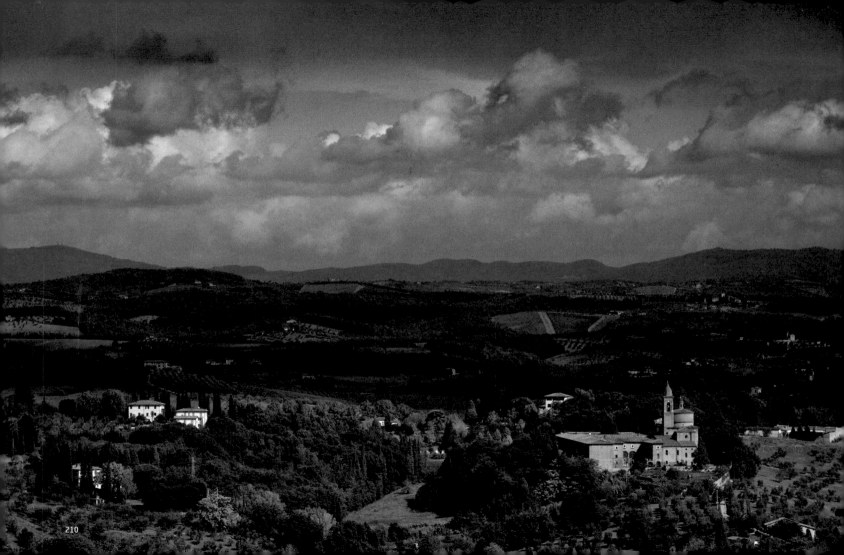

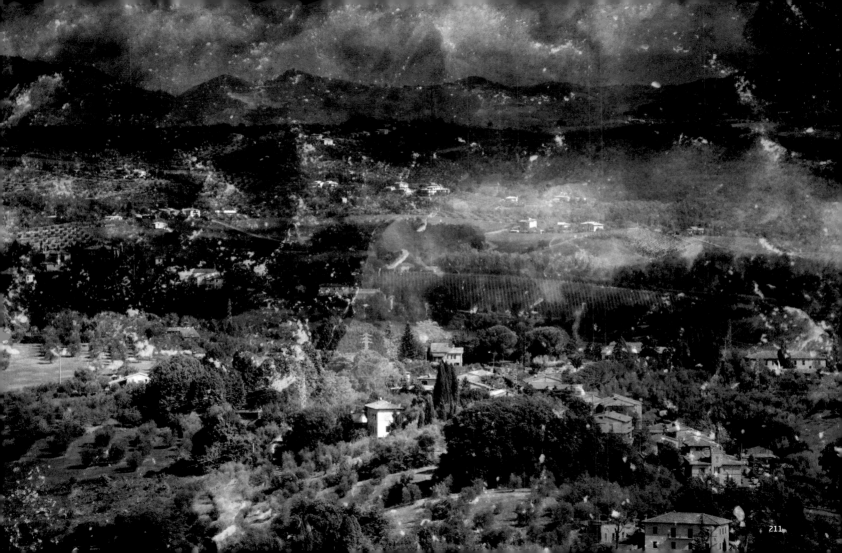

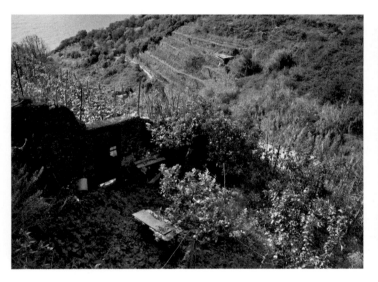
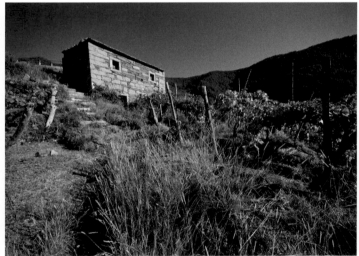

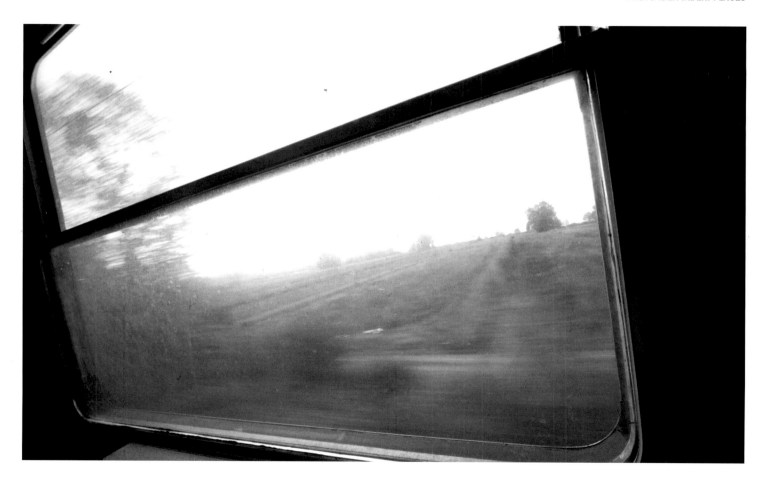

 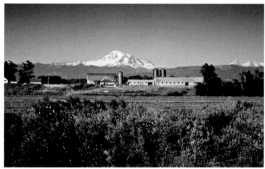 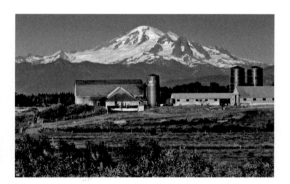

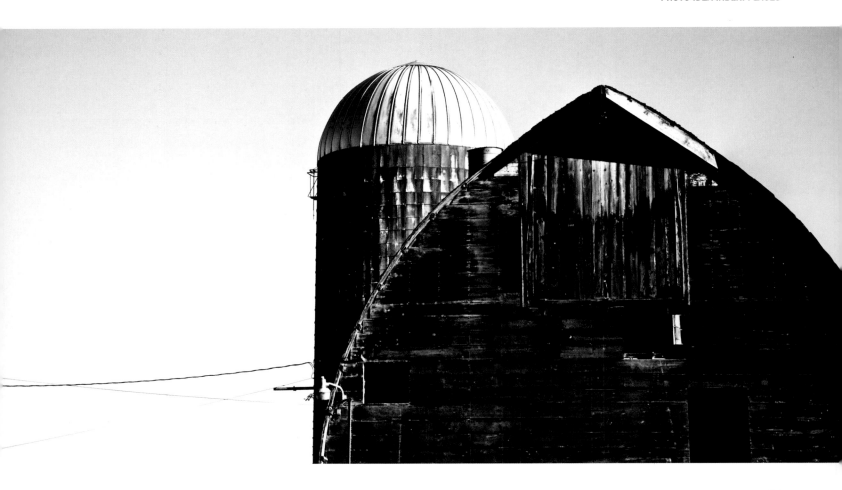

A rustic picket fence adds compositional charisma to this low-key rural scene. The photo was taken with a 12mm-24mm wide-angle zoom lens aimed from very near the fence's slats. This sort of combination between lens and vantage point results in dynamic conveyances of depth.

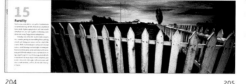

204 205

The photo on this spread, as well as those on the next two, were taken on the islands of San Juan and Orcas—the two largest islands of the San Juan archipelago in northwest Washington state.

Got a pair of waterproof boots or hiking shoes? A warm coat and hat? How about heading out for a picture-taking expedition on a winter day? And what about beginning your adventure where paved roads end and rurality begins?

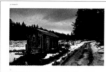

206 207

If you've ever gone out into the cold to take photos, you'll know keeping your body and hands warm is the key to outlasting the conditions. Heavy gloves work well to keep the hands warm, but they also interfere with dexterity when it comes to handling the camera. Personally, I like to let the camera hang from my neck between shots and keep my thinly gloved hands tucked into the pockets of my coat for warmth. This method works well as long as the conditions aren't too severe.

What began as a pair of decidedly ordinary color photos of historic rural dwellings end up here as a moody duo of monochromatic images. Two contrast-altering CURVES adjustment layers were added to these images in Photoshop. One of these layers was used to lighten the photo; one was used to darken it. Masks were selectively airbrushed into these adjustment layers to control the location and strength of the their respective effects.

208 209

The stark, nearly dead-center placement of the glowing structure in this photo leaves no doubt as to where the center of interest in this image lies. Conventional picture-taking wisdom often advises against positioning a photo's main subject in the center of a scene: It's a rule that's meant to be broken when seeking conveyances of immobility and unmitigated simplicity.

These two images of rural Italian countryside were taken from the top of the bell tower in Sienna's Piazza del Campo (featured on page 63). Unless you possess a plane, helicopter or a pair of wings, you'll need to be opportunistic when it comes to finding high vantage points from which to take photos of scenes such as these. To me, it's almost always worth the price of a ticket and/or the certainty of heavy exertion to gain access to high towers and hills—as long as I strongly suspect that the resulting photo opportunities will be worth my money and/or sweat.

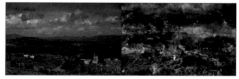 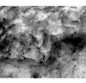

210 211

This rural scene was given a faux aging treatment in Photoshop in three steps: (1) the photo was converted to grayscale; (2) a sepia-toned PHOTO FILTER adjustment was applied; and (3) a weathered texture was added to the image by placing a high-contrast version of a textural image of dirty snow (right) in a layer above the original image. The snow image was inverted and "hard light" was selected from its layer's pull-down menu to give the landscape photo a weathered look.

This page, left: looking down into a private vineyard on the steppes of Italy's Cinque Terre. Right: looking up at an aged stone storage shed on the same terraced hills. If you enjoy hiking, swimming, wine (or grappa), food, coffee and gelato, there are few finer places to visit than the towns of Italy's Cinque Terre. There is a seaside trail that connects Cinque Terre's five villages, as well as less-traveled trails in the hills above the towns. These two photos were shot while traversing the latter.

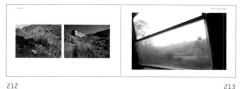

212

213

Shot through the smudged window of a moving train, this image records an impressionistic view of the farmland outside. Be willing to accept photographic "imperfections" (such as the blurred and over-exposed areas of this scene) when going for communicative images of everyday experiences.

A lens comparison. The three photos on this page were shot from the same spot. The first photo (far left) was taken with a 12-24mm wide-angle lens. The middle photo was shot with a 24-105mm standard zoom lens. The third image in the set was taken with a 75-200mm zoom lens.

214

215

A barn and a silo—quintessential icons of rurality. A CURVES adjustment layer was added to the base image in Photoshop to both deepen the photo's dark values and brighten its lighter values. As a result, the barn and silo stand out prominently against the pale blue sky, and the weathered look of the structure's exterior has been emphasized.

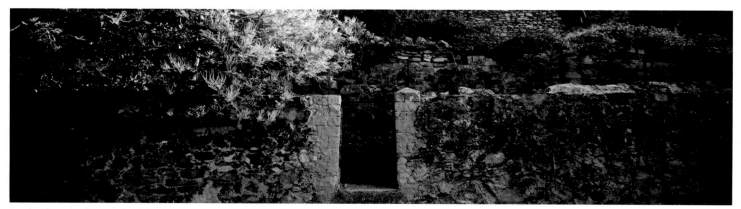

An aging vineyard wall—crowded by foliage and crawling with vines. Presented in monochrome, the image becomes an intriguing organic study of harmoniously contrasting forms and textures.

16

Forest, Field and Park

Ever notice how a camera in the hand equates to eyes that suddenly seem supercharged with powers of observation—how interesting scenes and objects that may have previously eluded our notice are suddenly highlighted when we are seeking photo opportunities for our SLR or pocket camera? Forest, field and park—with their vast depth of subject matter and relaxed ambiance—are great places to go to experience perspective-expanding effects.

Along with hand-carved walking sticks, a close friend or a faithful dog, cameras are among the best outdoor companions ever devised.

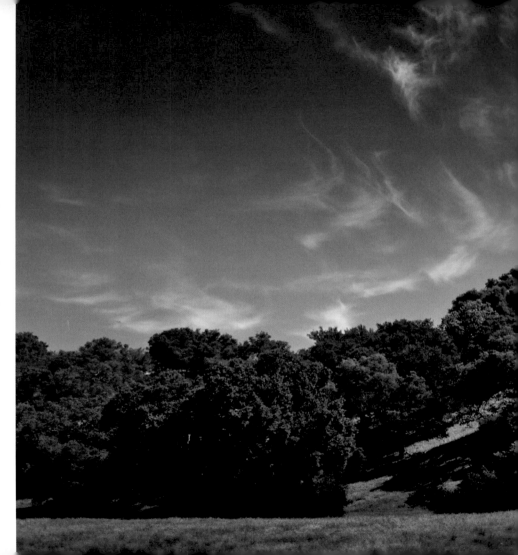

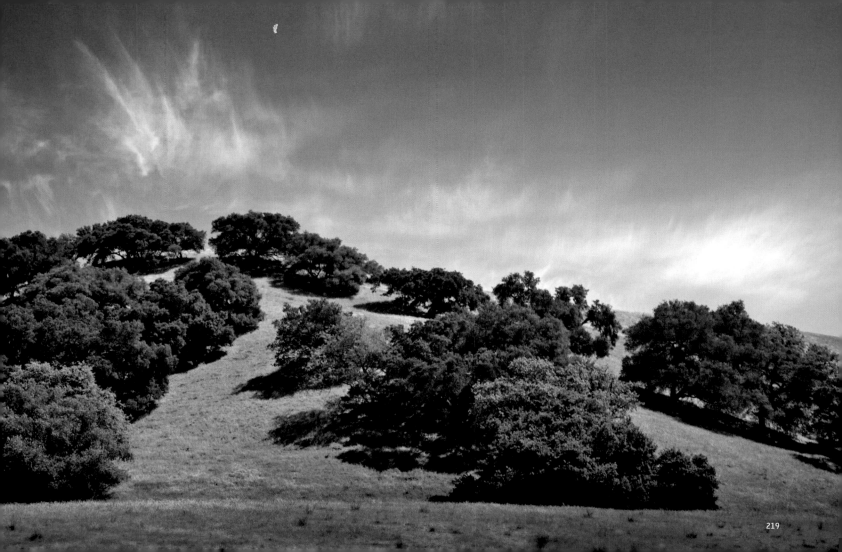

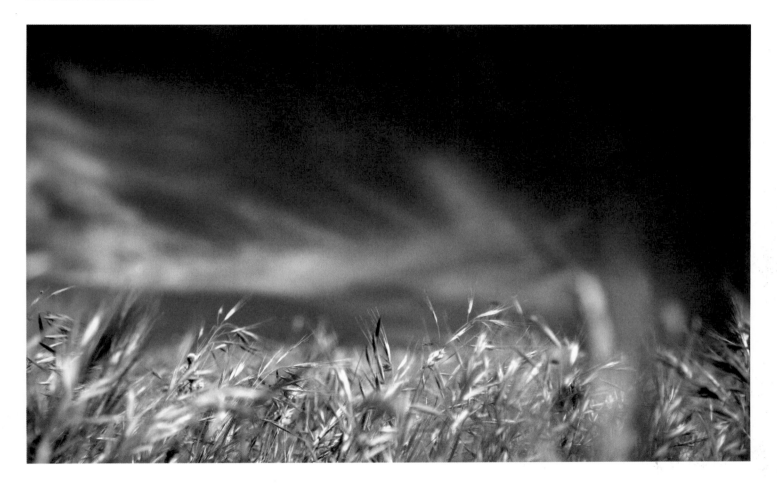

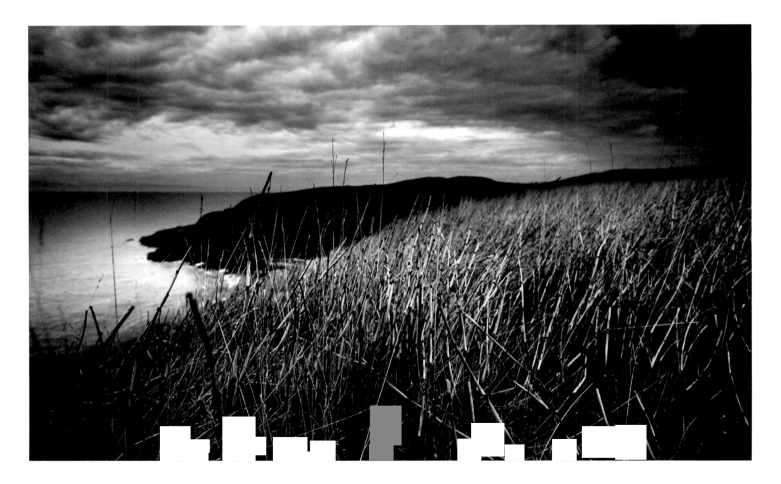

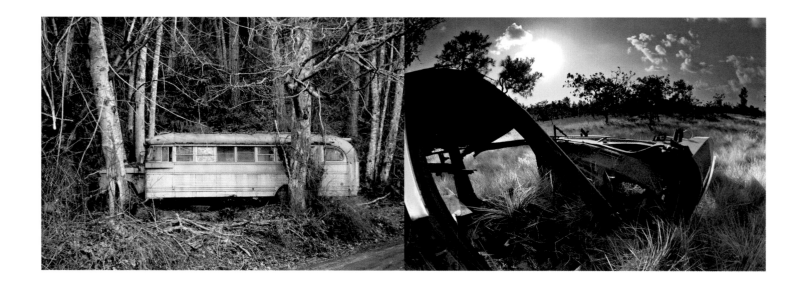

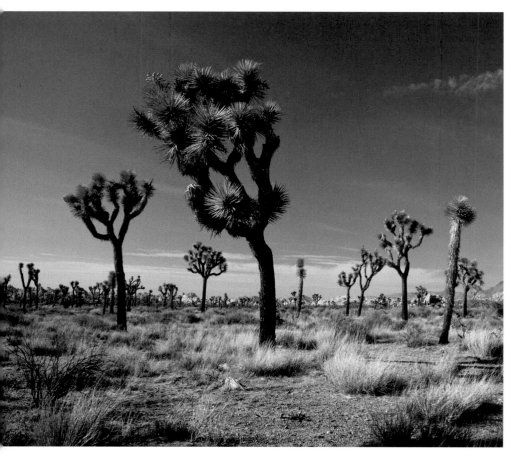

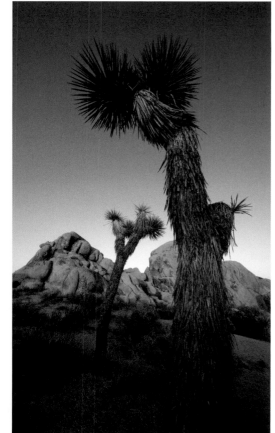

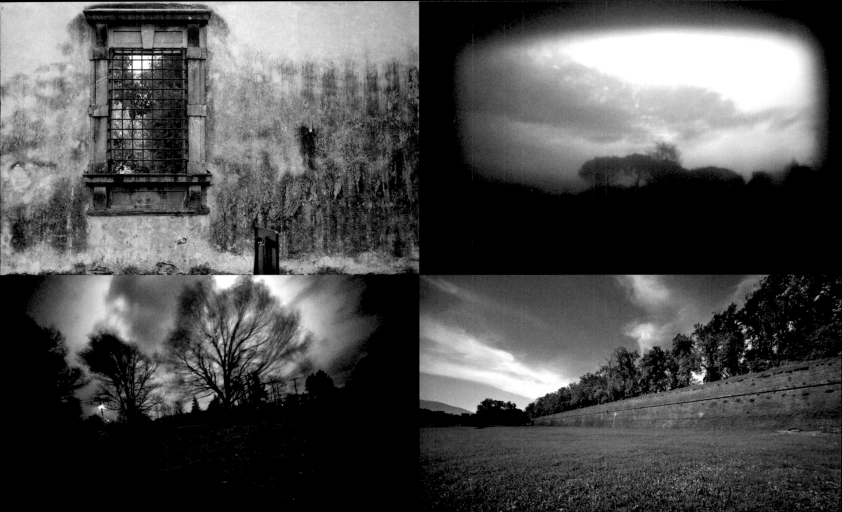

Richly saturated hues and a heaping application of warm tones lend connotations of pleasant memories to natural scenes like this. These color-enhancing effects were applied using Photoshop's CURVES and PHOTO FILTER controls.

218

219

Consider the following perspective-adjusting approach some afternoon when you're collecting photos in a forest, field or park. Begin by looking for large-scale photo opportunities—sweeping views of your environs. Then, after a while, adjust your mindset to concentrate on mid-sized scenes such as a grove of trees or a patch of wildflowers. And finally, when you feel ready to shift focus again, zoom your eyes and camera's lens in on the details within your environs—things like petals on a flower, textures of bark, lichens and insects.

Dive deep into the landscape you're photographing. Get your knees dirty and smell the grass as you search for vantage points that will give viewers the impression they are tucked into the scene—just as you were when you took the photograph.

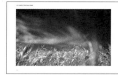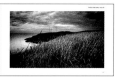

220

221

The mildly surreal appearance of this image was achieved by selectively deepening its contrast with a custom-masked CURVES adjustment layer—and by warming its colors with an orange-hued PHOTO FILTER adjustment layer (this layer was also masked to control where its effects were applied). Again, a reminder that the image-enhancing effects of Photoshop's customizable adjustment layers are relatively easy to learn and endlessly useful.

This spread: trees of field, forest, jungle and coast; trees alone and among others; trees healthy and dying. If you spend a fair amount of time in natural areas, consider creating a collection around certain subjects—trees, ferns, wildflowers, mushrooms, lichens, birds—anything that appeals to you.

222

223

Abandoned vehicles sometimes show up in the most surprising places. Forest and field have become the final resting places for the two deteriorating vehicles featured on this page. Intriguing juxtapositions—and the hint of an unknown story—make subject matter such as this prime material for photographers with an appetite for out-of-the-ordinary subject matter. (Similarly-themed images can be found in Chapter 10, Desolate Places, Empty Spaces, pages 138-153.)

Don't neglect the photo opportunities offered by the canopy above when walking through a forest or jungle environment.

224

225

How about doing something outlandish with one of your nature photos? Here, a mysterious forest creature has been created from an image of a mangrove tree's gnarled above-ground roots (far right). To fabricate this creature, the original image was mirrored horizontally, converted to grayscale and given an earthy gray tint using Photoshop's PHOTO FILTER adjustment. Certain roots were then selected using the LASSO tool and colored by applying a reddish hue using the PAINTBRUSH tool set to "multiply".

Images, far left: In addition to training your camera on broad landscapes, be sure to look for the intriguing details and smaller examples of beauty within the forest, field or park you're visiting. A 50mm lens, with its excellent depth of field capabilities, was used to take these three photos.

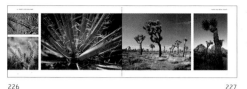

226 227

A forest of a different sort. In this spread's larger images, Joshua trees and scrubby undergrowth fill the landscape in Southern California's Joshua Tree National Park. The incredible variety of shapes, sizes and forms achieved by these trees is remarkable—they are truly a one-of-a-kind photographic subject.

A fog bank—not quite thick enough to hide the forest within. This photo was shot from the deck of a moving ferry, in dim light, using a pocket digital camera. When I reviewed the image I was pleased to find that my pocket-cam had what it took to capture an accurate recording of the scene under difficult shooting conditions. As their technology and design improves, the reasons for not keeping a pocket camera on hand at all times grow fewer and fewer.

228 229

This page, top left: A study in contrast—foliage in captivity. Top right: A dreamy impression of a park captured by aiming a pocket camera through the plastic viewfinder of an older camera. Bottom left: Taken during a storm, the central tree's branches were allowed to blur by setting the camera on a tripod and using a very slow shutter speed. Bottom right: Contrast has been significantly heightened in this shot to increase the imposing impression cast by the band of trees atop an aging fortress wall.

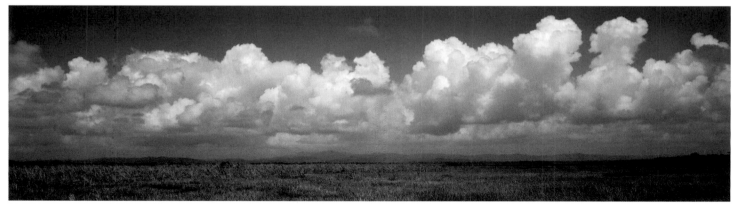

Shooting at high resolution with a wide-angle lens gives you the option of selecting extreme horizontal croppings from your image—as though the photo were taken with a special panoramic lens.

231

17

Regular Visits

Think of a place near where you live—a place you enjoy visiting and wish to become better acquainted with. How about making a habit of taking pictures there? Your visits could be spontaneous or planned. They could happen during different times of day and during different seasons—an especially good idea if your chosen place is outdoors. Visit your favored place with different photographic agendas. For instance, aim for big scenes and overall views one day and tiny details on another; or, take photos using only natural light during one visit and use a flash for the next.

The results? A richly descriptive collection of related images and a heightened awareness of the depth in which beauty lies in just about any space or place.

232

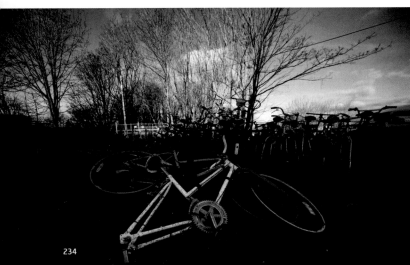

234

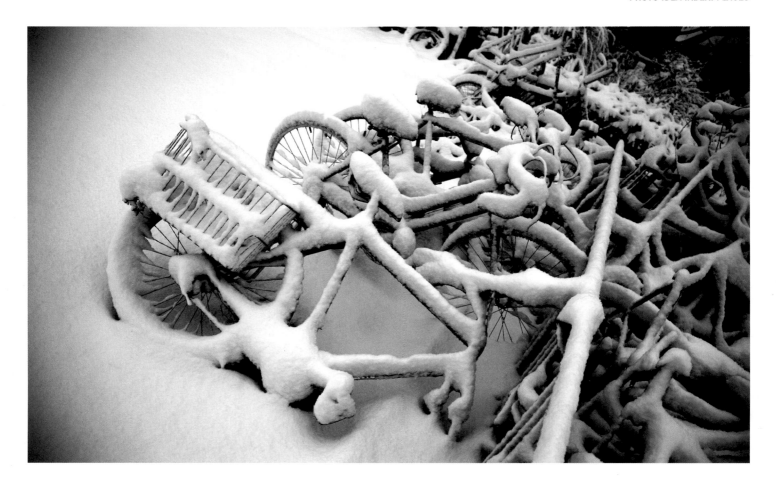

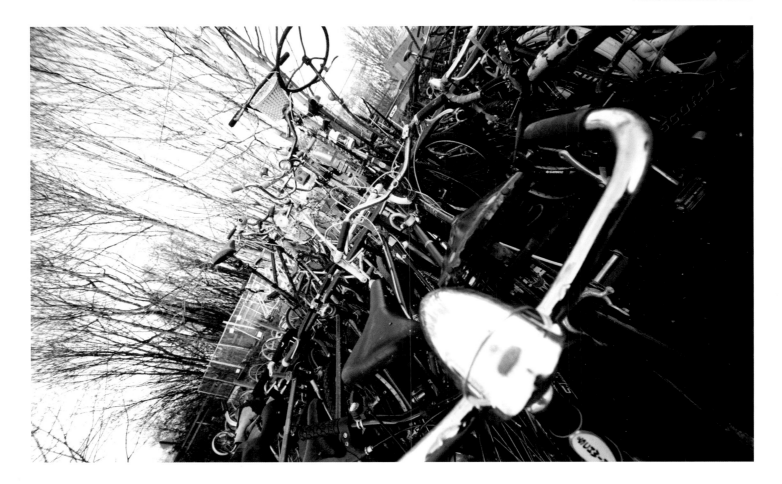

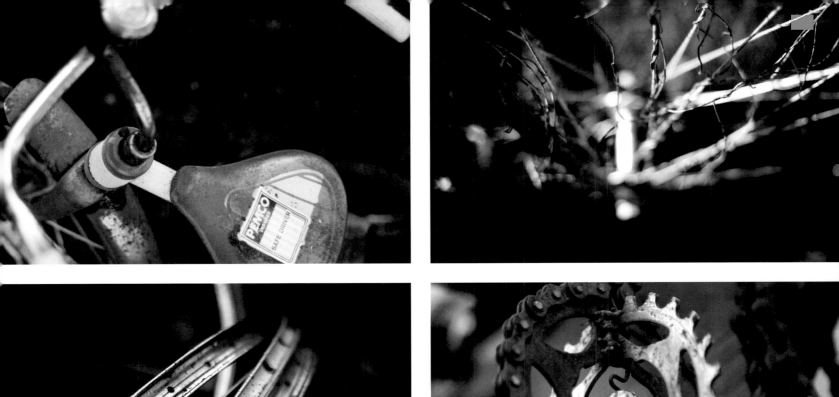

Allow me to introduce you to The Hub—a community bike shop near my home in Bellingham, Washington. What happens inside The Hub is this: used bicycles are bought, refurbished and sold. What happens outside The Hub is harder to explain. In short, outside is where certain bikes are parked, piled and sometimes pillaged so their components can be used as landscaping accessories and improvised works of art. It's a great place to visit if you're looking for a bike, a break or a unique photo opportunity.

232

233

To me, the yard around The Hub is a magic place. And I mean that somewhat literally since every time I visit there some new bicycle-inspired creation seems to have materialized out of nowhere. I love taking my camera to The Hub, early in the morning—before volunteers, staff and customers have arrived—to hunt for things to photograph. I visit there regularly. This chapter contains a small sampling of the photos I've collected at The Hub during the past couple years.

Search for points of view within the places you visit that convey its personality, purpose and quirks. The photos on this spread present larger scenes. These are the kinds of photos meant to give viewers an idea of the environment's layout and function. When collecting this kind of image, experiment with low and high vantage points: try out points of view that exclude—or include—horizon, backdrop and sky.

234

235

If you've chosen an outdoor place for regular picture-taking visits, be sure to think of going there when the weather shifts. How about creating a series of shots that portray "a year in the life" of your chosen place? If you were to begin a project like this, how regular would your visits be? Once a month? Once a week? Once a day?

Stoop, snoop and stalk your way through your picture-taking. Hunt for camera angles that capture content and compositions that excite and interest *you*. If you're a commercial photographer—someone who is usually required to please other people with your images—a "regular visits" type of project might be the perfect venue for you. Why? Because it will give you a creative outlet where you are under no pressure to please anyone but yourself with your images.

236

237

The chrome handlebar in the foreground of this image plays a neat compositional role as it scoops and holds together the erratic display of forms behind it. A 12mm-24mm wide-angle zoom lens was used to take this shot. The lens did a nice job expanding the form of the handlebars in the foreground while gathering a generous amount of content into the backdrop .

This photo was taken with a 50mm lens with the aperture set to f/1.2. Notice how narrow the band of focus is in the shot—everything in front of, or behind, the point where the lens is focused blurs gracefully away. If you have a digital SLR, consider adding a 50mm to your collection of lenses. 50mm lenses are among the cheapest and most versatile available. Many feature a large aperture (somewhere from f/1.2 to f/1.8) which allows for low-light shooting as well as lovely depth-of-field control.

238

239

The photos in this chapter were each treated to hue-deepening and color-harmonizing effects as a way of presenting them in a unified and artistic manner. In Photoshop, a CURVES adjustment layer was used to heighten their contrast. A palette-restricting SOLID COLOR adjustment layer was then added. This layer was assigned a deep orange hue and "soft light" was selected from the layer's pull-down menu. Finally, a HUE/SATURATION adjustment layer was used to heighten the saturation of each image's restricted range of color.

Thank goodness for the creative souls in this world who come up with the spontaneous works of art for the rest of us to chance upon and enjoy. This mobile, made from a bicycle cog, a coin and some random keys, is one of many treasures to be found at The Hub. A special thanks to Kyle M. for creating many of these works, inspiring other people's creativity, and allowing me the freedom to freely take pictures in the yard of The Hub.

240

241

A set of sculptures: some created by hand and others by happenstance. When recording two-dimensional images of three-dimensional works of expression, thoroughly explore vantage points. Certain perspectives do best when it comes to recording simple structural specifics. Other vantages—ones that may or may not include the subject in its entirety—could be used to create intriguing photographs that are works of art in their own right.

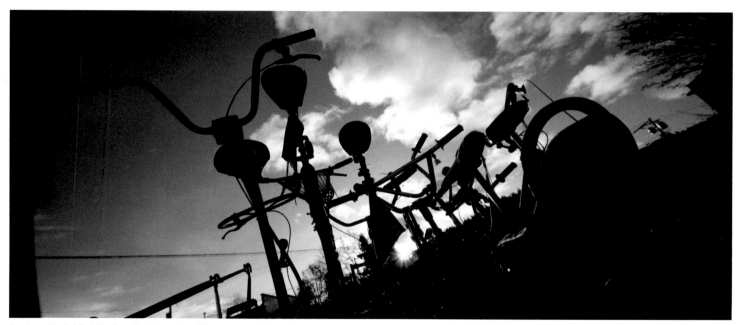

Sunrise at The Hub in Bellingham, Washington. Be willing to set your alarm and skip breakfast now and then so you can catch your favorite shooting grounds during uniquely photogenic hours.

243

18

Details

Some say the details of a thing are inhabited by none other than God. Others claim it's the devil that lives in the details. Either way, the significance details play in our existence is demonstrated by the notoriety they've achieved.

The next six spreads are devoted to the ornate and utilitarian, simple and complex, man-made and natural details that garnish the big picture in which we live. Most of the images in this chapter were taken in historical sections of Italian and American cities. Naturally, details can (and should) be sought in environs that reflect any and all eras.

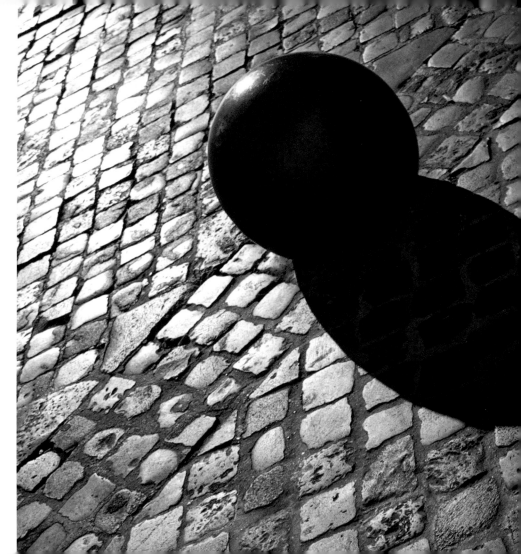

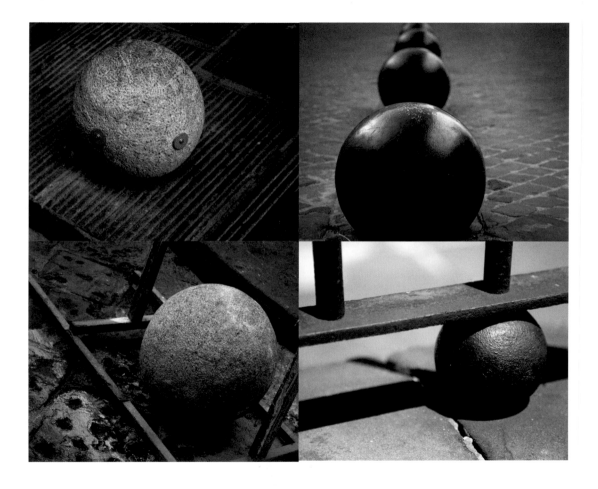

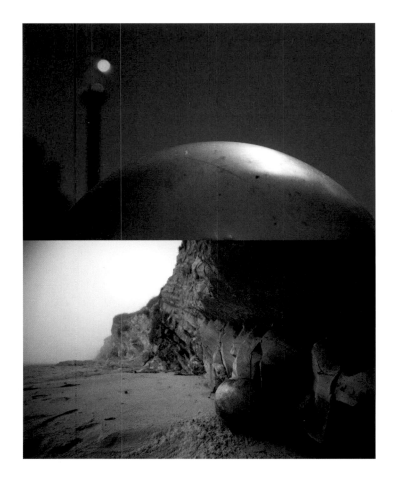

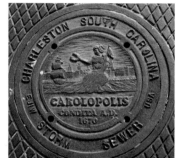

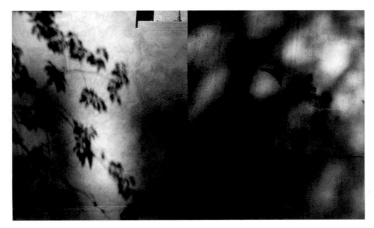
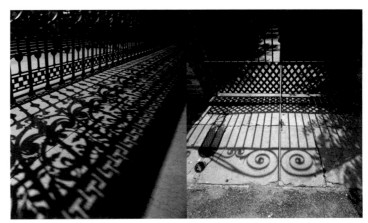

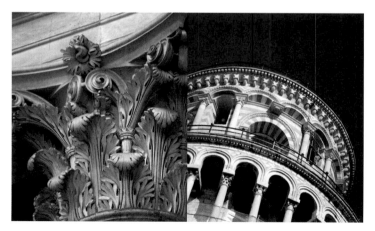

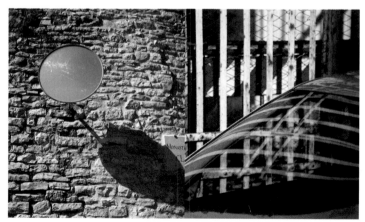

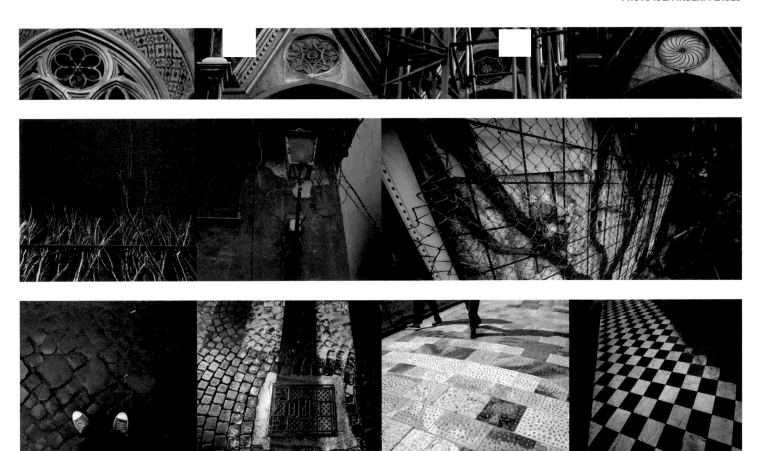

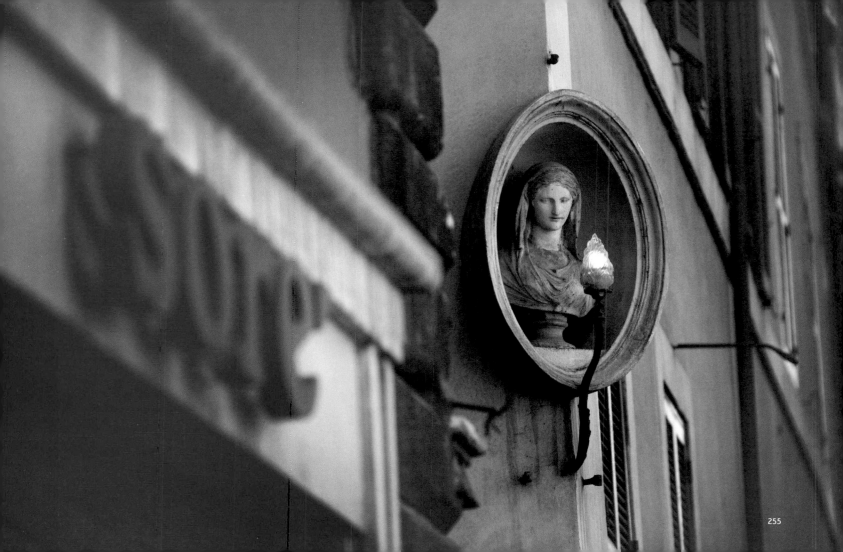

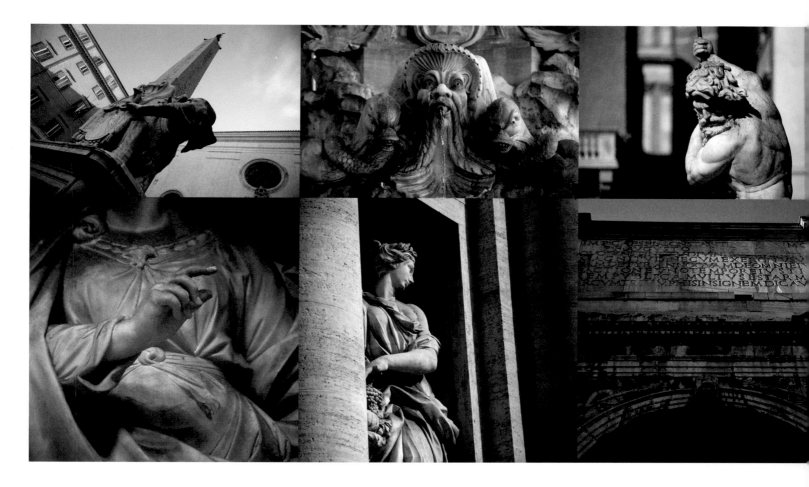

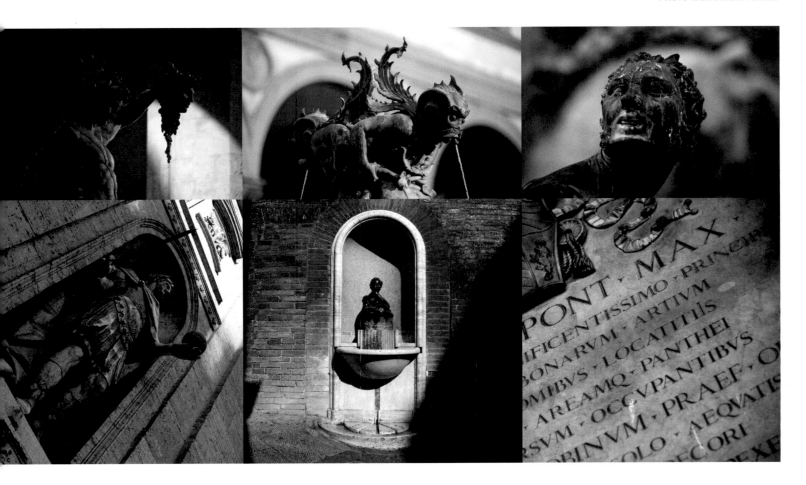

When you travel somewhere—near or far—take a look around and note the details that help make up your impressions of that place. These might be details that relate to things you did or people you met; details that convey ironic or humorous anecdotes about the place you're in; details that are unique to wherever it is you're at; or details that you are simply attracted to for their aesthetic qualities. How about photographing some of these details as a way of remembering and sharing your impressions of a place and time?

244 245

Light, shadow, form and texture are all here—all that's needed for an aesthetically complete composition. Coming from a background in design and illustration, and having a strong interest visual arts, I'm naturally drawn to ready-made compositions such as this. What types visual expression appeal to you? Realism? Abstraction? Minimalism? How can you capture the qualities of these forms of visual expression using the camera?

Globes from around the globe. Certain kinds of objects make good candidates as the basis for an image collection simply because they are so easily found the world over. This spread and the next both feature collections of this kind of nearly ubiquitous subject matter.

246 247

This page, top: The rich dimensionality of a pair of outdoor light fixtures contrasts nicely against the utterly flat expanse of blue sky behind them. The lower image is also characterized by contrast—the smooth surface of a plastic ball against the rough textures of sand and rock. There is also a minor air of mystery in the lower scene. What's the ball doing here? Where's its owner? Did it wash ashore or get left behind by a child? I never found out—this is how I found the ball and how I left it.

Art underfoot. Grates and utility covers are the focus of this collection. Interested in beginning a detail-driven photographic collection of your own? What would be in it? What's a category of things you're drawn toward? Some ideas: clocks; garbage cans; found notes; staircases; letters of the alphabet; things that light up; fountains; curious signs; graffiti; orphaned hub caps; ornate doors; funky windows; strange mailboxes.

248 249

In our daily lives, details like these utility covers rarely register in our conscious mind. For most of us, it's only when we have a reason (such as a goal of collecting a particular kind of photo) that we start noticing certain things that have long since lost their ability to attract our attention. Its one of photography's greatest attributes—that it wakes and exercises our eyes.

Themes connect the two photos in each of the pairs of images on this spread. Sometimes the connection has to do with the images' content; sometimes the link is conceptually oriented; and sometimes the images are related through compositional similarities.

250 251

How about combing through your stash of archived images in search of pairs of images that mutually agree on a theme? What about coming up with a couple dozen of these pairs and putting them on display in your home, in a gallery or on a website?

Inlay, painting, terra-cotta, bas relief, wrought iron and sculpture. It's hard to take a bad photo when aiming the camera at such fine examples of ornament and decor.

252 253

This chapter focuses primarily on handcrafted examples of detail. Detail, of course, exists in other forms as well. The center strip of images on this page gives a nod toward naturally-occurring examples of detail. This set features examples of plants growing (and dying) in conjunction with man-made fences, fixtures and facades.

Another endless source of detail-oriented subject matter: lights and light sources. On this page, a kitschy string of lights hangs from the ceiling of a tropical-themed bar. The aperture of the 50mm lens used for this photo was wide open when the shot was taken—thus the shallow depth-of-focus.

254 255

On this page, an electric candle illuminates a reverent figure overlooking an Italian piazza. For effect, all but the area directly around the light and its sculptural background were desaturated. This treatment was accomplished in Photoshop by adding two HUE/SATURATION adjustment layers to the image. One of these layers was used to amplify color; the other was used to desaturate color. Masks were applied to each adjustment layer to control which parts of the image they affected.

There's no shortage of historically significant eye candy in Italy. The images on this spread were taken while walking the streets, alleys and piazzas of Rome and Florence.

256 257

Time of day and weather conditions can make or break a shot when it comes to photographing sculpture and sculptural details. If you come across a great work when the available lighting is less than ideal, make a mental note to check back at another time to see if the shooting conditions have improved.

Intricate stone inlay from the wall of a centuries-old church in Lucca, Italy. If you enjoy creating designs for personal or professional works of art, seek and save images like this for ideas and inspiration.

19

Minimal 'Scapes

This chapter (as well as the next two) are meant to provide inspiration and examples centered around the idea that *less can mean more*. Enough said. Take a look...

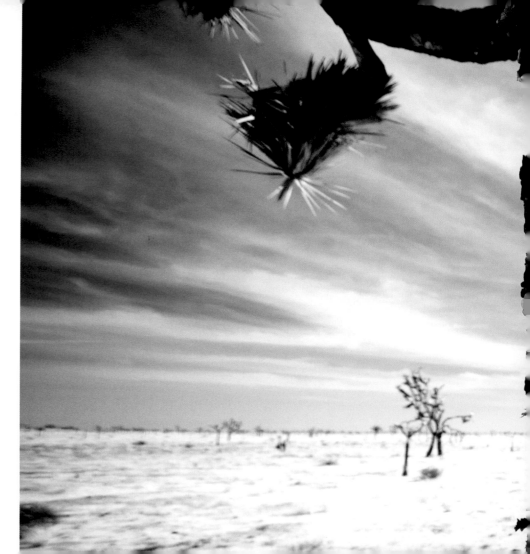

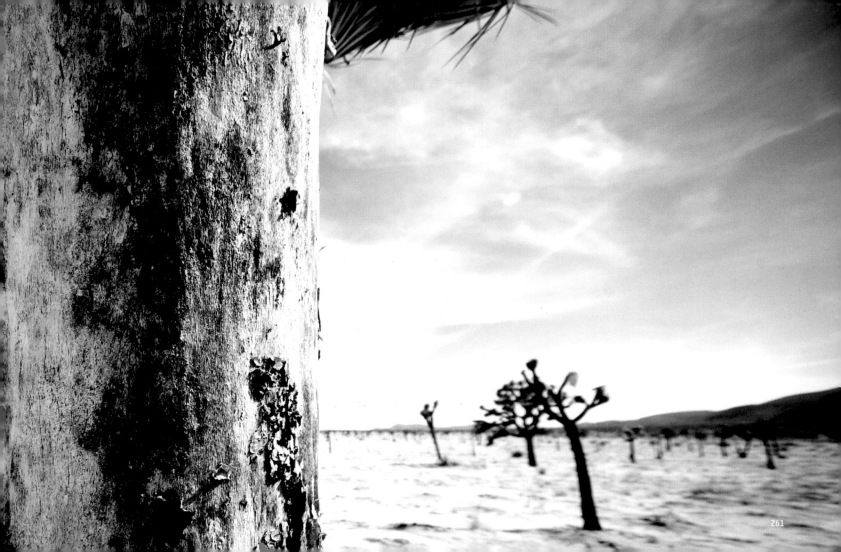

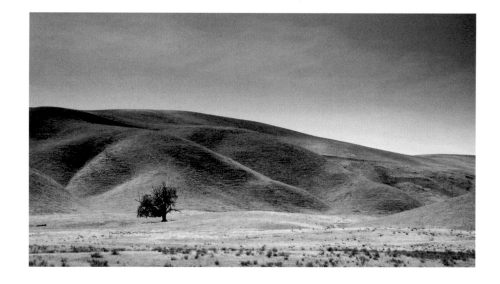

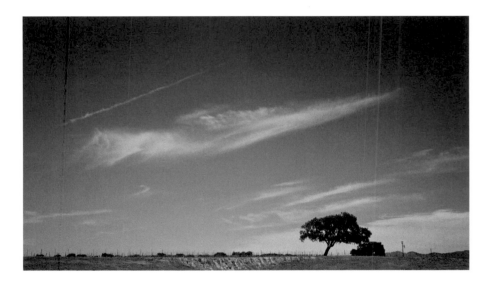

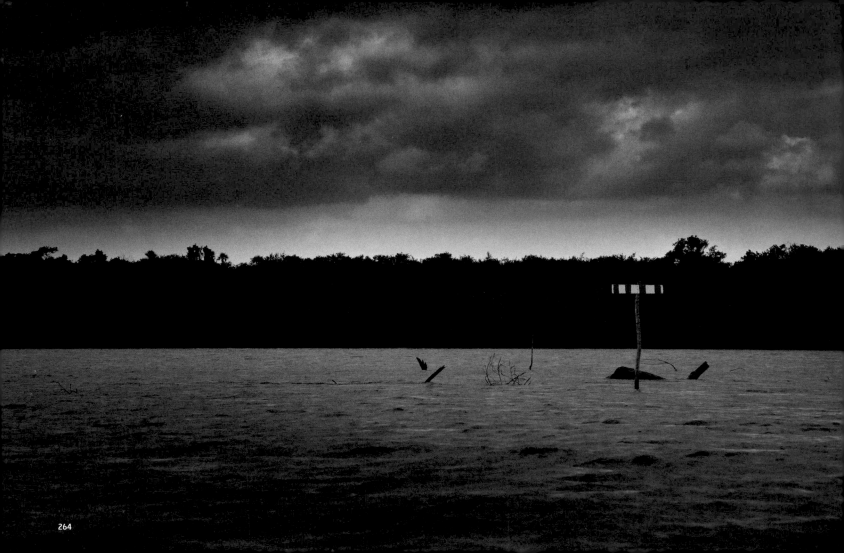

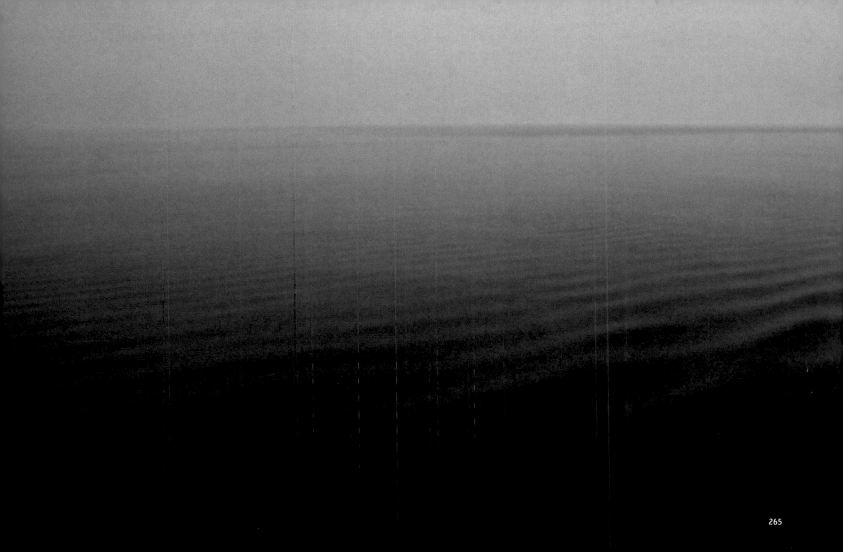

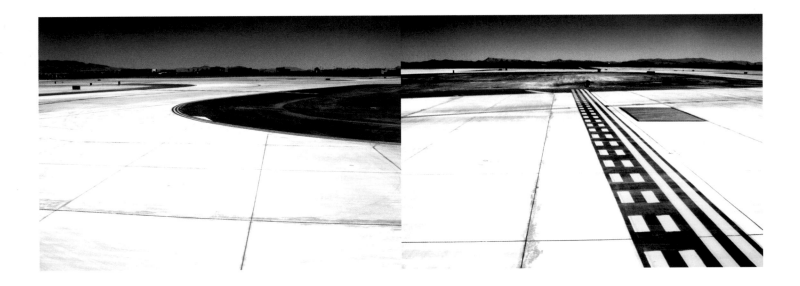

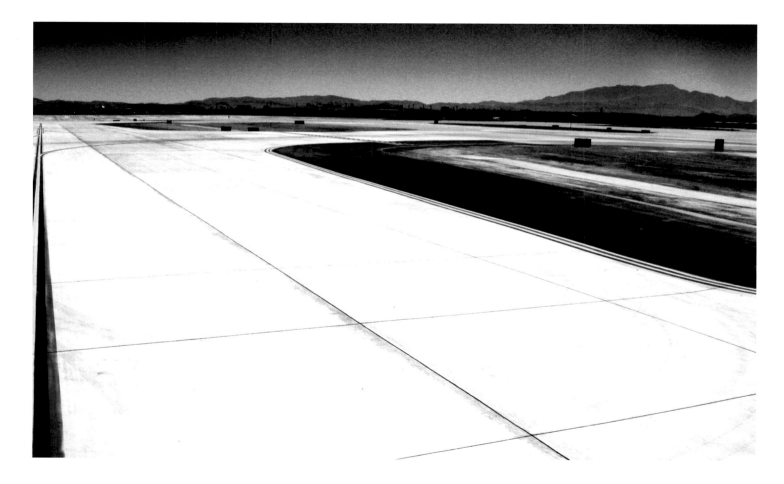

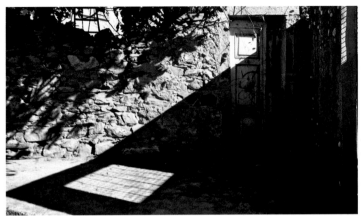

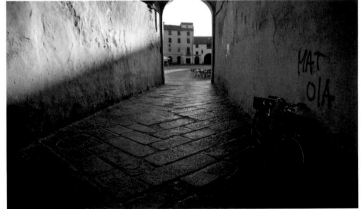

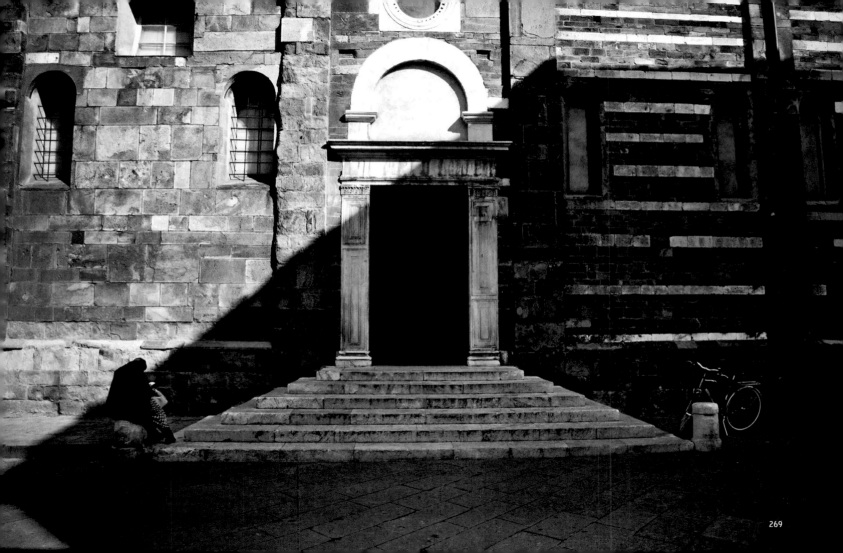

The bare and imposing trunk of a Joshua tree blocks much of what little there is to see in this mostly vacant landscape. This photo was shot from very near the tree in the foreground using a 12mm-24mm wide-angle zoom lens.

260

261

This image's colors were deepened and selectively desaturated by adding a CHANNEL MIXER adjustment layer. The "monochrome" option was selected within the layer's control panel and the red channel was set to 100%. The green and blue channels were set to zero. "Overlay" was then selected from the adjustment layer's pull-down menu. Experiment with other settings when you try this effect—try out different values in CHANNEL MIXER's controls and different choices in the adjustment layer's pull-down menu.

The inclusion of a solitary element in a scene (a tree, person, large stone, etc.) can convey a stronger impression of emptiness than emptiness itself. This image was snapped from the passenger seat of a moving car. When traveling through expansive landscapes—even at freeway speed—scenes pass slowly enough to be considered, framed in the viewfinder and recorded clearly.

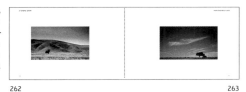

262

263

Take note of the presentation of these shots on this spread: Two minimalist landscape images surrounded by large amounts of empty white paper. Consider your presentation options no matter what kind of photo you wish to display. Would it be best—thematically and aesthetically—to give the image a large margin or a small one? Should you border the image with white, black, gray or a color? A pattern or texture?

In the land of the blind, the one-eyed man is king. Or, to put it in the language of photography, *in a monochromatic landscape, a splash of color rules the composition.*

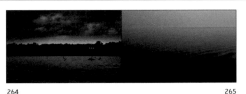

264

265

A fog-brimmed waterscape of ripples and waves makes for a quiet composition of rhythmic curves, subtly contrasting values and muted monochrome hues. The sea is a 'scape of many temperaments. Its features can be calm and subtle one day; furious and complex on another. If you live near the sea (or any large body or water), consider using your camera to record a range of its moods and mannerisms.

Yet another reason to ask for a window seat on your next flight: so you can capture compositions of lines and curves with your camera before the plane leaves the ground (as well as after it's airborne—see pages 330-331 for examples). If you are attracted to graphic, semi-abstract compositions such as these, runways, empty parking lots and vacant playing fields could be prime shooting grounds.

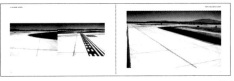

266

267

The contrast in these images has been amplified using a CURVES adjustment layer in Photoshop. The images' vaguely unnatural color scheme was engineered by adding a PHOTO FILTER adjustment layer set to "underwater."

Without distracting elements like smiling faces, beautiful works of art or shiny automobiles, shadows are left to themselves to play a decisive role in establishing visual interest within these underpopulated scenes. The impact of the shadows on the photos' compositions has been boosted by applying CURVES adjustments that heighten the difference between the images' dark and light values.

268

269

In this image, an elderly woman quietly waits for the door of an ages-old chapel to open while a dramatic shadow leads the eye strongly to her form. There's even a serendipitously-parked bicycle opposite the woman—something to add interest to an otherwise unremarkable area of the image. This is the kind of photo opportunity that makes me secretly jump for joy—I couldn't have art-directed this happenstance scene any better if I'd tried.

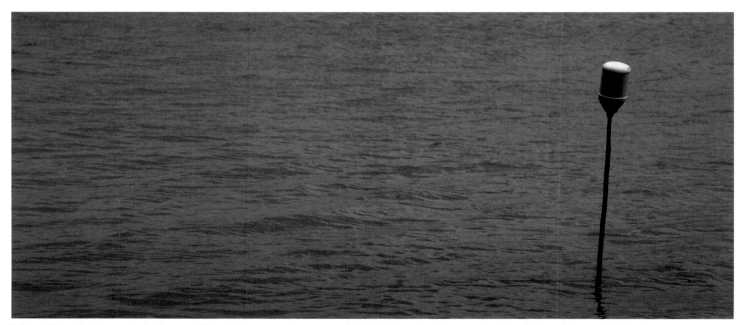

A discarded bleach bottle or a stick rises from a muddy bay. A photo opportunity or a waste of pixels? It all depends on the eye—and artistic ambitions—of the person holding the camera.

20

Out of Season, Off Hours

If there's a reoccurring theme in this book, it's probably along the lines of, "Why take the same kinds of pictures of the same kinds of things as everyone else?"

In compliance with this theme of noncompliance, this chapter offers the suggestion of taking your camera to places after the crowds have gone, after the big event is finished, after the windows been closed and the after the doors have been locked. Including images such as these in your travel photo album (along with the usual shots of glorious landscapes, works of architecture and action scenes) can help viewers appreciate more fully the depth of your experiences in the places you've been.

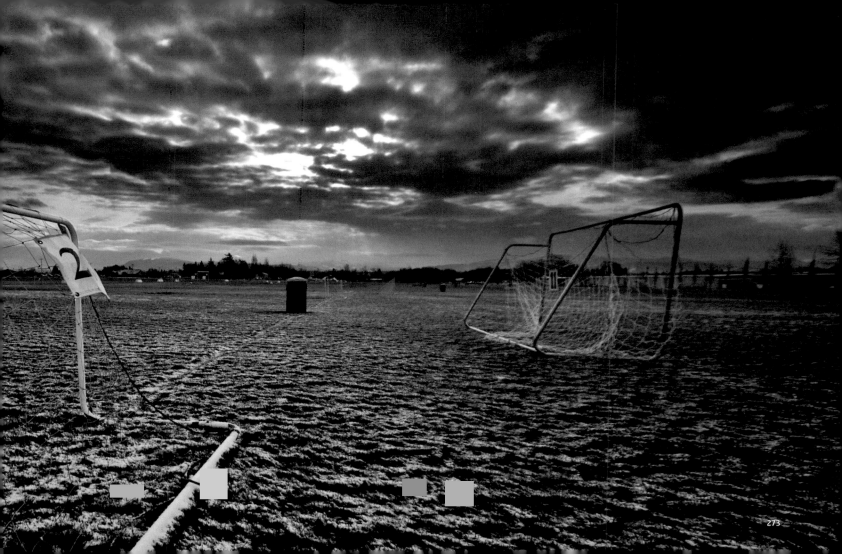

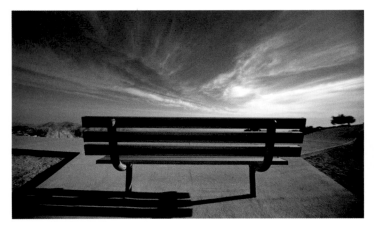

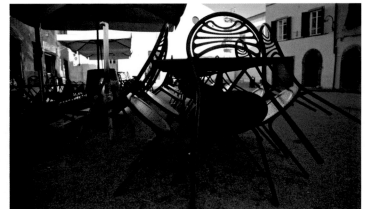

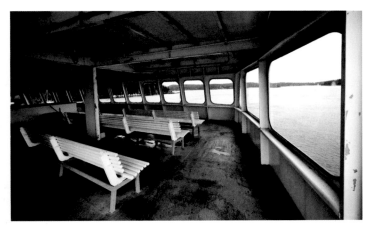

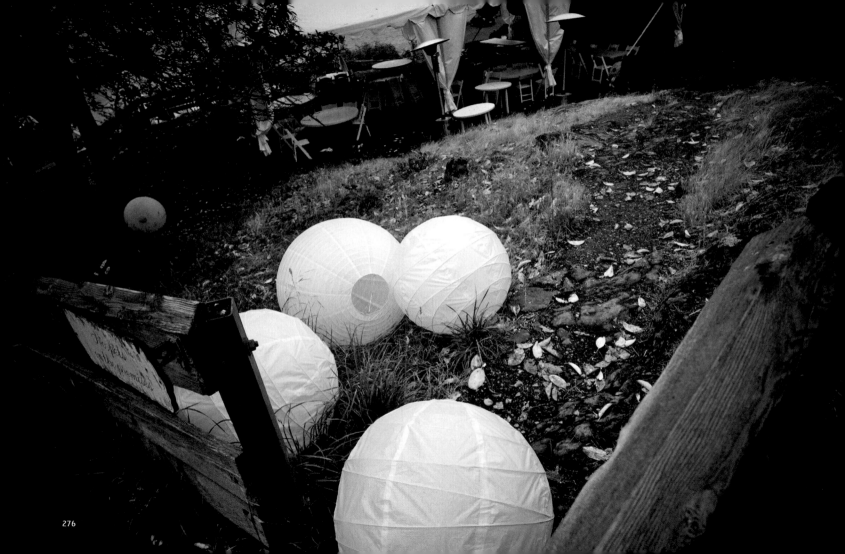

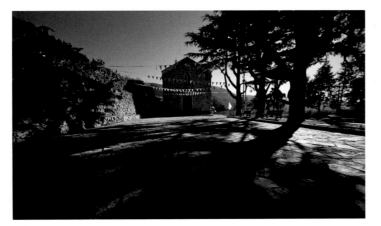
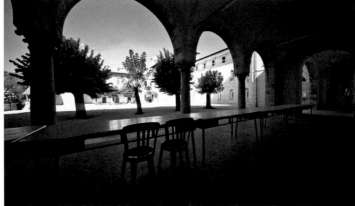

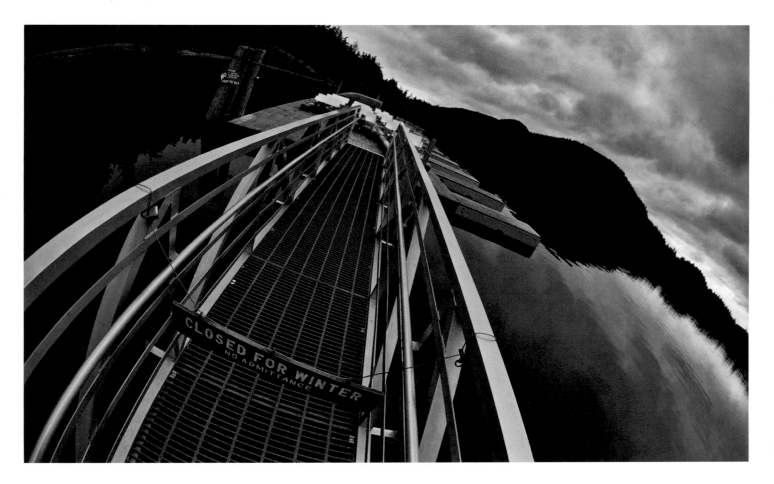

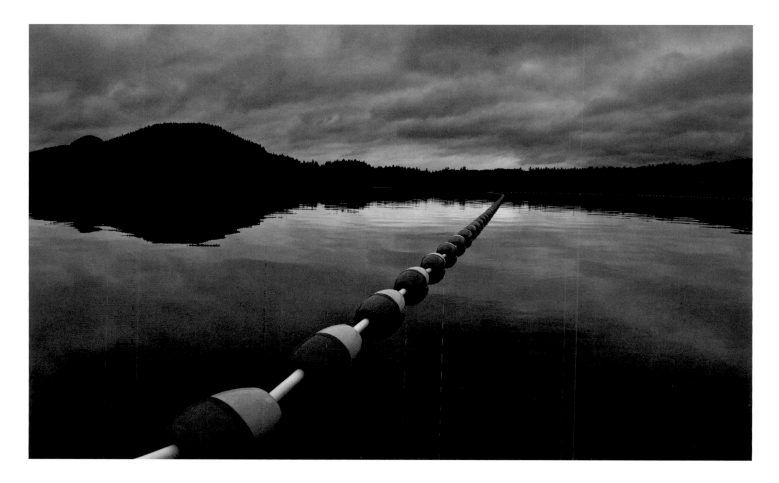

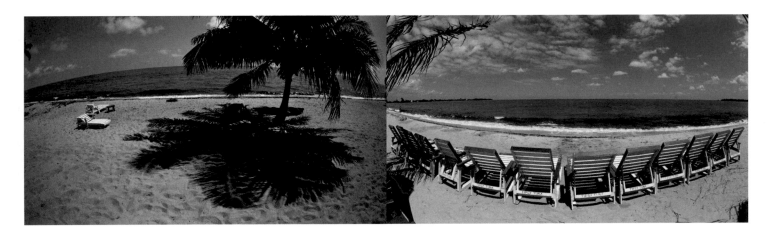

If you're looking for ways of making your photos appear different from other people's, here's a good place to begin: with images of your favorite places taken *before* the crowds arrive and *after* they are gone. Shooting during these times has an uncanny way of elevating the ordinary to the artistic; the plain to the poignant.

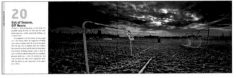

272 273

My assignment on this day was to photograph a young soccer player during a league game. I arrived half an hour early (wanting to spend time preparing for the photoshoot) and found that the fields still had ice on them from the previous night's frigid weather. The starkness of the scene appealed strongly to me and, instead of prepping for the upcoming photoshoot, I decided to take photos of the empty ice-crusted fields instead. Photo opportunities are often fleeting: Sometimes responsibilities just have to wait.

Empty seats radiating conveyances of expectation, abandonment, emptiness and waiting—good themes for photos being shot with fine art or commercial viability in mind. *Theme* can make an ordinary photo into a marketable piece of art.

274 275

Scenes from meals, pre and post. How about using your take-along pocket camera to record the pre-meal settings and the post-meal debris the next time you visit your favorite bar, cafe, coffee shop or restaurant? How about doing the same thing before and after a home dinner party or company banquet? Subject matter such as this is familiar to us all, and is bound to connect with viewers on some level.

The morning after: Wedding photography of a different sort. Having been tossed by overnight winds, lanterns that lit a festive canopy the evening before now rustle quietly against a wooden gate. The four images on the opposite page were taken beneath the canopy seen in the background of this page's photo. The reflective mood of the scenes has been amplified by converting the images to black and white by selecting a channel from each image's CHANNELS palette (a method described in more detail on page 18).

276 277

About an hour was spent combing through these environs—the joint aftermath of a wedding and a windstorm—for images of interest. I chanced upon this scene not knowing how long it would last before a clean-up crew (or possibly a security-minded employee) would usher me away. This being the case, I attached a versatile and scene-enveloping 12mm-24mm wide-angle lens to my SLR and got busy hunting for potentially interesting and poignant subject matter.

This page, left: A courtyard, prepped with hanging flags, conveys hints of activity yet to come. I was lucky enough to come across this plaza at a time when the blue flags—beautifully lit by the rising sun—stood out wonderfully against the dark backdrop of the church and its courtyard. Right: Empty tables and chairs rest in the shade alongside a church's sun-filled courtyard in Assisi, Italy.

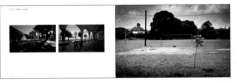

278 279

An empty soccer field sits behind a vacant basketball court in coastal Belize. The image's colors where muted by adding a CHANNEL MIXER adjustment layer in Photoshop. The adjustment layer's red channel was selected along with the "monochrome" option. The layer's effects were applied to the original image with the "screen" option selected from its pull-down menu.

If you're lucky enough to come across a sign that explains what's going on in your scene (or not going on, as the case may be), try out perspectives that include the sign's message in your shot. The gracefully arcing lines in this tilted view come courtesy of a 15mm fisheye lens (more about this lens in the caption below).

280 281

A string of colorful buoys sweeps dramatically through a deeply hued fall scene in northwest Washington state. The dramatic perspective of the buoys was achieved by shooting from just above water level. Photoshop's CURVES controls were used to bring out detail in the clouds and to strengthen the image's overall levels of contrast.

Notice the shore and horizon lines in the pair of images at the top of this page. The first image has a nearly flat horizon and a shoreline that bulges upward; the other features a level horizon and a shore that curves downward. Both shots were taken with a 15mm fisheye lens. The differences in each image's horizon and shorelines has to do with whether the ultra-wide-angle lens was being aimed slightly up or slightly down when shooting.

282 283

The line of kayaks in this page's top photo point like a quiver of arrows toward the sea and islands beyond. The visual convergence of the kayak's hulls in the scene and the dramatic expanse of earth and sea included in the shot are brought about by the generous perspective-gathering capabilities of a 12mm-24mm wide-angle zoom lens. The lower image, shot with a standard lens, delivers its content and directional inferences in a more straightforward manner.

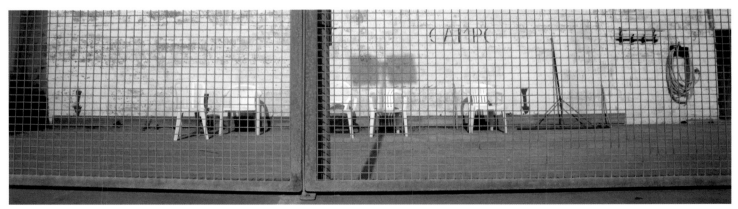

A row of vacant chairs bake in the afternoon sun behind the locked gates of a beachside game court. A warming PHOTO FILTER effect was added in Photoshop to bolster the scene's conveyances of heat.

Interiorscapes

Most of the photographs in this book were taken outdoors and many are of relatively large-scale scenes. This chapter is inserted as a reminder to consider indoor scenes when recording your impressions of a space or place.

Thematically, the majority of the photographs in this chapter are linked through thematic conveyances of stillness and solitude. How about coming up with an appealing visual theme of your own and using it as a basis for your collection of interiorscapes? Train your eye to notice scenes that echo this theme and start collecting! And keep a camera within reach as often as possible—you never know when a photo opportunity will present itself.

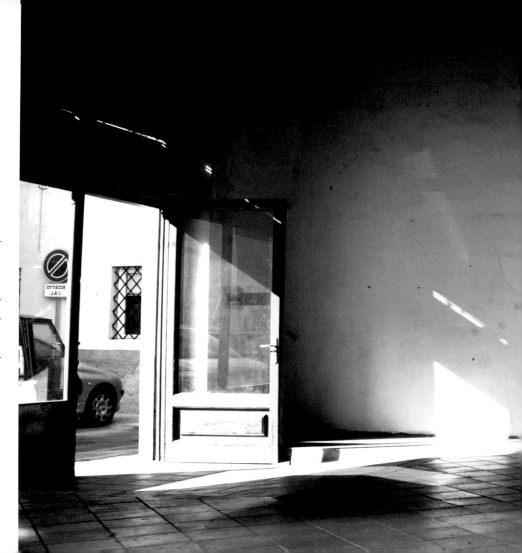

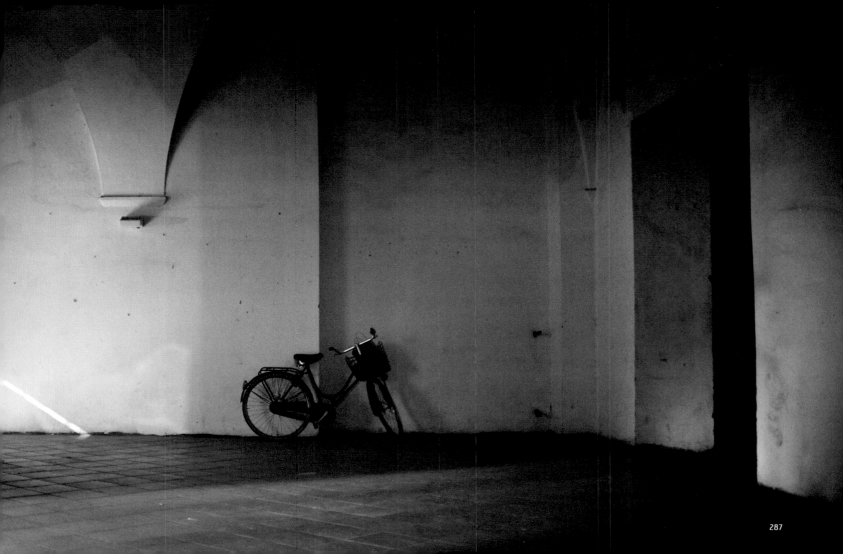

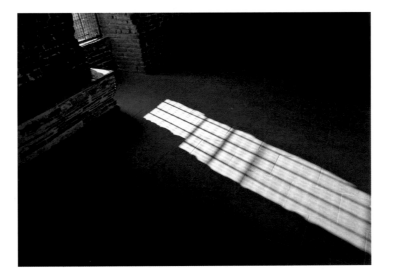

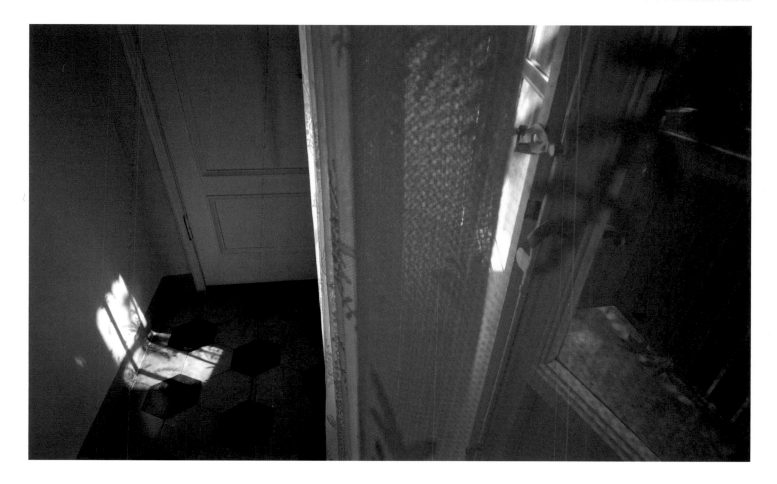

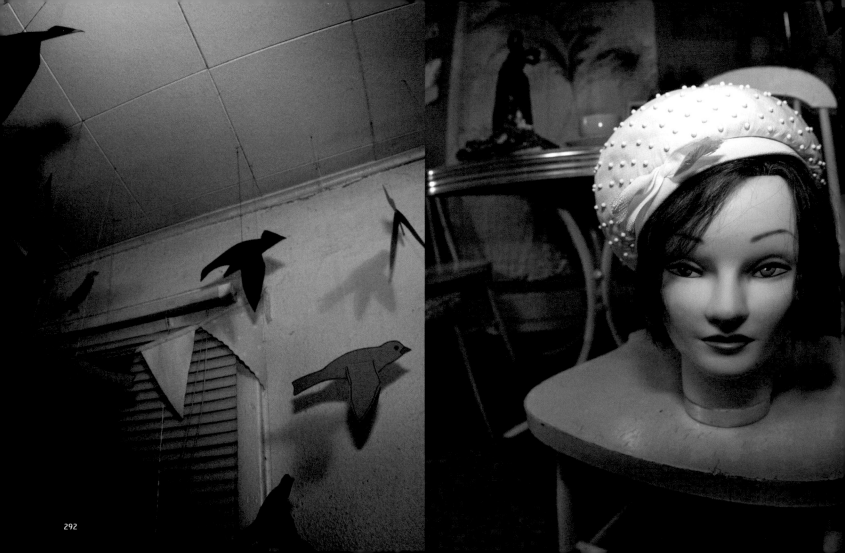

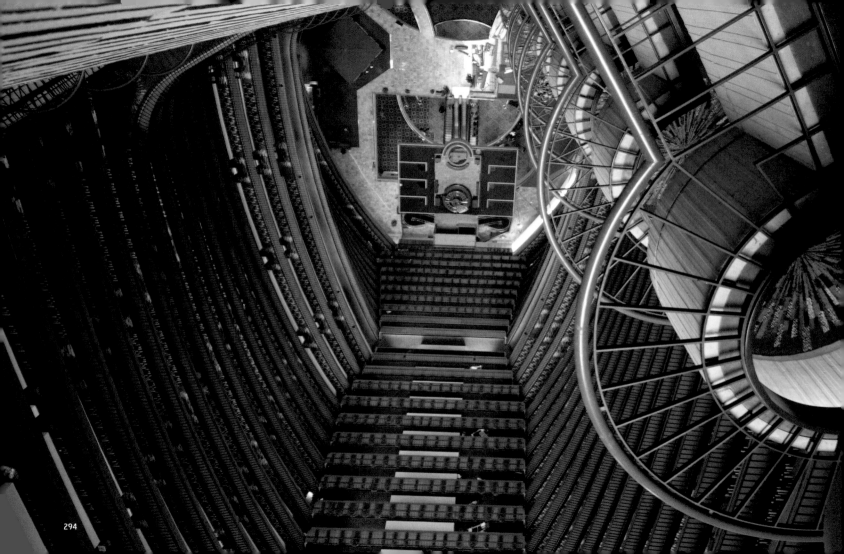

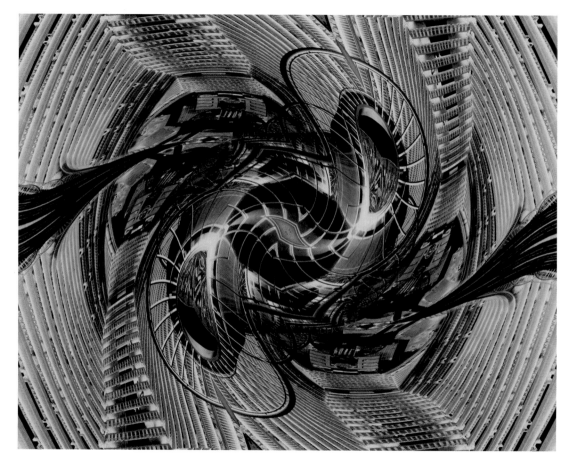

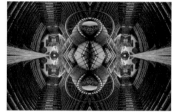

An open door, a patch of sunlight and a parked bicycle infuse this quiet foyer with hints of the world outside.

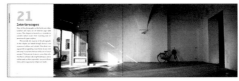

286 287

A wide-angle lens is helpful when shooting in a space that does not allow enough pull-back distance for a standard lens to record a full view. This photo was taken with a 12mm-24mm wide-angle zoom lens. A wide-angle lens may cause the vertical lines in a shot like this to slant inward or outward. When this occurs, consider using Photoshop's DISTORT > LENS CORRECTION filter to make these lines vertical.

Sunlight from a grated opening warms the tile floor of a landing of the historic Guinigi Tower in Lucca, Italy (a glimpse of this tree-topped tower can be seen on page 34). Photoshop's SHADOW/HIGHLIGHT controls were used to rescue a small amount of detail from the shot's dark areas—areas that needed to be underexposed in order to save the brighter portions of the image from losing detail to overexposure.

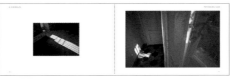

288 289

You can almost hear the sounds of silence emanating from this curtained hallway. As I was leaving my rented room in Lucca, on my way to take photos of the city's stone walls, I walked right past this beautiful still life of light and shadow. It wasn't until I was out the front door that it dawned on me I had ignored an unscheduled photo opportunity and needed to go back and take a shot. Do you ever suffer from this kind of mission fixation—the overlooking of certain lovely scenes while obsessing about others?

Unusual perspectives can freshen a viewer's perception of their day-to-day environment. How about taking some portraits of your living room from a mouse's-eye view? What about capturing a similar view of the interiorscape beneath your bed (dustbunnies and all)? What if you were to document your entire house in this way and combine the images into an album or display?

290 291

A thin ribbon of sunlight follows the winding contour of a sheer curtain—the kind of effect that only happens when serendipitous conditions align.

Next time you visit a friend's place, how about bringing your camera and taking some portraits of their home or apartment? Instead of aiming for generically descriptive shots of the space itself, look for details within that space that illustrate aspects of this person's lifestyle, personality and passions (and sometimes, if you're lucky, you'll find a subject that rolls all these attributes into one).

292 293

This page includes images of places I stayed while taking photos for this book. I'm glad I took these pictures and wish I'd taken more like them during my five weeks of out-of-country travel. Photos like these seem to connect deeply with memories of time, place and state of mind. A suggestion (to the reader and myself): Take spontaneous photos of the places you stay while away from home—save them as part of your larger image cache of landmarks, landscapes and friends.

This interior, shot from an upper floor of a modern hotel, conveys a colorful and dizzying impression—a very different effect from those imparted by the more subdued interiorscapes presented on the previous pages.

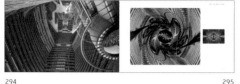

294 295

Here, the shot featured on the opposite page has been given special treatment in Photoshop. First, the image was repeated and reflected to form a kaleidoscopic effect (small image, far right). This compiled image was then skewed using the TWIST filter and recolored by applying the INVERT command. What about applying effects such as these to a series of your own images? Other variations of image-reflecting treatments can be seen on pages 156 and 225.

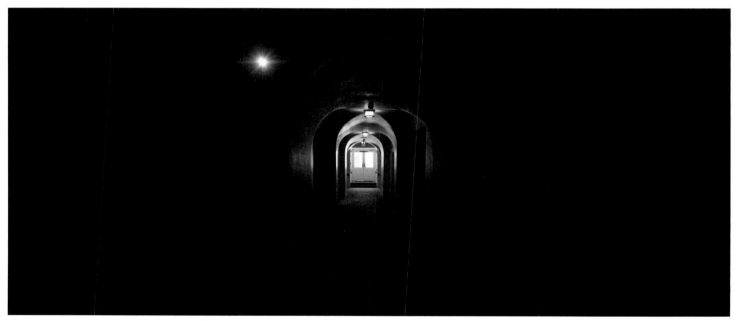

The generous amount of black in this image emphasizes the presence of light at the end of a dark corridor beneath a statehouse in Charleston, South Carolina.

22

Windows and Portals

When taking pictures of a home or building, pay special attention to its windows. (You can be almost sure the structure's architectural designer did the same.)

Windows and portals have a number of enticing photogenic qualities. From a design standpoint, windows and portals are often embellished with an extra measure of decor and ornamentation. And glass, as a photographic subject, has the distinction of being a material that both transmits and reflects light. Yet another perk of taking pictures of—and especially through—windows and portals is the self-describing compositional quality known as "framing" that these openings lend to whatever is being viewed through them.

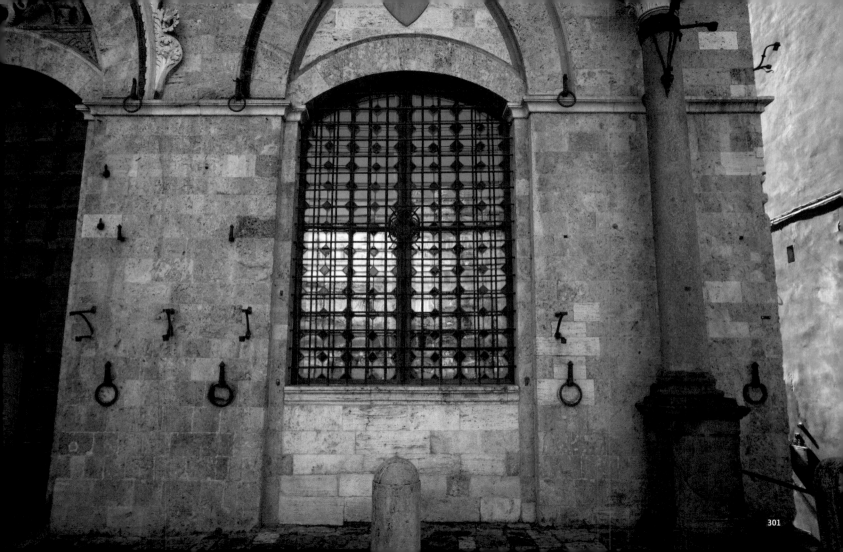

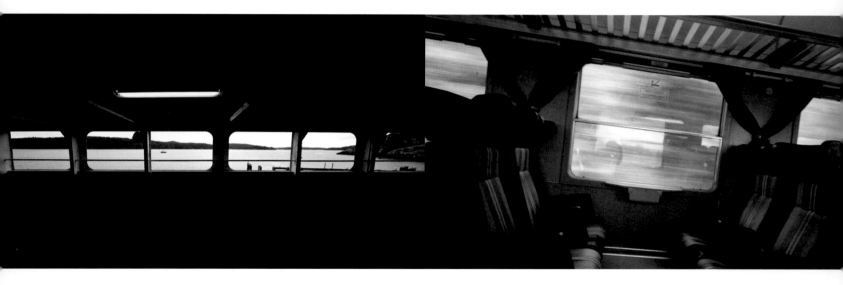

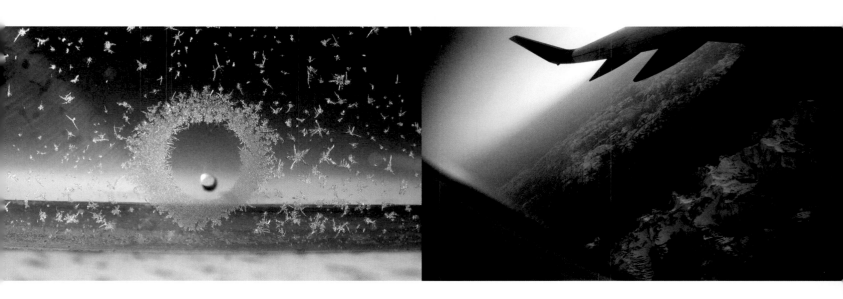

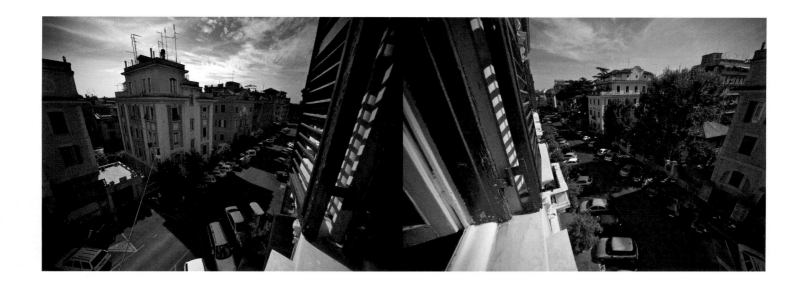

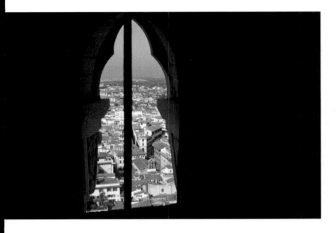

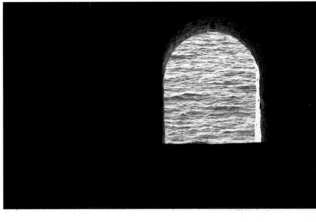

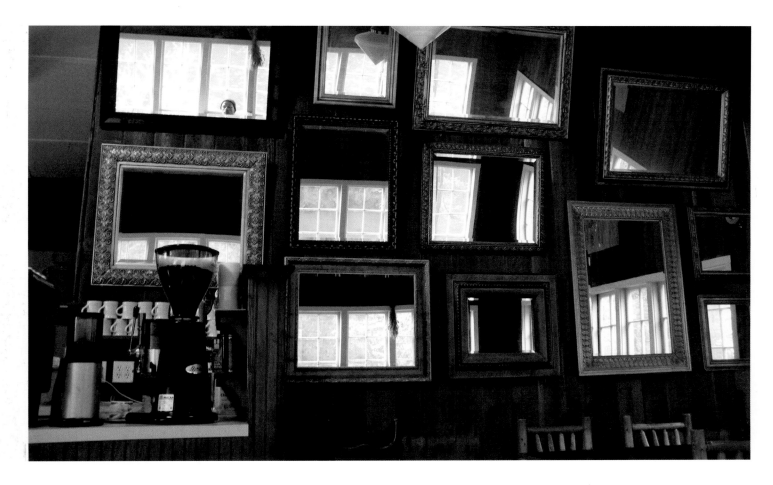

A round, paned window peeks out amidst lavish decor on the face of Florence's Duomo. If you find yourself shooting during a time of day when the light is relatively flat, look for points of view that generate visual interest through content and composition. Also, consider enhancing the available light's effects (however subtle they may be) using post-shooting adjustments such as those available through Photoshop's CURVES, HUE/SATURATION and SHADOW/HIGHLIGHT controls.

298 299

When photographing a structure as richly adorned as this, consider focusing your attention on one aspect of its decor at a time. For instance, take one journey around the building photographing windows. Then, how about taking a lap while concentrating on sculptural elements and roof-line treatments? And then there are the inlaid designs to consider... and the doorways... and the architectural nuances...

Windows in cool shade reflecting the warm colors of sunlit structures and sky. Painters have long sought to portray the pleasant association between the warm and cool hues produced by sunlight and shadow. How about striving to do the same with your camera?

300 301

Most times, a "properly" rendered image is considered one that features a full range of values. The image on the far page is comprised of only darker values and is thus defined as a *low-key* image (if its values were all light, it would be labeled *high-key*). Given the pleasing look of the deeply saturated hues in the image, its values were left as shot rather than being digitally expanded to include lighter tones. Consider going with a rule-breaking low-key (or high-key) effect if an image's presentation would benefit.

This spread: The view from a boat, train and a couple of planes. Wherever you go—and as long as there's a window to look from while going there—how about snapping some photos along the way?

302 303

Airplane windows are usually speckled with tiny flaws. When aiming your camera toward the window of an airplane, you can either focus on the window itself—and welcome its pits, scuffs and scratches as part of your image (this page, left)—or you can allow the camera's focus to bypass these near-the-lens flaws while sharply recording a scene in the distance (right).

Throw open the shutters and let some light in—and your camera out. How about extending yourself from the window of your home or hotel and taking some shots of the streetscapes below?

304 305

What about using a window or portal as a ready-made frame for a photo of whatever's outside?

A wall of mirrors reflects a wall of windows in the cafe at Doe Bay Resort in Washington state. (Look closely and you might find a certain author peeking into one of the mirrors in this scene.)

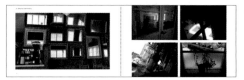

306 307

A sense of quiet intimacy is often projected through images taken from near a window—a sense of being on the outside looking in—or on the inside looking out. Are there commercial or personal uses you can think of for images that project thematic impressions such as this?

New technology meets old-school improvisation. These are pinhole photos—taken with a digital SLR. To capture these images, a tiny pinhole was poked into the camera's dust cover (the plastic piece that attaches to the camera's body when no "real" lens is in place). This hole focuses light in such a way that an image is created against the camera's image sensor. The methods of creating a pinhole fixture for digital cameras are many—as are pinhole shooting techniques. Search the web for tips, tricks, ideas and examples galore.

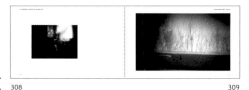

308 309

If there's one thing I don't necessarily love about digital cameras, it's that they work too well. Sometimes I simply want a shot that looks a bit tattered, worn or out-of-sorts. This is when something like a pinhole approach appeals. Another lo-fi technique I enjoy involves aiming a pocket digi-cam through the plastic viewfinder of an older camera (see pages 126-129).

A orange tabby lazes on a sun-warmed window ledge. (And judging from the looks of the window shade behind the cat, this isn't the first time this spot has been occupied by a heat-seeking feline.)

23

Up

Since we were old enough to move about, most of us have been encouraged to "Watch where you're going." Good advice—and certainly well intentioned—but maybe it does lead to an exaggerated favoritism of horizontal perspectives. How does this relate to photography? Well, it's great news—it means that there is a whole realm of vertical perspectives that are just waiting to yield interesting and uncommon views of everyday subjects.

Let the images in this chapter serve as reminders to lift your gaze once in a while next time you are taking pictures—indoors or out. Upward is not only a good direction to look for interesting subject matter, it can also be an outstanding angle from which to capture images of buildings, trees, signs and people.

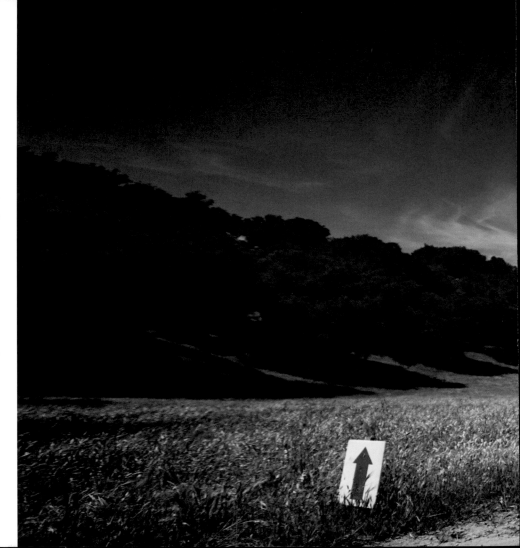

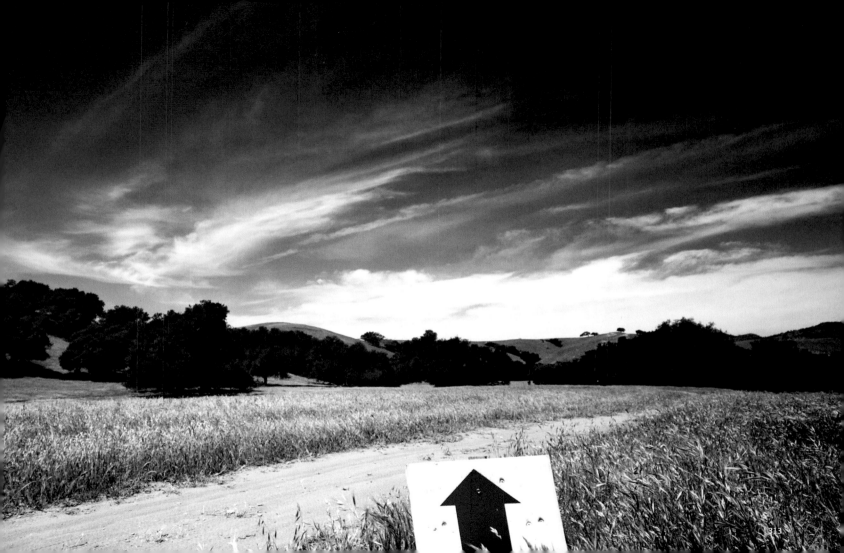

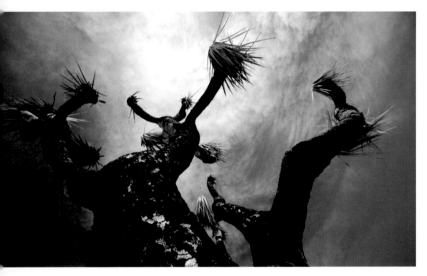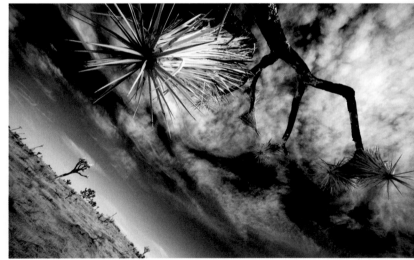

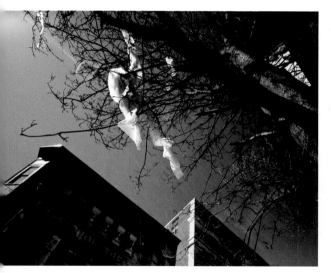

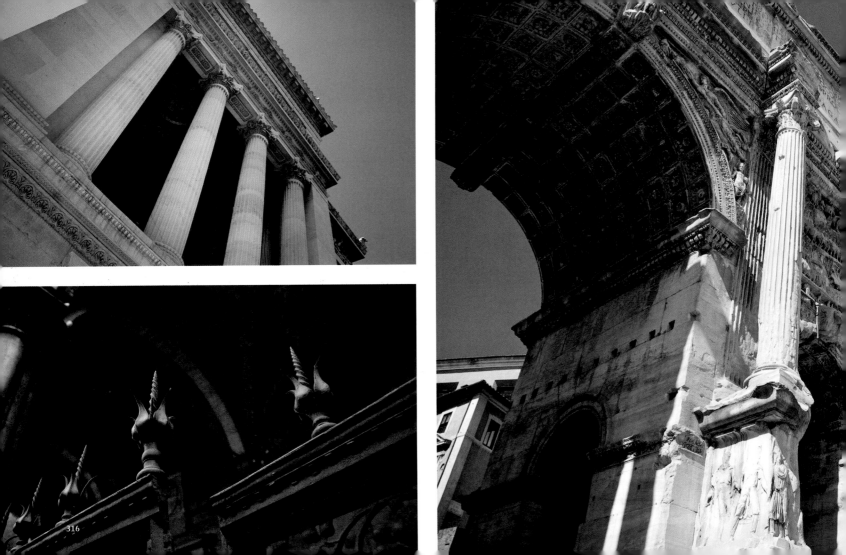

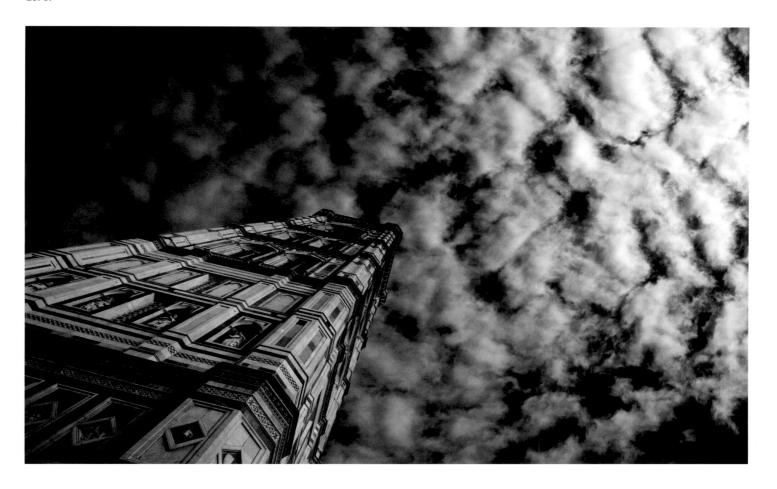

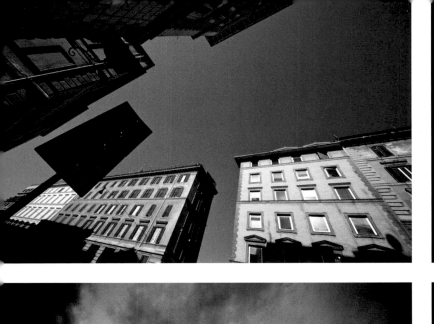

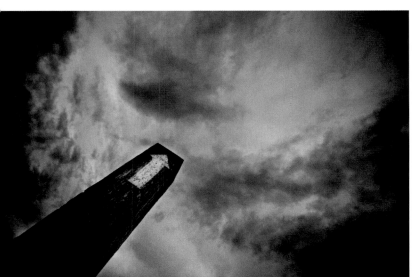
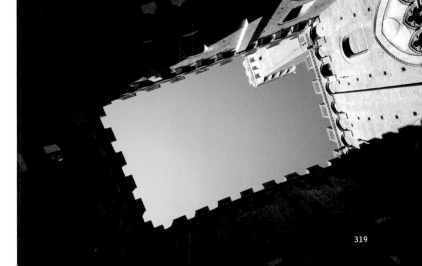

a plume
with a view

The morning began overcast and dark. Not the best omen—or so we thought—given it was moving day and these were the first clouds we'd seen since beginning to pack three weeks ago.

Carl was outside piecing together a makeshift tarp over the big, half-filled, open trailer when the phone rang. It was Fiona. She was calling to say that it was already raining heavily in Corniglia and that her behemoth truck was having trouble getting up the muddy cobbles of her drive and onto the main road. She asked if we had a backup plan.

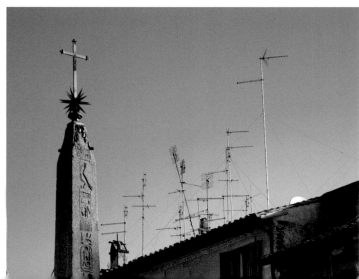

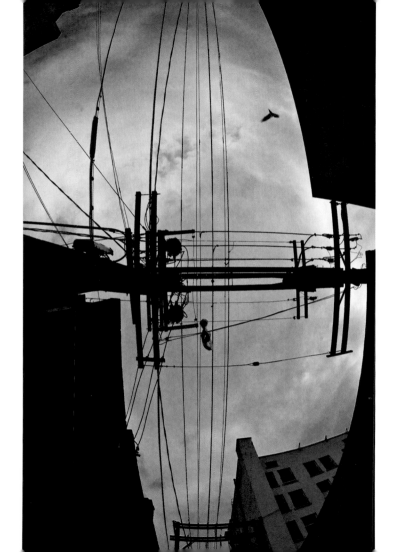

In this image, the reference to "up" comes from a couple of conveniently present graphic symbols. Images that include such visual aids make good candidates for use in commercial media where they can be paired, for instance, with a headline that points out an ironic or humorous association in the scene.

312 313

Digital effects came in handy to ensure the thematically essential arrows in this scene received ample notice in spite of their small size. Specifically, Photoshop's HUE/SATURATION controls were used to amplify the arrows' red hue while desaturating all other colors. A PHOTOFILTER adjustment layer, set to "underwater," was also added to the document with the arrows masked from its effects (thus making sure the arrows' red hue would be far and away the warmest hue in the scene).

At left, the forms of two burnt Joshua trees gesture dramatically skyward. It's unlikely that a level perspective would have conveyed as much visual interest in this scene (or in any of the scenes pictured on this spread) as these upward-facing views. The two photos at the center of this spread were converted to grayscale by selecting one of their RGB channels using a CHANNEL MIXER adjustment layer (more on this technique is mentioned on page 18).

314 315

This page, from left: windblown garbage hanging from the bare branches of an urban tree; vines cascading down from a building-side utility pole; sunlight finding its way through an arbor covered in grape leaves.

The grandeur of these historic architectural details is amplified by the perspective-generating vantage points from which they were taken. Note also how none of these shots has been taken with a horizontally level camera—tilted compositions tend to amplify stirring conveyances.

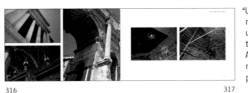

316 317

"Up" with a limit: interior views of ceilings and rooflines. I hadn't noticed the word "up" in the image of an abandoned classroom until after I'd already chosen it for this chapter. Ever the opportunist, I decided to highlight the word for its on-page presentation. And this brings up a worthwhile topical question: What kinds of non-photographic digital additions could you make to certain photos to enhance—or create from scratch—a thematic message?

The photos on pages 326-329 were taken while looking down from the top of Giotto's tower in Florence, Italy. This page features a shot taken from its base. An intriguing perspective has been captured by standing close to the tower and aiming upward with a 12mm-24mm wide-angle zoom lens. The off-center placement of the tower adds drama and interest to the scene.

318 319

Many people (myself included) can go days without making a conscious effort to enjoy—or at least consider—an upward-facing view of our surroundings. Let us all allow our cameras to remind us of alternative points of view: upward, downward, ground-level, bird's eye, up-close, far away and skewed.

Ask yourself, *How much can I leave out of the scene I'm shooting without sacrificing my subject's recognizability, context or meaning?*

320 321

Shots that include large amounts of vacant sky make versatile backdrops for a layout's typographic elements. Here, an opening page for an article has been created over the top of a photo with a generous swath of blue through its middle. If you are working as a commercial photographer, add photos such as this to your stockpile of commercially-available images.

Simple of shots of ordinary life—with an emphasis on the trappings of transport and connectivity that exist overhead. Sometimes I'll drive my car while taking photos with my non-driving hand. Naturally, I keep my eyes on the road and shoot without looking at the viewfinder. It's not until I review my shots, later on, that I find out what I've photographed and how the pictures look. The top photo on this page (as well as those on pages 116 and 118) were each shot in this way.

322 323

A bird flaps its way through an intricate composition of lines, forms, shadow and texture. This image was shot with 15mm fisheye lens—aimed directly overhead from the narrow confines of an inner-city alley.

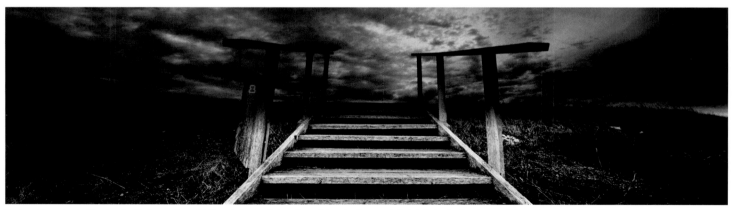

Having a theme in mind (such as "up") when you're out taking photos can help ordinary things (such as a set of stairs) stand out and present themselves as photoworthy subjects.

24

From On High

People tend to enjoy seeing images of their world from novel points of view—perspectives that are out of reach during everyday life. And since relatively few people have a pilot's license (and even fewer have wings), images taken from elevated places have a way of charming viewers by presenting ordinary places and things in extraordinary ways. Give your camera a fresh view of your home planet by taking the stairs, elevator or flying machine to an elevated vantage point and aim for images (both recognizable and abstract) that take advantage of the view from on high.

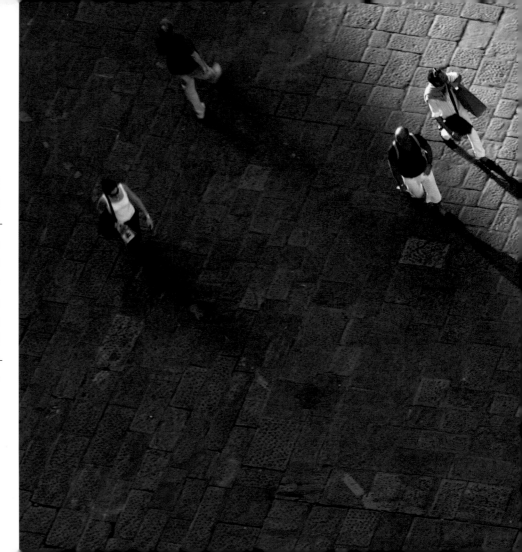

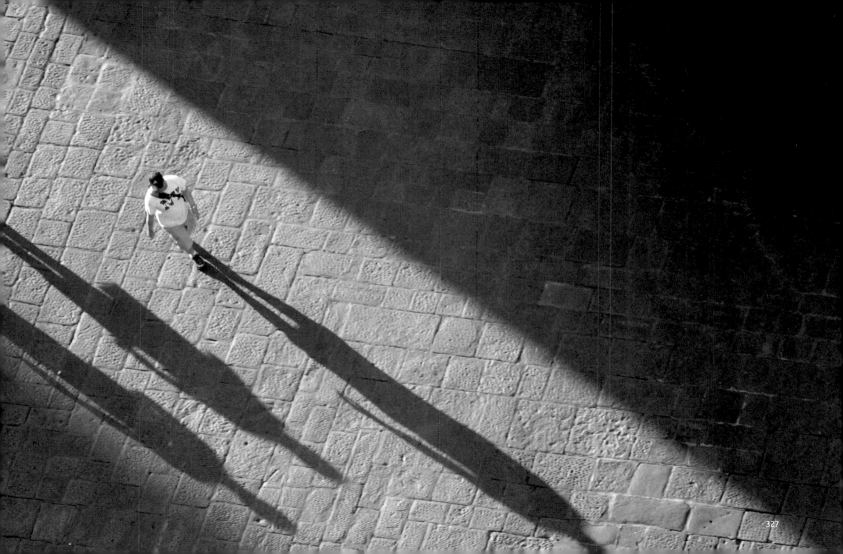

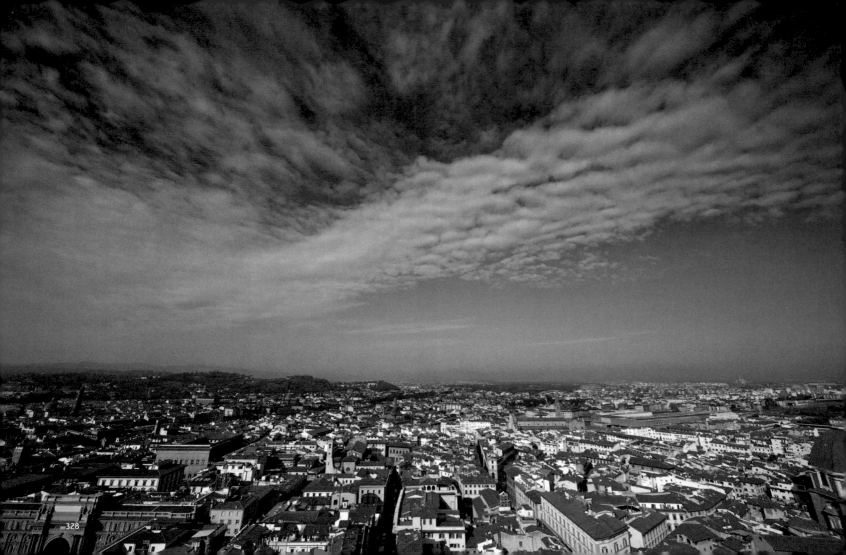

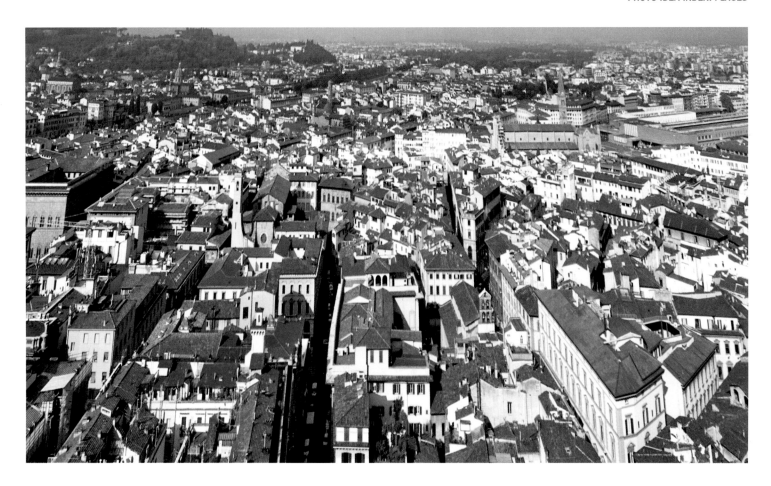

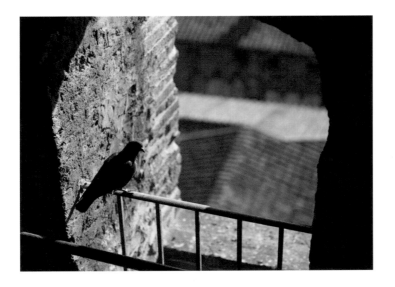

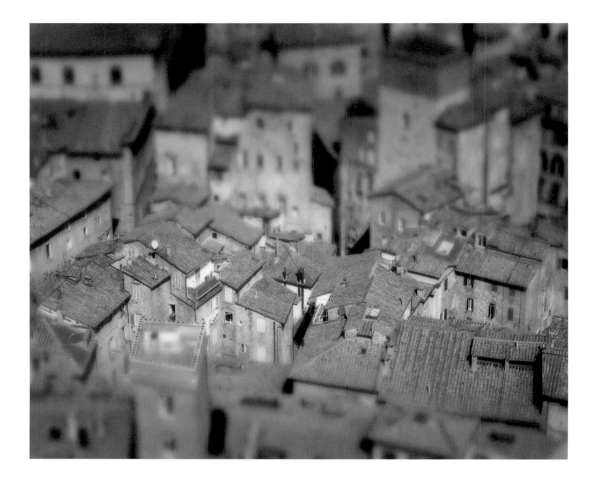

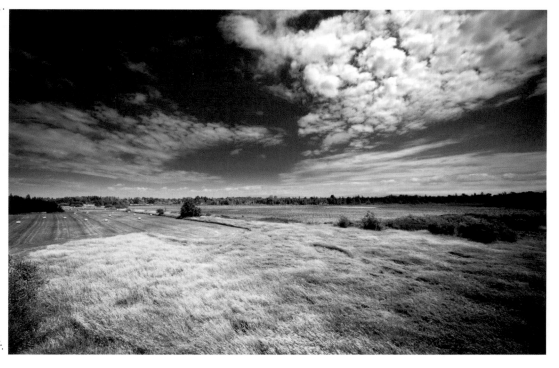

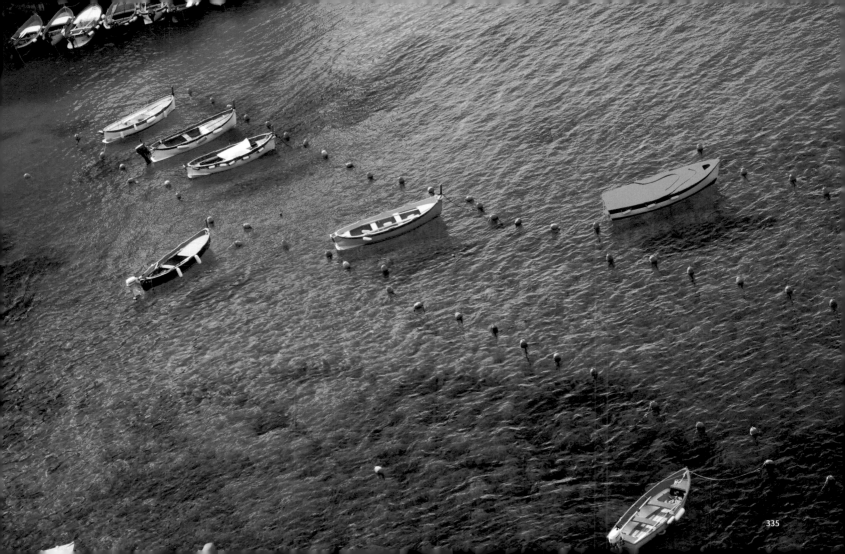

A 300mm telephoto lens was aimed from a high vantage point to capture this shot of foreshortened pedestrians and their elongated shadows. Without the extreme angle of light provided by the evening sun, this scene would have had little appeal. Photographers have long regarded the hour after sunrise and the hour before sunset as the "golden hours."

326 327

The photo on the next spread was taken from this same high vantage point (though during a different time of day) using a 12mm-24mm wide-angle zoom lens. When heading to a high viewpoint such as this, I like to bring my digital SLR along with a telephoto, wide-angle and standard lens.

The view from the top of Giotto's tower in Florence, Italy. When taking a photo from an elevated vantage point, experiment with different placements of the horizon in your composition. Should it be high, low or middle? Should earth or sky dominate the scene?

328 329

The photo on this page is the same as the photo opposite. It looks different because it's been vertically distorted, cropped and converted to black and white.

How about requesting a window seat the next time you take an airplane somewhere? Intriguing perspectives and interesting abstractions are available in abundance when you're perched a few thousand feet in the air.

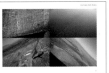

330 331

As mentioned on page 310, the plexiglass inner windows on most airplanes are often pitted with tiny bubbles and striated with stress marks. Don't let this deter you from taking photos through them—their imperfections rarely show up when the camera is focusing on subjects in the distance. Each of the photos on this spread were taken by aiming a pocket digital camera through less-than-perfectly-clear airplane windows.

The rooftops below the bird in this photo were cast out of focus by zooming a standard lens to its maximum and selecting a wide aperture setting (a low f-stop number). Notice the framing effect the portal has on the shot's composition—effective in directing attention to the bird and rooftops. It's not often I find myself looking down on a bird who's looking down from a great height. I moved very slowly and quietly while getting in position for this shot—not wanting to startle the pigeon from its perch.

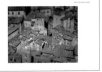

332 333

Life-size or a miniature? It's difficult to tell with shots where the foreground and background have been artificially taken out of focus in Photoshop. The same affect can be achieved directly from the camera by using a tilt-shift lens.

Hovander Park in Ferndale, Washington, has a special-built observation tower that allows visitors to enjoy the park's wildlife and scenery from an elevated perspective. When the oppurtunity presents itself, take advantage of upper-story views of sweeping scenes to give your camera the photo opportunities it deserves.

334 335

Photoshop's CURVES and HUE/SATURATION controls have been used to take full advantage of the rich hues in this colorful scene. This image was shot using a 300mm telephoto lens aimed from a seaside hilltop. These boats are the same as those seen in the background of the low-angle shots on pages 8 and 9. It's amazing the difference in photographs a few hundred feet of elevation can make.

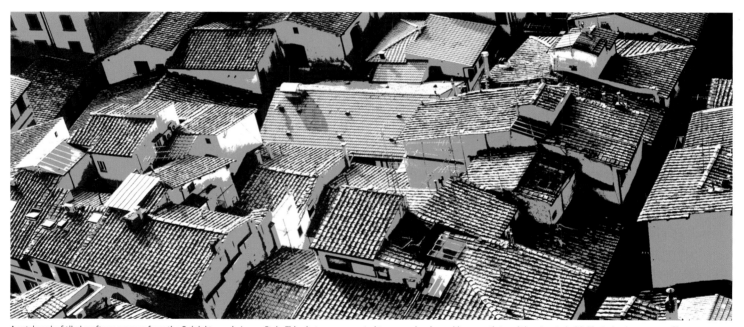

A patchwork of tiled rooftops, as seen from the Guinigi tower in Lucca, Italy. This photo was converted to grayscale, given a blue-gray tint, and then treated with Photoshop's POSTERIZE effect.

337

25

Firmament

The sun, moon, clouds and stars — things that occupy the space high over our earthbound heads — are the focus of this chapter.

The heavens' contents are not always easy to photograph. Taking pictures of (or toward) the sun involve dealing with excessive amounts of light; photographing the moon or stars often means adapting to low-light conditions. Here's a suggestion: Address whatever difficulties you can by using aids such as a tripod or shutter-speed, ISO and aperture adjustments. Beyond that, accept whatever photographic "imperfections" occur (burn-out, lens flare, graininess, blur, etc.). Consider welcoming these naturally occurring effects as aesthetically interesting additions to your photo's presentation.

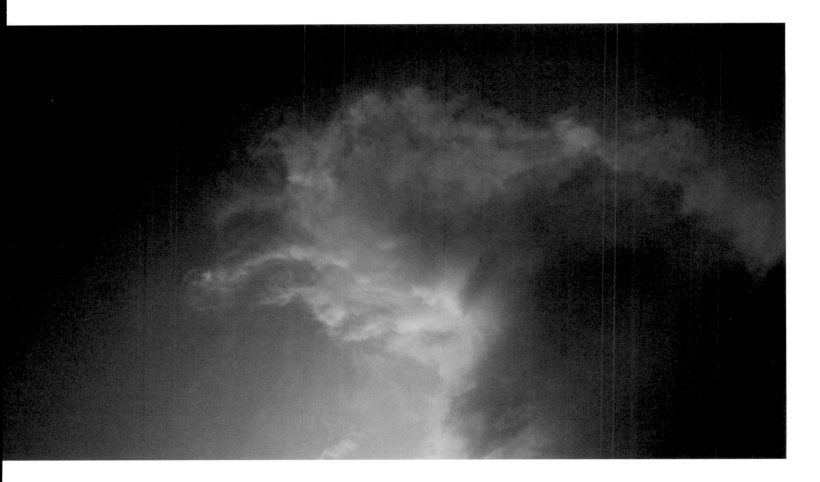

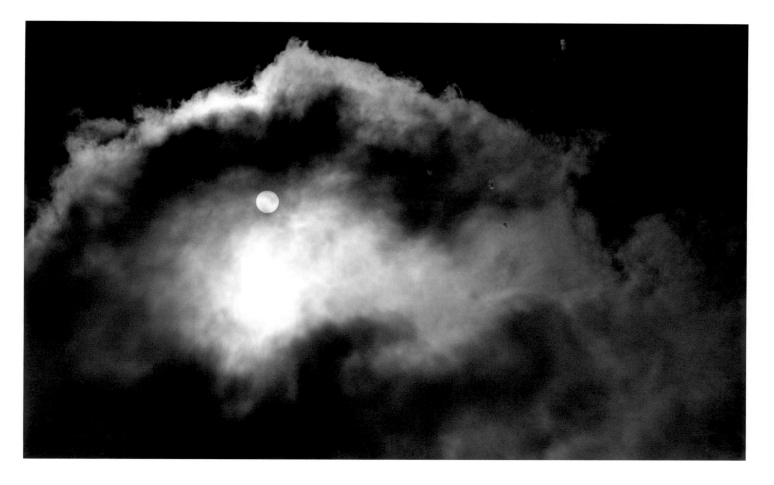

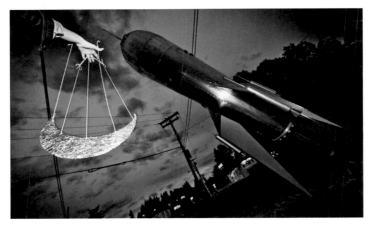

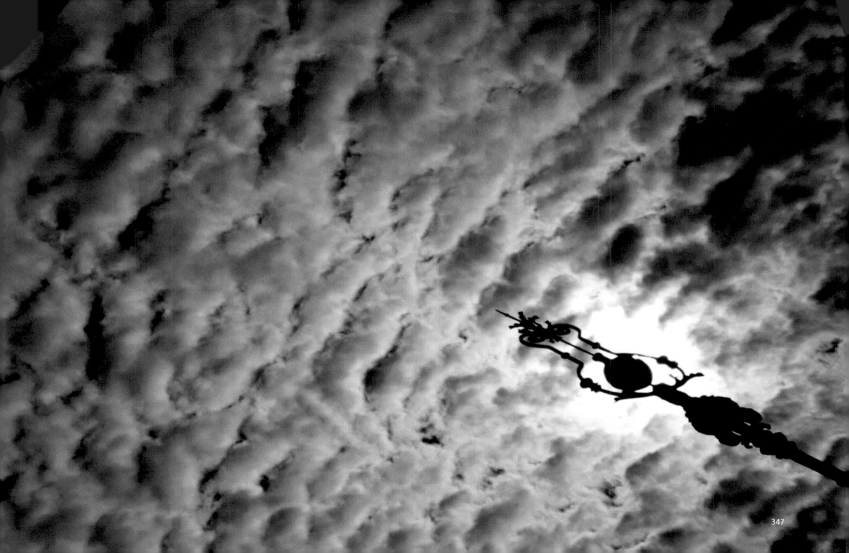

A contrail left by a passing plane makes an intriguing impression above the asterisk of the afternoon sun. An ambiguous photo—and perhaps appropriate as an opener for a chapter devoted to a much debated topic: the heavens.

338

339

One of the best things about using a digital camera is that you can try shots that may or may not work out (like aiming your camera toward the sun) and then look on the LCD to see how the photo came out. From there, the picture can be accepted, deleted or used as a reference for adjustments applied to the next shot. Take advantage of these digital benefits—take chances, and be open to whatever the results may be.

Quiet, impressionistic photos of clouds, sky and a certain celestial neighbor. Unless you're using a lens with a very large aperture (signified by a very low f-stop number) you may want to immobilize your camera when shooting under low-light conditions such as these—otherwise your shots are likely to be affected by blur and poor focus. These two images were recorded with the help of a tripod.

340

341

Near image: A grand billow reaches high into the evening sky. Notice how the cloud appears dark at the bottom and lighter toward its top. Now notice how the sky's tones are the reverse. The result is a delicate exchange of values that help the cloud's expressive form stand out adequately against its low-key backdrop.

The sun paints a faintly prismatic effect on the fringes of a dramatic whorl of clouds. Some advise against taking photos of the sun since the lens' focusing effect could produce enough heat to damage the camera's image sensor. Others say it's safe as long as fast exposure times are used. Do some web research on the topic before deciding if—and how—you want to take pictures that include the sun. (As you can see in many of this book's images, I've chosen to forego extreme caution in this area.)

342

343

Foggy conditions create a minimalistic impression of the sun in this image. (For additional "less is more" photos, see Chapter 19, Minimal 'Scapes, pages 260-271).

Moonshots. Clockwise from upper left: The moon rises above the lunar-like landscape of Joshua Tree National Park; a half moon appears in broad daylight in the compositional wedge formed by the rooflines of two buildings; an image of the full moon, taken using a tripod, a mid-level digital SLR and an affordable 300mm zoom lens (you might be surprised how well you can photograph the moon using modest equipment); and a long-exposure shot of the moon over a stand of palms along the California coast.

344

345

How about playing around a bit with the idea of "the heavens?" Here, a sun pendant, a handcrafted foil moon and a large model rocket (a roadside attraction outside a local donut shop) act as stand-ins for the real articles. Both shots were taken at dusk using the camera's flash to illuminate the above-mentioned props.

This photo of a lamppost in a Florentine piazza was shot from a vantage point that placed the sun in direct alignment behind the structure's unlit light fixture. The result is a dark, ornate silhouette that contrasts nicely against the mottled sky above. An extreme off-center placement for the image's main subject has been utilized for two reasons: dramatic effect; and to give the eye-catching clouds in the backdrop plenty of space within the scene to display themselves. 346

347

I once heard a photographer say that, to him, it wasn't worth going outside to take pictures unless the clouds were doing something interesting. And while I don't quite share his opinion in absolute terms, I can definitely understand where he was coming from.

An expression of awe—a suggestion of the overwhelming splendor and mystery of the firmament. This exquisitely rendered figure inhabits Rome's Pantheon.

349

Glossary

Note: Any Photoshop controls, functions or tools are denoted by the use of SMALL CAPS.

ADJUSTMENT LAYER. A layer added to an image in Photoshop to alter characteristics such as contrast, levels and color balance. Alterations made using an ADJUSTMENT LAYER can be revised by double-clicking on it in the LAYERS palette and readjusting its controls (an option that would not be available if the original adjustments had been applied directly to the image using a menu command). ADJUSTMENT LAYERS can also be selectively applied to an image. This is done by using the PAINTBRUSH or other rendering tools to create regions of varying opacity in the MASK layer that automatically accompanies an ADJUSTMENT LAYER when it is created. Consult Photoshop's help menu or manual for detailed information about these useful and easy to use image editing tools.

Aperture. The adjustable iris-like opening inside a lens that controls how much light reaches the image sensor. Some cameras allow for manual control of the aperture opening—others handle its functions automatically. Aperture affects both exposure and depth of field.

Backlighting. A lighting arrangement where the subject is between the camera and the light source.

Bracketing. A technique of taking a set of photos—each shot at a slightly different exposure—to help ensure that at least one is properly exposed. Most brackets are shot in sets of three images. Full-featured digital cameras usually offer an automatic bracketing feature that shoots a burst of three differently exposed shots when the shutter button is pressed.

CHANNEL MIXER. An editing tool in Photoshop that allows the user to adjust the distribution of red, green and blue in an image. These color channels can also be isolated—by selecting the CHANNEL MIXER's "monochrome" option—as a way of converting an image to black and white.

CMYK. Abbreviation for cyan, magenta, yellow and black. For most printing purposes, images need to be converted from their native RBG mode to CMYK via software.

Continuous shooting mode. A feature of many digital cameras that allow them to take a steady stream of shots while the shutter button is held down.

Crop. To select only a desired portion of an image for display.

CURVES. A highly adjustable Photoshop control that allows the user to control the distribution of values and hues within an image.

Depth of field. The zone in which the camera sees things as being in focus. Objects outside this zone (both nearer to and further from the camera) appear out of focus. Depth of field is the product of several fac-

tors: the focal length of the lens being used; the distance to the object being focused on; and the aperture opening (a narrower opening means a deeper depth of field; a wider opening means a shallower depth of field).

Desaturate. The removal of all color hues from an image. Full desaturation results in a black and white image.

Exposure. The amount of light that reaches the image-sensor to create an image.

Fisheye lens. A lens with an extremely wide field of view—from 100° to 180° and beyond.

Framing. A visual term used to describe when certain elements of a composition enclose others.

Grayscale image. Another term for a black and white image.

Hue. Another term for color.

HUE AND SATURATION. A control within Photoshop that allows for adjustments to the color, intensity and brightness qualities of a specific hue—or all hues globally—within an image. These adjustments can be applied directly to an image through a menu command or through an adjustment layer.

LASSO TOOLS. A family of tools within Photoshop that are used to manually select elements with clipping paths.

LCD. Liquid Crystal Display. A panel on the back of most digital cameras that can be as a viewfinder, to review images, and to control menu items.

LEVELS. A control within Photoshop that allows adjustments to be made to an image's range of values and color balance.

Macro lens. A lens specifically designed to take close-up photos. Most macro lenses have a magnification ratio of 1:1 or greater.

Monochromatic. An image or scene composed of values of one hue.

Overexposure. The effect that occurs when cells of the image sensor receive so much light that the corresponding areas of the image are pure white. Some photographers consider overexposure unacceptable in images—others allow it for visual or thematic effect.

Pixel. A single cell within the complex grid of individual hues that make up an image captured by a digital camera.

Resolution. The level of detail recorded by a digital camera. Also the level of detail present in an on-screen or printed image.

RGB. Red, green and blue: The three colors with which digital cameras and computer monitors build their images. Images in RGB format can be converted to other color models (such as CMYK) using software.

Saturation. The intensity of a hue. Highly saturated colors are at their most intense. Colors with low levels of saturation appear muted.

SHADOW/HIGHLIGHT. A control within Photoshop that allows the user to bring out details within overly dark or overly light areas of an image.

Shutter speed. The duration of time during which the shutter is open (and thereby allowing light to reach the image sensor) during a shot.

SLR. Single Lens Reflex. A camera whose viewfinder sees through the same lens that will be sending light to the image-sensor. The lenses on most SLRs are interchangeable.

Standard zoom lens. A versatile lens that has a field of view comparable to the human eye's central viewing area. This lens is also capable of moderate image magnification.

Telephoto lens. A relatively compact lens capable of a wide range of telescopic magnifications.

Underexposure. The effect that occurs when cells of the image sensor have not received enough light to fully portray the corresponding areas of an image.

Value. the relative lightness or darkness of a color or shade compared to a scale of white to black.

Visual texture. A dense repetition of elements that form anything from an organized pattern to a freeform, chaotic assemblage.

White balance. The way in which a camera measures and records prevailing light so that whites—as well as all other colors—appear normal to the eye of the viewer.

Wide-angle lens. A lens with a broad field of view.

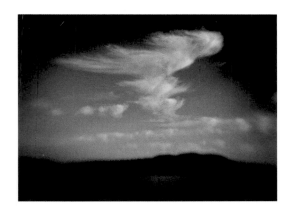

More Great Titles from Jim Krause and HOW Books!

Photo Idea Index

This innovative guide offers designers the information and inspiration they need to take creative photos and use them in real-world design applications.

ISBN: 978-1-58180-766-0, vinyl cover over paperback, 360 p, #33435

Color Index

Color Index makes choosing hues for any job easier. It will help designers start working with color in exciting new ways and create original, eye-catching designs that pop off the page.

ISBN: 978-1-58180-236-8, vinyl cover over paperback, 360 p, #32011

Design Essentials Index

Combining three invaluable, practical design books for idea-hungry designers, the *Design Essentials Index* offers designers solutions for everything from design basics, to new systems for combining colors, to an in-depth examination of creative and practical applications of type. This uniquely designed box set includes Jim Krause's best-selling *Design Basics Index, Type Idea Index* and *Color Index 2* to give designers a wealth of practical design information.

ISBN: 978-1-60061-142-1, vinyl cover over paperback, #z2375

Creative Sparks

This playful collection of rock-solid advice and thought-provoking concepts, suggestions and exercises is sure to stimulate the creative, innovative thinking that designers need to do their jobs well. It will encourage readers to find inspiration in the world around them, spark new ideas and act as a guide to each designer's creative path.

ISBN: 978-1-58180-438-6, hardcover, 312 p, #32635